ERWIN
BLUMENFELD

PHOTOGRAPHS
DRAWINGS AND
PHOTOMONTAGES

ERWIN BLUMENFELD

PHOTOGRAPHS
DRAWINGS AND
PHOTOMONTAGES

H
A
Z
A
N

JEU DE PAUME

Distributed by Yale University Press, New Haven and London

Contents

Preface

Marta Gili
Director of the Jeu de Paume

Suggesting connections that are rarely established in everyday life between ideas, situations or concepts is among the singularities of artistic expression. Occasionally, art is even capable of representing the unrepresentable. In composing several studies for a portrait of Hitler, Erwin Blumenfeld not only symbolised the face of evil, but also rejected any possible identification with the quality of being human. By showing the failure of verisimilitude in a portrait of the dictator, Blumenfeld expressed the very incapability of representing him, and thus his dehumanisation.

What characterises Blumenfeld's work is precisely its capacity for creating "visual conflicts", achieved through the experimental technical and aesthetic methods extolled by the "New Photography", Surrealist and Dada movements between 1920 and 1940 (such as the superimposition of negatives, collage, montage, solarisation and multiple exposures), as well as through drawing, watercolour and typography. Through these "visual conflicts", the work takes on the possibility of seeing in a different way.

Blumenfeld is best known for his exceptional use of colour in commercial and fashion photography. Upon arriving in the United States, he established himself in this particular world as one of the indisputable masters at portraying the female body. His artistic career, however, began in Europe. Therefore, this exhibition brings together a selection of the graphic and photographic work he created during his early days as an amateur photographer in Berlin and subsequent professional career in Amsterdam, Paris and the United States.

The Jeu de Paume wishes to express its most sincere gratitude to Ute Eskildsen, who has so generously shared her entire, renowned critical and professional experience as a photography historian with the curators of this exhibition. We also wish to thank all of the public and private collections that made it possible to bring together these works, particularly the heirs of the photographer, Yorick Blumenfeld, Henry Blumenfeld and Yvette Blumenfeld Georges Deeton. This exhibition would not have been possible without their support. We would also like to extend our gratitude to the authors of this catalogue, Helen Adkins, Wolfgang Brückle, Nadia Blumenfeld Charbit, François Cheval, Janos Frecot and Esther Ruelfs, who, under the direction of Ute Eskildsen, proposed a new contextualisation of the artist's work. Finally, we thank the Ministry of Culture and Communication as well as Neuflize Vie, main sponsor of the Jeu de Paume.

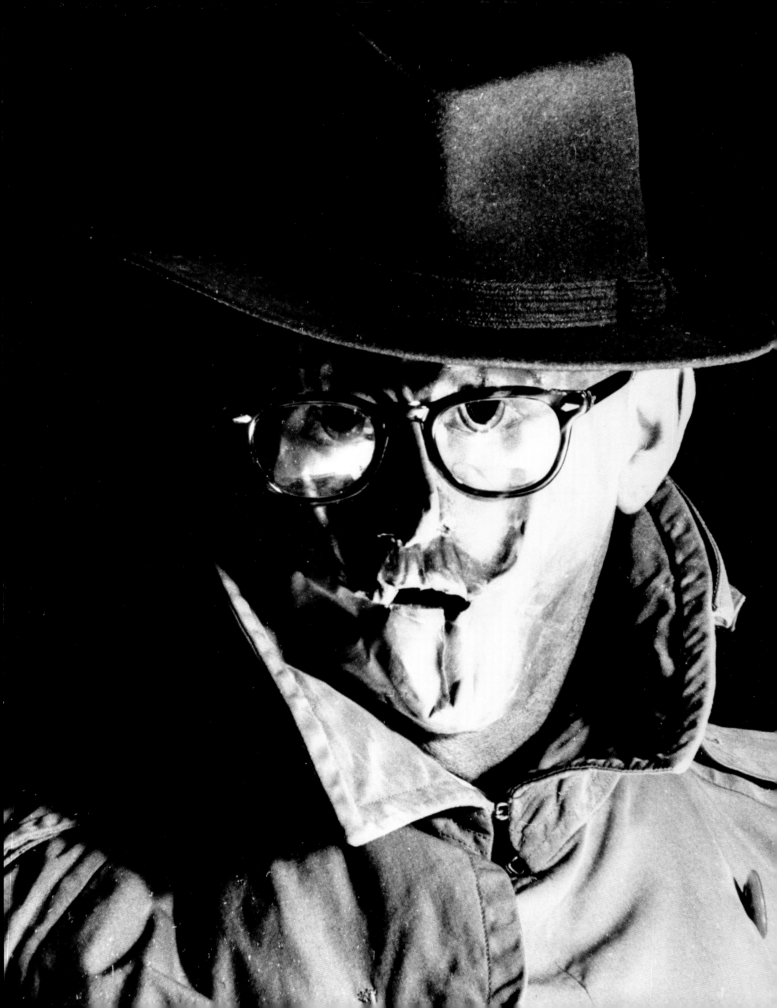

Berlin – Amsterdam – Paris – New York Erwin Blumenfeld – A 20th-Century Figure

Ute Eskildsen

Erwin Blumenfeld
Masked Self-Portrait
New York, c.1958

And so I became, when there was really nothing left for me to do, a photographer.[1]

Just how could the women's clothing apprentice, this wilful youth from a middle-class Jewish background in Berlin, become a sought-after and highly paid advertising and fashion photographer in the New World?

And how did this owner of a leather-bag store in Amsterdam become one of the best-known figures of creative New York in the 1950s?

In his autobiography, *Eye to I – a novel of conceit* first published posthumously in France in 1975 as *Jadis et Daguerre* – Erwin Blumenfeld gives sufficient information on this subject. These memoirs greatly influenced how his artistic work is received. There is no author who has not been seduced by these provocative, cynical and egotistic memories. Family, friends and clients are articulately, humorously and sometimes a little darkly entangled in stories, and portrayed for immense reading pleasure. This was to remain Blumenfeld's only literary work.

Our exhibition traces his visual creativity and encompasses the early drawings, the collages and montages, which mostly stem from the early 1920s, the beginnings of his portrait art in Holland, the first black and white fashion photographs of the Paris period, the masterful colour photography created in New York and the city documentaries recorded towards the end of his life.

Success

Erwin Blumenfeld died of a heart attack in Rome in the summer of 1969. It was here, and not in his hometown of New York, that he was buried – the grave no longer exists. He had completed work on his autobiography in New York beforehand. Togeth-

The quotes from Erwin Blumenfeld (EB) and Alfred Andersch (AA) are taken from the publication *Erwin Blumenfeld: Durch Tausendjährige Zeit. Erinnerungen*, Munich, Deutscher Taschenbuch Verlag, 1980.

1. EB p. 217.

er with his assistant and companion, Marina Schinz, he had undertaken the precise editorial work on the text in the 1960s. He had begun to deal intensively with the memories of his life and work in the 1950s and had already begun to write in the 1920s. Many typescripts remain, one of which is to be found in the public collection of the Akademie der Künste, Berlin. The book was published posthumously for the first time in 1975 in France as *Jadis et Daguerre*, the title of its 20th chapter. Publications followed in German, Dutch and English but the edition published by Eichborn Verlag[2] in 1998 was the first not only to use the original title, *Einbildungsroman*, but also to add the photographs chosen by Blumenfeld. The Berlin expert Janos Frecot writes on the character of the book in this catalogue and Blumenfeld himself speaks in the exhibition installation through the recording.

Blumenfeld revisited and photographed Berlin for the first time in 1960, and documented other postwar cities as well.

Several thousand colour slides emerged in the 1950s and 60s, using a miniature camera. We have chosen three city representations from this previously unexhibited material.

The projected photographs are of New York, Paris and Berlin, collated by François Cheval, director of the Musée Nicéphore Niépce in Chalon-sur-Saône, and which he describes as an intimate portrait of the photographer.

Even in the early years of his photographic career in Holland and in Paris, Erwin Blumenfeld also repeatedly sought motifs outside the studio. He had photographed still lifes, but also urban situations. In contrast to these early atmospherically picturesque photographs, the small colour images that came later appear distant, documentary.

Until 1955 Blumenfeld had worked for ten years under contract to the Condé Nast publishing house in New York:

"As an insignificant émigré I really had no choice but to embrace my illusions with blind abandon, unencumbered by factual knowledge."[2]

Following a gruelling and debilitating escape from the Germans in occupied France and after a number of internments in French camps, the Blumenfeld family arrived happily in New York in the summer of 1941.

In 1943, Blumenfeld was quickly able to activate the contacts he had already made in the fashion world in 1939 and he produced work in his own studio Central Park South, after another successful European emigrant, Martin Munkácsi had initially made his studio available.

In the decade that followed, Blumenfeld developed an exceptional and original repertoire of forms, from the use of colour for fashion photography, through the experimental experience of black and white photography. He created dreamy, erotic pictures in Paris endowing the models with a sense of mystery through the use of mirrors and fabrics. In New York, he worked more with graphic effects and colour-conscious studio productions.

Blumenfeld had expertly tested and refined colour photography in particular, which was used for commercial purposes earlier in the USA than in Europe, and recognised its pictorial potential early.

In 1948, Edward Steichen chose six of Erwin Blumenfeld's photographs for his exhibition, "In and Out of Focus, A Survey of Today's Photography" at the Museum of Modern Art in New York, a selection that included none of his colour fashion photos. In the

same year the Los Angeles County Museum included ten photographs in its exhibition, "Seventeen American Photographers". (He had received American citizenship two years earlier.) The catalogue described Blumenfeld as, "one of the greatest interpreters of the medium. [...] Blumenfeld does not take the straight picture as he finds it in life in normal light; he seeks rather by deformation and extreme psychological effects to bring out the hidden and unknown quality of his objects; his quest is not realism but the mystery of reality."[3]

The ongoing exhibition, "Blumenfeld Studio, Color, New York 1941-1960" summarises the works of the American period for the first time. It was organized in cooperation with the Musée Nicéphore Niépce and the Museum Folkwang, Essen, accompanied by a comprehensive publication and has been touring. This prompted us to depict the quality of the fashion photography he created in the United States in this catalogue with a selection of his many magazine titles alone.

Most of the colour fashion shots were originally in 8 x 10 inch format (20.3 x 25.4 cm) on Ektachrome or Kodachrome filmstrips, but when enlargements were planned, 4 x 5 inch (10.2 x 12.7 cm) colour negative material was used. While the films were developed in other laboratories, Blumenfeld carried out the paper preparation himself. As in black and white photography, the darkroom was a decisively important place in terms of picture composition.

Even when given specific guidelines, and not always to the joy of his clients, Blumenfeld sought experimental design solutions, whereby he was taken by the boundaries between photographic and graphic shaping of forms.

Quite often using the simplest means, Blumenfeld created constructions before the camera, reached into the former instrument box of the Dada fitter and Surrealist alienator, took fluted glass, scissors and paper and thus supported his stagings with light. He also did not shy from sticking transparent film to his large-format sheet film, wherever it increased the graphic quality of the image.

He hated dependency on art and picture editors, the controllers of magazine pictures irrespective of the fact that they often transferred his picture ideas directly to the front page. And although the legendary *Vogue* art director Alexander Lieberman, praised Blumenfeld as, "the most graphic of all photographers" and described him as the one, "who is most deeply rooted in the fine arts" (quoted in B. Ewing Note 54/Liebermann), the photographer complains in retrospect, "That my ideas, my work, my photos should be manipulated by strange hands, those of an art director appeared incomprehensible to me. They were alleged to have artistic motivations in the Paris of those days."[4]

The ideas he developed for fashion clients were successful at the time but have been even more influential since then and still inspire photographers today.

The decision

Paris is the city in which Blumenfeld's photographic career began. Paris was the city upon which he projected his artistic existence. Paris was also the city of fashion and fashion photography, an assignment field with great freedom for ideas and experiments – this is where Blumenfeld saw his chance not only to implement his visual ideas but also, in the best case, to be able to feed his family through it. He was to work in this place, where he had long yearned to be, for just four years, but this short period, where he could experience French avant-garde photogra-

3. Exhibition catalogue, p. 3.
4. Quoted from William A. Ewing, *Erwin Blumenfeld 1897-1969: A Fetish for Beauty*, London, Thames & Hudson, 1996, p. 54.

phy close at hand, had perhaps the most lasting influence on his photographic development.

While he was still living in Holland, he took part in the exhibition, "Exposition internationale de la photographie contemporaine" at the Musée des Arts Décoratifs in 1935 and Lucien Vogel had published some of his photographs in his magazine, *Arts et Metier Graphique* before Blumenfeld moved to Paris. On his arrival there in 1936, he was no longer unknown and his photographs were shown at the Galerie Billiet in the same year. However this early artistic recognition did not secure his livelihood. In retrospect, there were three people who eased his professional entry to Paris. Support from the art dealer Walter Feilchenfeldt, husband of the Berlin photographer Marianne Breslauer, enabled him to rent a studio. The painter Georges Rouault's daughter Geneviéve gave him access to Paris society and in 1938 the already successful British fashion photographer Cecil Beaton helped to pave his way to the magazine *Vogue*.

In the next three years he produced not only classically elegant fashion photography, but also nuanced erotic glamour photographs, experimental portrait studies and isolated pictures of sculptures and architecture. In these few years, Blumenfeld had found his own formal language. He used photomurals as backgrounds, dolls as models, visually expanded the studio with mirrors and panes of glass and tested the bandwidth of chemical manipulation in the laboratory; for example using infrared light during the negative process.

In terms of his artistic interests, he is certainly a child of Surrealism, and the images of his great idol, Man Ray were deeply influential. For example in his self-portraits conceived with the motif of a composite face, both front on and in profile, he varies a larger

picture idea, that is both invention in the spirit of playful amateur but also an expression of a modern fractured identity.

However it was the fashion series he photographed on the Eiffel Tower (published in French *Vogue*, May 1939) that created a furore at this time. Erwin Blumenfeld travelled to New York for the first time in 1939 with these pictures in his suitcase and returned with a contract from *Harper's Bazaar*, *Vogue*'s rival magazine. However he could not fulfil the mandate to report on the Paris fashion scene for long.

In May 1940 the Germans had begun attacking the Benelux countries. Rotterdam was bombarded in the same month and on 14 June Paris was occupied. Following France and England joining the war in September 1939, France had to register all Germans with the authorities. Erwin Blumenfeld was interned in Montbard in May. He was later incarcerated in Loriol, Le Vernet, Catus and Agen, his 18-year-old daughter, Lisette was sent to the camp at Gurs.

In his autobiography, Blumenfeld refers to the use of his Hitler-montage *Grauenfresse*, for propaganda. It is said to have been airdropped as a flyer in its millions over Nazi Germany. Wolfgang Brückle concentrates specifically on this flyer in his text, as well as on the picture, *The Dictator*.

The Dutch years

In 1933 when living in Amsterdam, the city that Blumenfeld had settled in after the First World War, he created *Grauenfresse*, an immediate strong political statement, which in its public reception mutated to *Hitlerfresse*. His brother had been killed in the war, Erwin's Blumenfeld desertion attempt failed, but he then managed to enter Holland in 1918. His fiancé Lena Citroen, who he married in 1921, lived in Ams-

terdam. He tried his luck for a short and relatively unsuccessful period as an art dealer with Paul Citroen, his best friend from the Berlin days and his wife's cousin. Both were self-designated directors of the Dada Centre. In this context, Blumenfeld signed his name Bloomfeld or Bloomfield.

Blumenfeld's Fox Leather Company, a women's handbag store founded by Blumenfeld, was not crowned with success either but an opportunity for the amateur photographer – customers, friends and their families were portrayed in the store and the films developed in Blumenfeld's first own laboratory. Looking at the contact prints from that time it becomes apparent that it was in the darkroom that Blumenfeld often created modern images from rather traditional portraits. At this time, around 1920, he also did numerous drawings, sketches and collages. An exhibition at the Berlinischen Galerie, Berlin, in 2008 was specifically dedicated to the montages and collages. We were also fortunate enough to have the curator and author of the accompanying book, Helen Adkins, contribute an essay on these early works to this catalogue.[5]

Although Blumenfeld described his time in Holland relatively negatively: "Amstelodamum, city of my youthful dreams, the Venice of the north, turned out to be an impenetrable labyrinth of swamps, well below medieval sea-levels from beneath which sunken bells gave voice by day and night",[6] he began his photographic career there. His portrait photography from these years marks the professionalisation of the amateur. In her catalogue contribution, which deals specifically with his treatment of women, Esther Ruelfs starts looking at these early portraits. Blumenfeld had his first exhibitions in Holland in 1932 and 1933 in the Kunstzaal van Lier in Amsterdam. Interestingly, no montages or collages were shown.

This may have been due to the German themes and German texts, as the montage was also a much used and discussed picture format in Holland around 1930. However it was not only the content that alluded to his experiences as a youth in Germany and the First World War, his early artistic method was also influenced by cultural experiences and friends of that time.

Early experiences

Born in Berlin in 1897, he was already forced to leave this city as a 20 year old. He was drafted into military service in 1917 and in 1919 moved to Amsterdam, as previously mentioned. Just how much the Berlin years influenced him is evident from the fact that more than half of the chapters in his autobiography are dedicated to them.

"Twice a year I had to accompany Papa to the Great Berlin Art Exhibition, with its stench of oil, where German anecdotal painting flaunted its tawdry wares. Cloying boudoir scenes alternated with imposing battle pictures, the harsh tumult of war with serene still lifes of fruit."[7]

Photography, an interest which he shared with his fellow classmate Paul Citroen, had already interested him as a schoolboy, a fact very beautifully documented by two double self-portraits – both in the same pose – from the years 1916 and 1926. Through Citroen, who had begun to work in the orbit of publisher and gallery-owner Herwarth Walden, an important promoter of the avant-garde, Blumenfeld was kept constantly up-to-date. A long friendship developed from the first encounter with George Grosz in a lavatory: "A young dandy [...] stood beside me, fixed his monocle in his eye and in one fell swoop pissed

5. We have not, however, included any of the 20 montages attributed to Blumenfeld, which have appeared on the art market successively since 2000, denoted "Paul Zech" in our exhibition as their provenance cannot yet be ascertained.
6. EB p. 212.
7. EB p. 113.

8. EB p. 122.
9. AA p. 8, Foreword.
10. AA p. 8, Foreword.

my profile on the wall so masterfully that I could not but cry out in admiration."[8]

The schoolfriends Blumenfeld and Citroen explored the artists' meeting places in cafés and became acquainted with Bohemianism.

It was a time of inquisitiveness and absorption, but also of mistrust toward societal developments. Reactions, reflections and provocations are formulated in the collages from 1919 onwards: towards the empire, the military, the German middle class and other forms of authority too, such as the church. In contrast to John Heartfield, he does not focus in his montages on a specific current political constellation, but more a sarcastic settling of the score with the social milieu and the ruling elites of the empire, from which he himself came and which had been discredited by defeat.

As Alfred Andersch judged in his introduction to the autobiography, "That someone can at once be so naïve and so brilliant seems paradoxical, but it is from exactly that contradiction that this strange book lives",[9] this is also true of some of the collages, where Blumenfeld places drawing and photo in an illustrative, symbolic relationship.

In the time from 1919 to 1933 Erwin Blumenfeld created a large number of collages and drawings. Almost all of his collages contain drawings and texts. In them, he plays with printed words and typographies written and found, combines terms and places, creates ironic commentaries and provocative titles for which he often uses writing paper. The emphasis of the font, the unspoilt open space of the leaf, is characteristic of his collages as emphasizing a stage for his constructions.

The drawings, many of which are shown here for the first time, as well as numerous collages, are rarely dated. There are hasty sketches of experiences and thoughts, sketched jokes and biting caricatures in pencil, ink, watercolour or coloured pencils – he used whatever was to hand. The quality of the drawing medium, the most direct means of creating a picture obviously fascinated Blumenfeld and inspired a playful approach in him.

According to his last assistant Marina Schinz, he was no longer interested in these early works in the later years. Photography had become the fundamental means of expression for him and brought him, he who had no opportunity to enjoy an education in art, much admiration and commercial success.

The life of Erwin Blumenfeld, this, "splendid, angry narrator" and, "ingenious inventor of facts",[10] records in fatal manner the tragedy emanating from Germany in the 20th century. His photographic pictures seldom directly represent the contradictorily individual and the socially disastrous. This retrospective will not truly be able to depict the artist Blumenfeld's extreme life experiences. However, in this overview of his work, considering all the picture formats he used, from all decades of his creativity, substantive responses and reflections, formal correspondence and repetitions are recognisable and comprehensible.

What is expressed in the collages as ironic and bluntly mocking develops ambiguity through photography as a concrete medium. Attributing layers to the real subject, gaining mystery, suggesting the demonic – the enlivening of the dead and the deadening of the living – this is the hallmark of his photographic work. Erwin Blumenfeld was not a photographer of the first photographic avant-garde in the 1920s, but more of a creative successor to or developer from the pioneers of the "New View" at the start of the 20th century. He was, however, an

avant-gardist of colour photography, who was not shy of reactivating past pictorial ideas with new techniques and developing them further. Erwin Blumenfeld was an imaginative and accomplished photographer and in an unusual way, by convincing his clients to let him experiment, a continual experimenter. With a playful interest in destroying conventional practice and techniques of photography, Blumenfeld succeeded in developing an individual, unmistakable and enduring visual vocabulary.

With over 200 photographs, structured in five thematic areas, this exhibition presents a magnificent, multifaceted 20th-century oeuvre. It is the first Erwin Blumenfeld retrospective in France – yet some of his greatest pictures were created in Paris, with his most desired, figurative subject, the woman.

I would like to express my heartfelt thanks to Nadia Blumenfeld Charbit, Yvette Blumenfeld Georges Deeton, Henry Blumenfeld, Yorick Blumenfeld and Marina Schinz, for kindly passing on their information and knowledge regarding Erwin Blumenfeld's life and work.

Wim van Sinderen, Fleur Roos Rosa de Carvalho, Alfred Hübner, Helen Adkins, Wolfgang Brückle and Matti Boom, thank you for your helpful information, and Susan Kismaric and Birgit Langshausen for archive and library research. Special thanks to Marta Gili and her team, for such enjoyably productive cooperation.

Drawings

Allegro, Sterb. Schwan [Allegro, Dying Swan]
February 1919

Man with Red Lips
Early 1920s

Man with Bell
Early 1920s

Du Ich Frühlingsabend [You Me Spring Evening]
May 1919

Interieur und Liebe (Der Menschenliebe Blatt 100) [Interior and Love (To Human Love Sheet 100)]
1919

Figuration
Early 1920s

Woman with Blue Jacket
Early 1920s

3 Mark
c.1919

Seated Man
Holland, c.1919

Sie heisst Olga Schmidt und er Abdullah [Her Name is Olga Schmidt and his is Abdullah]
25 January 1919

The Jockey
1919-25

Man
January 1923

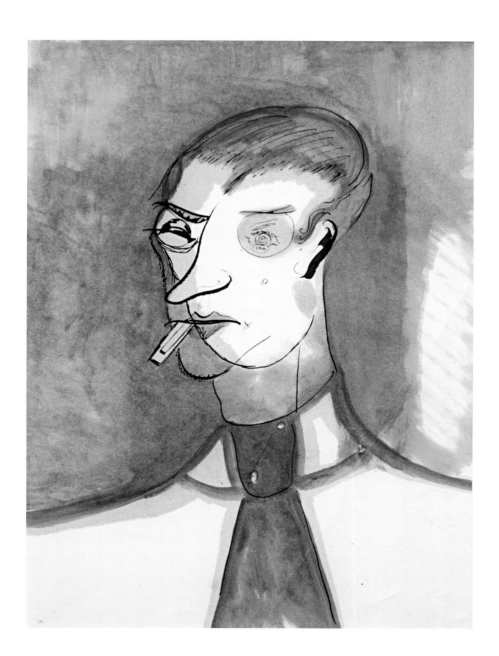

Portrait of Sylvia von Harden, journalist and poet
c.1926

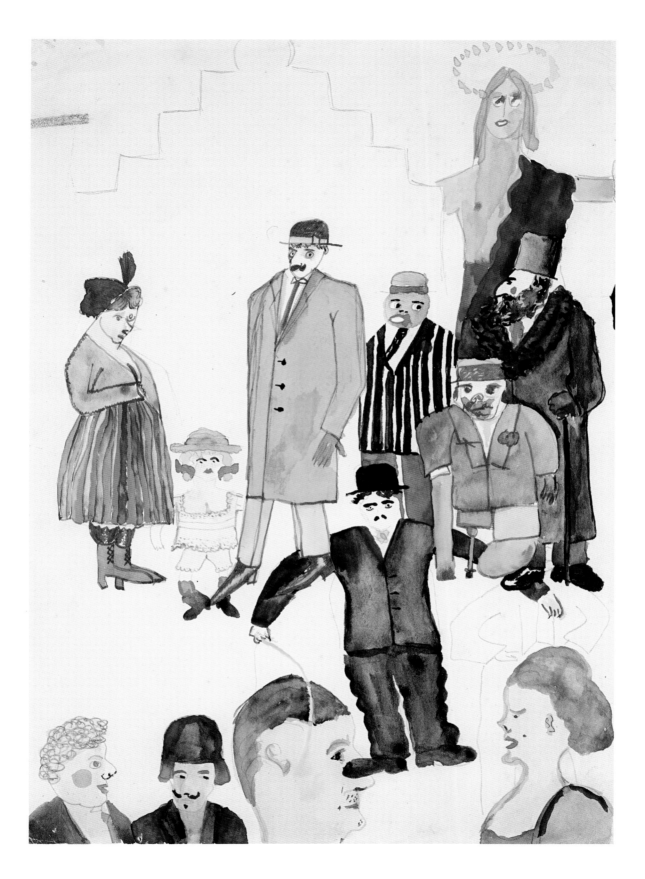

Group with Charlie Chaplin
1920

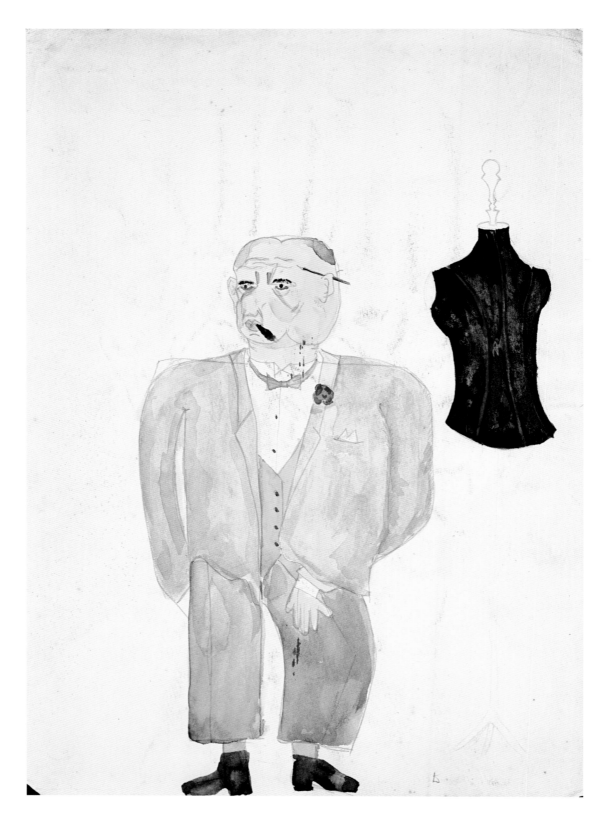

Old Man with Cigar
Early 1920s

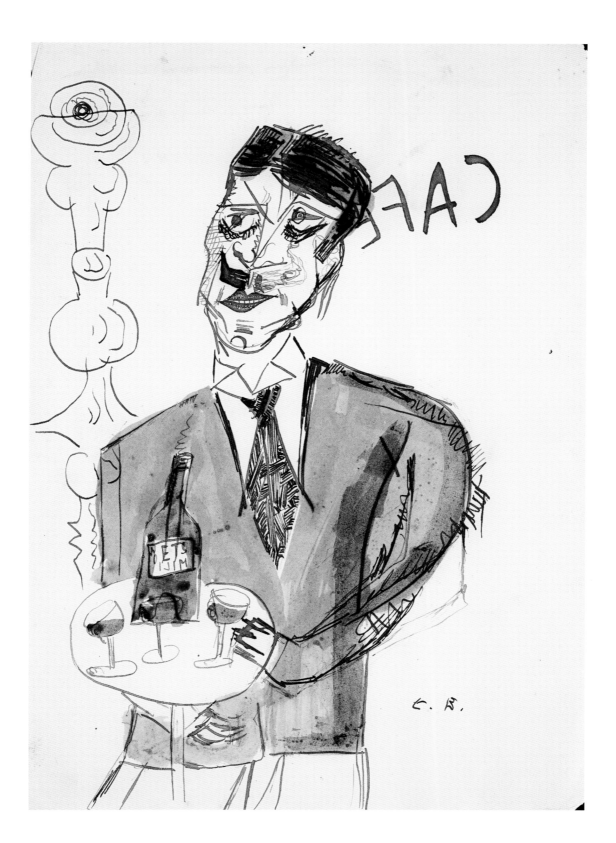

Café
Early 1920s

Man's Face
1920s

Woman with Transparent Dress
1921

DON JUAN HEIRATET

DON JUAN HEIRATET

"Every Picture a Short Story, Complete in Itself."[1]
A Reading of Erwin Blumenfeld's Early Work

Helen Adkins

Between 1916 and 1933, Erwin Blumenfeld produces a small quantity of drawings and montages.[2] Created mainly in Berlin and Amsterdam, they coin the basic ideas the artist will experiment with throughout his entire life. The earliest works pay homage to Erwin's love for Lena, who in 1915 becomes his fiancée on the strength of letters, before they ever meet. Lena Citroen lives in Amsterdam and their correspondence discloses Erwin's eager interest in the thriving bohemian Berlin.[3] As a young man, he spends his spare time writing letters, poems and short stories. When he retires from daily business at Condé Nast in 1955, he returns to writing, authoring his autobiography. During the years of his leather store in Amsterdam, he thinks of himself as a Sunday painter and produces a number of oil paintings. In December 1933, he writes to his friend George Grosz that – dedicating so much time to photography – he has consequently decided to give up painting.[4] Despite this, he later creates his own coloured backdrops for his fashion photography and, in 1961, even works once more on a self-portrait in oils.[5]

Erwin Blumenfeld is raised in Berlin in the stiff atmosphere of a well-to-do Jewish family. Among the rich library of classics at home, Meyers' *Lexikon*, a comprehensive encyclopaedia, is one of the titles he consults most. His father, an umbrella manufacturer, dies when he is 16. In the necessity of earning a living and on decision of the family council, Erwin and his younger brother Heinz go into the garment trade. Erwin feels the enormous pressure to train in a "respectable" profession and has no other choice than to set his artistic aspirations behind this foremost duty. A frustrating situation, since Paul Citroen, Erwin's best friend from an early stage, after an apprenticeship in a bookshop, takes art lessons in

1. Erwin Blumenfeld, *Eye to I, The Autobiography of a Photographer*, London, Thames and Hudson, 1999, p. 282.
2. I call them "montages" rather than "collages" due to the designation "Dadamontage" provided by Blumenfeld himself in a caption in the autobiography. "Collage" I consider to be the technique that leads to a montage. See: Helen Adkins, *Erwin Blumenfeld. Dada Montages 1916-1933*, Ostfildern, Hatje Cantz Verlag, 2008, p. 50 ff.
3. The correspondence between Erwin Blumenfeld and Lena Citroen is in the Erwin Blumenfeld Archive, Akademie der Künste, Berlin.
4. Erwin Blumenfeld to George Grosz, 15 December 1933, Houghton Library, Harvard University, Cambridge (Mass.).
5. For the backdrop he uses a spray gun. The self-portrait of 1961 is illustrated in Helen Adkins, *Erwin Blumenfeld. Dada Montages 1916-1933, op. cit.*, p. 57.

Erwin Blumenfeld
Don Juan Heiratet
[Don Juan Gets Married]
1919

Erwin Blumenfeld
PER
1919-21

6. Quoted from: Erwin Blumenfeld, "I was an amateur", in *Popular Photography*, September 1958, p. 88.
7. *Eye to I, op. cit.*, p. 224.
8. *Ibid.*, p. 130.
9. *Ibid.*, 1999, p. 190.
10. *Ibid.*, 1999, p. 213.
11. Lena Citroen in a talk with the author, Cambridge 1987.
12. Lena told me how upset he was about the murder of Karl Liebknecht and Rosa Luxemburg (Cambridge, 1987).
13. Jack Johnson (1878-1946) is the central figure of six of the montages, the earliest of which was most probably a collaborative piece that Blumenfeld did together with Paul Citroen (see my book, *Erwin Blumenfeld. Dada Montages 1916-1933, op. cit.*, pp. 132, ff.).

a private school and later at the Bauhaus to become a key figure in the art scene of the period. Most artists who practice photography in the 1920s are trained painters. Even in the later successful years, Blumenfeld repeatedly states that he is only an "amateur" photographer. In his usual ambiguity, however, he turns this definition into something positive: "To me an amateur photographer is one who is in love with taking pictures, a free soul who can photograph what he likes and who likes what he photographs."[6] Positioned somewhere between a strong ego and existential anxieties, he writes: "That fear [of starvation] has never left me for a second in my whole life."[7]

Blumenfeld is trapped between the rigid notions of late Wilhelminian moral values and "the world revolution set in motion by Nietzsche, Van Gogh, Rimbaud, Strindberg, Wedekind, Freud, Einstein, Curie, Cézanne".[8] Disastrous personal experience adds to the dilemma of his generation: the syphilitic insanity and death of his father in 1913, combined with the family's subsequent embarrassing bankruptcy is traumatic. Just five years later, in the summer of 1918, when the war is clearly lost for Germany, this is topped by his mother's betrayal of his plans to desert from the Western front to Holland. Following her conviction "Better dead in the trenches than a traitor!", she leaks her son's plan to her brother, who promptly declares his nephew to the police, causing his arrest and risking his execution. Unable to prove his intentions, the authorities release Blumenfeld, who has to return to the front in Flanders as if nothing had happened. Recalling his school education, he resumes: "They hadn't taught us anything as basic as desertion when I was at school. It was reckoned to be immoral to save your life by running away

from lunacy".[9] From Flanders, he writes to his younger brother Heinz, who is serving in the infantry at Verdun. The letter comes back with the appalling mention on the envelope, "killed in battle, return to sender".[10]

These are among the key events that shape Erwin Blumenfeld's cynical approach to the world and direct hate of the Kaiser. Wilhelm II is a recurring character in the montages until Blumenfeld switches his anti-hero impersonation to Hitler. In Germany, he suffers severely of what was identified as the cliché of a Jewish appearance – Lena recounts: "He certainly wasn't beautiful. He had wonderful eyes. But in his thin face a much too big nose that then, in that time, was very *auffallend* [conspicuous]."[11] Sensitised to the impact of a profile, this prompts him to emphasise the profile in his enface images, as if the face were simultaneously reflected in a mirror. Thus highlighting the individuality of his characters, he goes beyond a conventional portrait. His marked nose also makes him sensitive to someone being judged by his looks – the idea that a black person is considered inferior to a white person, and the irony that a snarling little man with dark hair by the name of Hitler could propagate the superiority of the Aryan race – deeply perturbs him. He has enormous respect for individuals who succeed in life despite unfavourable circumstances, and for personalities who stand up for their convictions.[12] One of his super heroes is Jack Johnson, the first Black-American heavyweight world boxing champion.[13]

From the start, Blumenfeld is attracted to the stage and takes photos of himself in roles from Shakespeare and August Strindberg. According to Lena, "he could recite *Hamlet* in German by heart. He saw himself as Hamlet. He wanted to become

an actor. This was not possible after the war because he was German and he could never recite Shakespeare in English, he knew that."[14] A number of his works on paper depict actresses he admires, such as Henny Porten, Tilla Durieux and Eleonora Duse.[15]

He is a passionate reader, both of the classics and modern literature. At 14, he agrees to celebrate his bar mitzvah on condition that he can set up a list of 360 books he wants to have as a start to his own library. Paul Citroen, who from 1915 manages Herwarth Walden's Der Sturm bookstore, keeps him updated on contemporary art publications, most specifically the flood of avant-garde periodicals. In 1916, he himself helps out at the antiquarian bookshop of Edmund Meyer. This fires his love for autographs, ephemera, encyclopaedic plates, periodicals and pamphlets. His early friends and mentors are all involved in books: he runs a reading club with his brother; his childhood friend Walter Mehring is a poet; George Grosz a famous illustrator; Else Lasker Schüler, formerly married to Herwarth Walden, a poetess; Wieland Herzfelde has his own publishing house... Books and magazines are Blumenfeld's means to overcome the deficit of a missing art-school education and represent a "lifesaving" connection to the art world during his years in Amsterdam. Blumenfeld likes the idea of infecting the world with published material. The high edition of a book, magazine or postcard, ensures that it will have impact.

The early works are a visual diary entry in commemoration of a special moment in Blumenfeld's life. He initially only makes them for his own imaginary universe or as a gift, often commenting on something he sees or reads. In this, he lines up his name with those of famous authors, artists, and composers he feels akin to. Accordingly, the style and character of the works differ strongly. Among some 60 drawings and over 100 montages,[16] the specific "handwriting" of the artist can principally be identified by his unmistakable choice of motifs and approach to the themes, details of technique and composition, together with an underlining humour mixed with derision. The drawings are related to a personal experience, and reserved mainly to the human figure. Their characters are morose individuals seen in cafés, or freaks from the circus: "different" people with a special talent. In some of the montages Blumenfeld uses his letter paper and a script fragment as the stage set for the scene, thereby emphasising the narrative character of the image. The letter heading turns the work into a personal message.

Early "fashion" drawings could go back to the summer of 1916, before Blumenfeld is drafted and when in his letters to his fiancée, he also sends fashion and jewellery designs.[17] The very first themes of his visual works are love, women and fashion. His readings of August Strindberg – where the male eternally suffers under the female's power, but at the same time is irresistibly and even fatally attracted to her – support his ambivalent attitude towards the opposite sex, having learned only after his father's death that it was from syphilis, contracted at the age of 19. His vision of women is further influenced by Otto Weininger's book, *Sex and Character*.[18] In a letter to Lena, Blumenfeld enthusiastically writes that after Strindberg and Nietzsche, in whose lines he often finds his own words, he is now reading Weininger. And is most impressed by the author's "courage to reveal what he believes to be true", and surprised that he can be a Jew and anti-Semite in one. "Weininger says: every individual

14. Lena Citroen in a talk with the author, Cambridge 1987.
15. Blumenfeld will have collected the theatre cards from the many performances he regularly went to.
16. None of these works were ever exhibited during Blumenfeld's lifetime. A selection from the estate was first shown in 1981 in the gallery Sonia Zannettacci in Geneva and in The Israel Museum, Jerusalem. Even in the later years, except for a short phase between 1932 and 1936, when he was trying to start up as a photographer, Blumenfeld withheld from any kind of exhibition activity.
17. Erwin Blumenfeld Archive, Akademie der Künste, Berlin.
18. First published in Leipzig in 1903; an authorised translation into English from the sixth German edition was published by William Heinemann, London, and G. P. Putnam's Sons, New York, in 1906. Soon after the original publication, Weininger, who was homosexual, committed suicide at the age of 23.

19. Erwin to Lena, 25 May 1916, Erwin Blumenfeld Archive, Akademie der Künste, Berlin (translated by the author).
20. Lena Citroen in a talk with the author, Cambridge 1987.
21. See the comprehensive list of works in my book (*Erwin Blumenfeld. Dada Montages 1916-1933, op. cit.,* p. 213 ff.), where I suggest a probable period of production, which sometimes stretches over several years.
22. For each technique – watercolour, colour pencil and crayon, ink, and Indian ink – he develops individual characteristics, related to his source of inspiration.
23. In the spring of 1920, Citroen and Blumenfeld are living together with Lena at her mother's house in Amsterdam. It would seem that only two works from the announced series were ever produced; the mention of them travelling through Holland was a Dadaist imposture (for more details consult my book, *Erwin Blumenfeld. Dada Montages 1916-1933, op. cit.,* pp. 129-135).

consists of male m and female w cells. The best matings are when the male m cells + the female w cells are equal to the w female cells + the m male cells [...]. He divides all human females into whores and mothers. The ideal female exists just as little as the ideal male." [19] Blumenfeld doesn't expand to Lena on the fact that Weininger also attempts to provide scientific proof of the moral inferiority of women and genius of men.

What stays in his mind is the idea of human androgyny, expanded to a universal duality of life: man and woman, admiration and disdain, love and hate, beauty and ugliness. His images of women are adaptations of Weininger's whores and holy virgins: sensual and untouchable goddesses. Accordingly, famous figures from Greek mythology and characters depicted by the old masters stand model for many of his fashion portraits. From an early age – supported by a three-year apprenticeship at Moses and Schlochauer started in 1913 – he prizes fabrics and accessories. "He was also terribly interested in the big *Warenhaus* [department store], KaDeWe, long before he himself had the *Ledertaschen* [leather bags]. [...] He loved it; it was a part of him. He was much more interested in fashion than I was. In the materials, in everything. One of his special qualities. [...] That terrible experience of his youth going to Schlochauer's was later for *Vogue* a blessing without words." [20]

Only few of the works are signed or dated; due both to their small number over a period of 17 years, and to the recurrence of themes, it is difficult to reconstruct a reliable chronology. [21] It can be generally observed that as the years go on, there are fewer drawings and the montages tend to include larger photographic elements. Blumenfeld rarely signs his works on paper: "Erwin", "Erwin Blumenfeld", "Blu-

menfeld", "BLOOMFIELD" and "E.B." are found in diverse typographical variations on less than half the sheets.

Many drawings are likely to have been made in the early months of 1919, when Blumenfeld first lives in Amsterdam and Lena is training as a librarian in The Hague. Here, with spare time on his hands, he is inspired by the work of George Grosz and the artists represented by Herwarth Walden in his Der Sturm Gallery, experienced in the few intensive weeks in Berlin on his return from the front. The influence is Futurist, Cubist and Dadaist; his bright colours, in crayon or pencil, come from Expressionism. He varies, interprets or adapts something that he has seen, applying respective techniques and styles. [22] In May 1920, Paul Citroen and Erwin Blumenfeld, calling themselves "Commissie voor dadaistische Kultur in Holland", write a letter to Francis Picabia, announcing a series of 32 works under the title of "Dadamérique" that have allegedly been filmed and shown all around Holland, before soon travelling to Paris. Whereas Citroen adorns the letter with a small collage around a photograph of himself, Blumenfeld ironically chooses the industrial magnate Lord Leverhulme as his Dada-representative. [23] A further concentration of works could go back to 1921, under the impact of his honeymoon, once again, in Berlin. In reference to contemporary graphic cycles, Blumenfeld often plans large series but rarely does more than a few "set sketches" from his imaginary narrative. When he creates an image, the piece is a universe in itself, an entity made for a special occasion and addressed to a specific person or public.

A number of montages are fierce and relate to the artist's emotional comment on the absurdity of war, a condition of society, or a headline event. Blu-

Erwin Blumenfeld
Bird and Woman
Amsterdam, 1919

menfeld is instinctively attracted to concerns of humanity and chooses images for their inherent value and sustained impact on him. When the works have titles – borrowed from a prayer, a bestseller, or film – these determine a context for the visual information: They are the title story of a fictitious magazine cover. *Don Juan heiratet* [*Don Juan Gets Married*] picks up its title from one of the earliest German films. With Josef Giampetro in the lead role, a famous stage actor and extravagant personality, the film reverses the idea of the seductive libertine hero.[24] The montage does not only pay homage to the film and its idea, but is at the same time Erwin's marriage proposal to Lena. Formally, these title-page early works are the predecessors of Blumenfeld's fashion magazine covers. Through the painstaking and precision demanding manual collage technique, he puts enormous thought into the composition of an eye-catching motif with text. A strong influence could be John Heartfield's montage-work, where not the original montage, but far more the printed page, including title and text, edition and distribution, is the final work of art.

Letter paper, advertising inserts, magazines, illustrated plates, postcards, music scores – Blumenfeld rarely uses a blank page as a background to his montages. At their peak in 1920, the Berlin Dadaists, Grosz among them, practised collaging their own drawings or creating a composition with a formal reference to pure chaos. Blumenfeld sometimes starts a montage from a rediscovered drawing. His prior interest in the montages is not in breaking rules, as professed by the Berlin Dadaists, but rather in exploiting the collective connotation attached to popular elements: he attracts the viewer into his work by classical means of visual association. In contrast to his colleagues in Berlin, he works on a

precise and elaborate composition. Rather than adopting formal traits from the avant-garde, he uses 19th-century language.[25] His modernity is in the time span of the comment, in the most specific amalgamation of content, form and colour, the simple but visually effective ideas, and the total freedom of treatment in materials, size and fragmentation. Blumenfeld's play with the power of an image to trigger subconscious associations stands at the base of advertising methods.

Not only does Blumenfeld compose his own covers, for the scenery of his "plays" he soon reverts to a found "backdrop". Specific illustration plates, postcards and magazines provoke his fantasy to rework them. He plays with the captions, layout and images in a dialogue with both content and form of the original message. The cinema and theatre programme from Leiden *Het Weekblad*, *La Baionnette*, a French satirical World War I magazine, and *Le Journal de la Décoration*, a chronolithograph revue for Art Nouveau from the end of the 19th century, are his favourites.[26] The magazine's aesthetics determine the optical character of the subsequent works. Remarkably, he preconises using older print materials, thereby incorporating the contrast of time into the work. When in Omnium Photo (1923/24; p. 62) we see the official photograph of the German Declaration of the State of War from 31 July 1914 at 5pm by Lieutenant von Vierbahn on Unter den Linden in Berlin, the document has a very different connotation from the initial euphoria at the outbreak of war.

Maybe Blumenfeld's greatest hero is Charlie Chaplin. Chaplin's films were prohibited in Germany until 1921 but he will have seen them in Amsterdam. The collaged watercolour *Charlie* of 1920 (p. 52) is bursting with metaphors and mystical

24. *Der Herzensknicker oder Don Juan heiratet* [*The Heartbreaker or Don Juan Gets Married*], directed by Franz Porten, 1909, 9 minutes. The film was very popular.
25. Many avant-garde artists "re-discovered" printed material from the 19th century as a base for their work.
26. Blumenfeld creates two montages on the Dutch magazine, five on the French war journal (of which three are not in my book, *Erwin Blumenfeld. Dada Montages 1916-1933, op. cit.*) and three on the older magazine.

27. Quotation by the anarchist Gustav Landauer, "Strindberg", in *Neue Jugend*, Berlin, July 1916, p. 135, 136.
28. Works figuring Jack Johnson and Hitler are signed "BLOOMFIELD".
29. Both the text fragment c. 1920/21 and the letter to Lena, c. 1930: Erwin Blumenfeld Archive, Akademie der Künste, Berlin (translated by the author). Also around 1930, maybe prompted by the plans of Chaplin's visit to Berlin in March 1931, a further collaged postcard shows Chaplin between his admirer's mirrored profile.
30. Lena Citroen in a talk with the author, Cambridge 1987.

allusions. Here, Chaplin is the modern Christ crucified by the German Reich, as told by the flag flying from the cross. *Bloomfield President-Dada-Chaplinist* (p. 51) is the self-portrait Blumenfeld sends in April 1921 to Tristan Tzara for *Dadaglobe*, a Dada anthology never to be published. The background is an erotic postcard. The face, shirt collar and tie are cut out from a photographic self-portrait. His salutation "à mon cher Tzara" underlines a personal relationship that didn't exist. The androgynous figure would seem to be an illustration of a phrase written on August Strindberg: "The male intellect and the female nature: these were his two ground principles."[27] Here, Blumenfeld uses his Dada-pseudonym, "Bloomfield". Does he feel more comfortable with his Dada-name when addressing Tzara, or does he choose it in analogy to John Heartfield, who anglicises his German name, Helmut Herzfeld, in protest against the German war motto "God punish England"? Lena tells us that he never liked his surname but in a draft version of the autobiography he attributes Bloomfield to the Dadaists, as "unconscious German Anti-Semitism". A group of particularly acerbic montages are signed Bloomfield; maybe it is simply the signature of the Chaplinist.[28]

A further postcard of around 1923 shows Chaplin above the logo of Blumenfeld's shop "Fox Leather Comp." as if it were the Fox Film Corporation in Hollywood (p. 53). Here, one could imagine that the portrait above the logo is that of the shop owner – a merge of Chaplin and Blumenfeld. The ambiguous figure is depicted as a Dadaist: both hat and moustache are taken from an advertisement for *Le Coeur à barbe*, a Dada newspaper published at Tzara's instigation in 1922. The title of an early text fragment by Blumenfeld reads: "Charlie Chaplin, Friedrich Nietzsche, und ich! [and I!]". Around 1930, he once again picks up on the same idea and writes to Lena: "This is the century of Friedrich Nietzsche and Charly [sic] Chaplin. Whoever doesn't understand this belongs to the past, never to the present."[29]

Lena didn't remember the montages and said that it was quite possible that Erwin never told her anything about them since she was not really interested. However, she did know about his drawings: "Well he had that business that was so disappointing and that gave him so much free time because nothing happened the whole day. That was the time that he made all those drawings. He had a little room upstairs you see. You know that photo with the hyacinth in the window? Well it was there you see. And that was the time he did that. Then he had time to do it. Later when he went to the next shop on Kalverstraat in Amsterdam, there he found all the things for developing photos. So at that time he could make photographs and develop them there."[30] Indeed in 1932, as soon as Blumenfeld has access to a darkroom that he discovers at the back of his new shop, he abandons the painstaking cut and paste work for the vast freedom of composition offered by photographic technology.

Blumenfeld's early images engage us in the artist's world with the intricate and wonderful complexity of the autobiography: semi-fictional and based on a personal interpretation of metaphoric content. After the montages, the darkroom liberates him from the single image in a defined format. It enables him to work with features that he didn't have with paper: the transparency of multiple exposures and the experimentation with contrast, focus, solarisations and other methods transcend the documentary value of the photographic image. With his cam-

era, he exploits the facility of repeating certain themes and formal elements in different variations and under different light, rather like a painter's life-long attempt at capturing the fragility of a flower. In the first years of his intensified photography, he is limited to black and white, but experiments with colour photography immediately it becomes possible.

In New York, he can at last earn a living with his camera and focuses his energy on fixing a moment of eternal beauty: his models are more often character personalities, where Blumenfeld's challenge is to catch the hidden Goddess in them. "All my portraits are reflections caught in my eye. Every artist lives from variations on a single theme. Whether he writes by hand on paper or with his foot in the sand, the signature remains the same."[31]

31. *Eye to I, op. cit.*, p. 282.

Collages / Photomontages

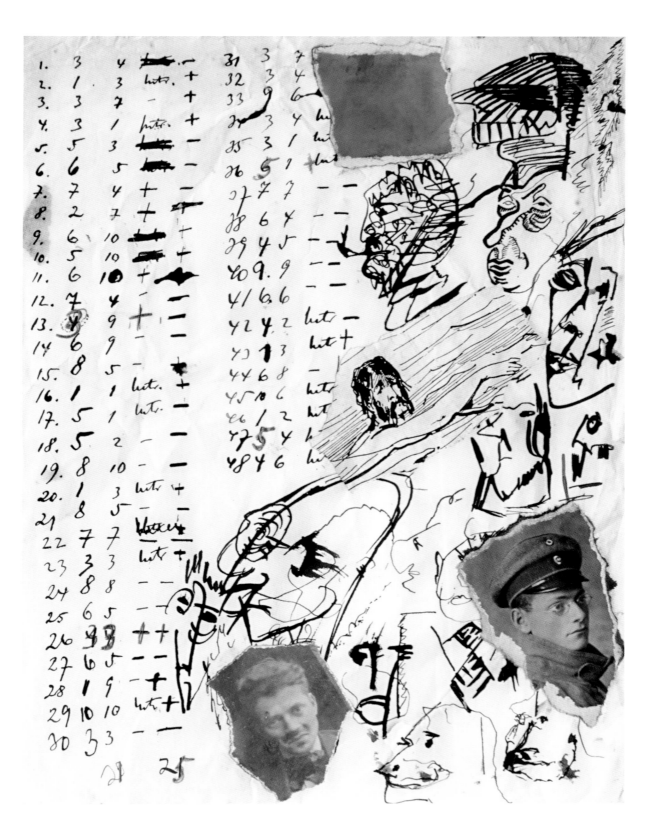

Numerals, Strindberg, Heinz
Amsterdam, c.1918-19

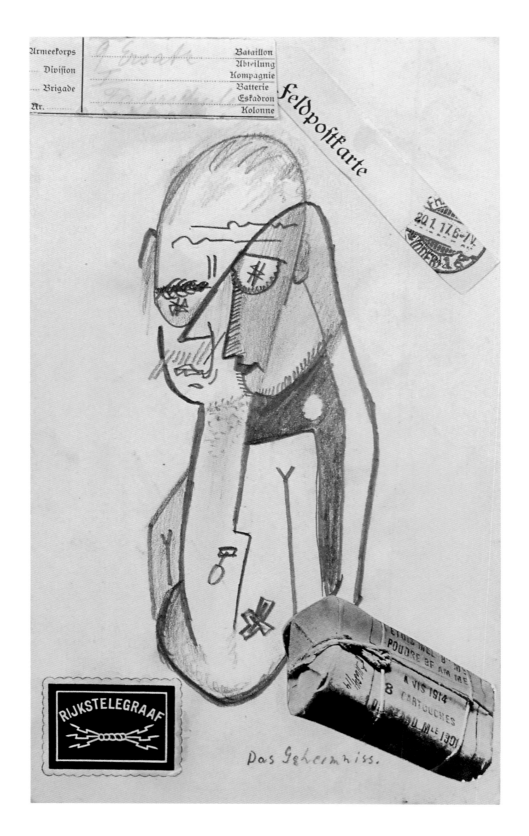

Das Geheimniss [The Secret]
1919-24

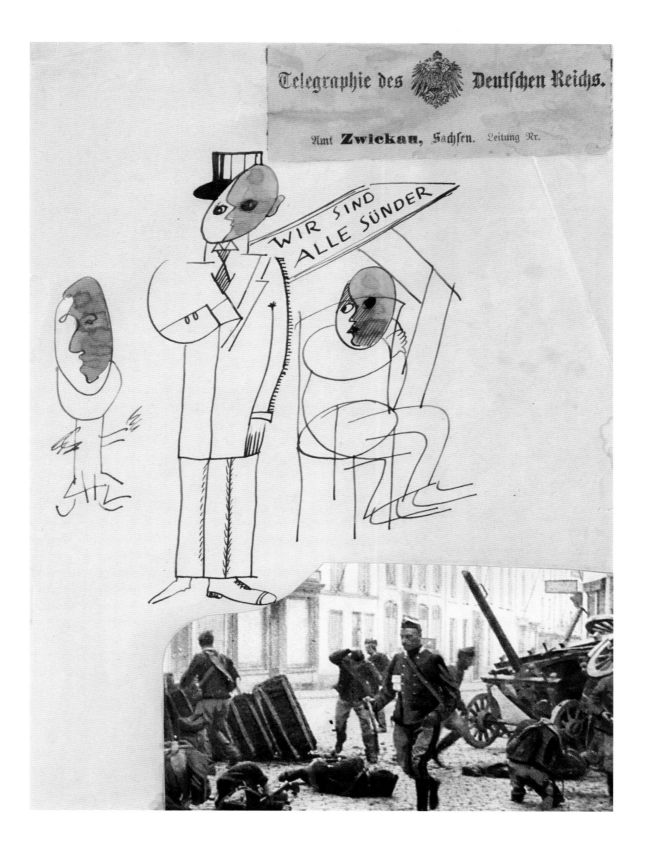

Wir sind alle Sünder [We are all Sinners]
1919-21

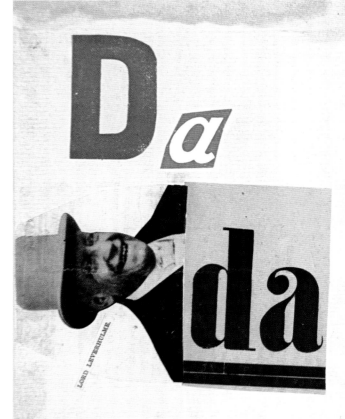

Erwin Blumenfeld and Paul Citroen
Letter Montage for Francis Picabia
12 May 1920

Les tableaux se nomment: 1) dada 2) The American girl, 3) Johnson training again 4) America - the longing of Europe 5) Les Dadaistes entrant dans le café américain à Amster, dam etc. etc:

Ces tableaux ont été ciné, matographiés. Ils sont montrés dans toute la Hollande et arriveront bientôt à Paris.

Agréez, Monsieur, mes salutations très distinguées

„Commissie voor dadaisti, sche Kultuur in Holland. Vondelstraat 21 Amsterdam.

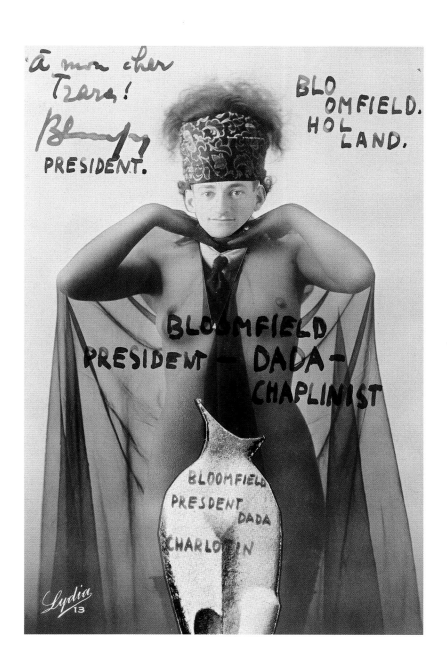

Bloomfield, President-Dada-Chaplinist
1921

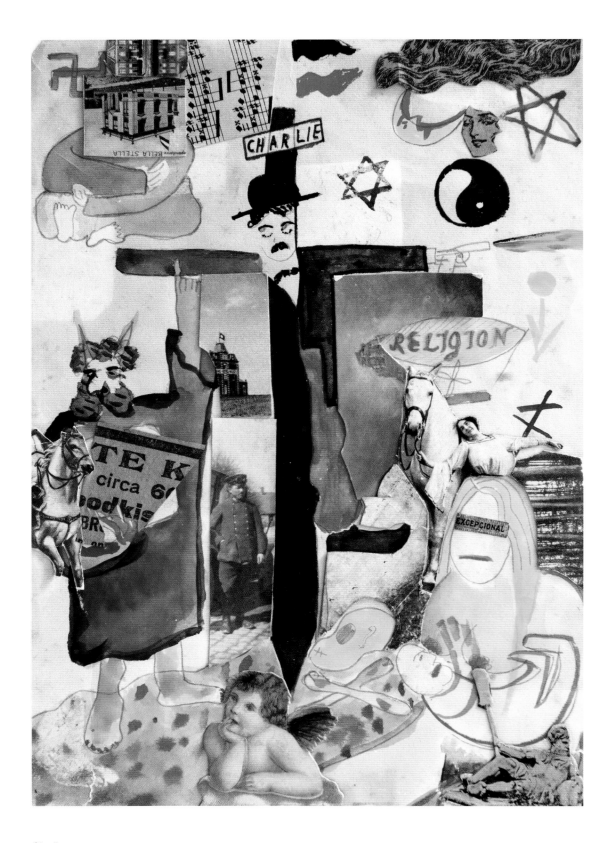

Charlie
1920

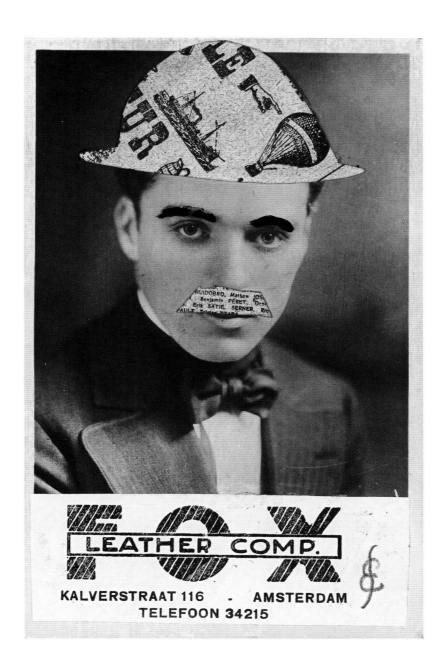

Chaplin Fox
Early 1920s

Diskus [Discus]
1919-25

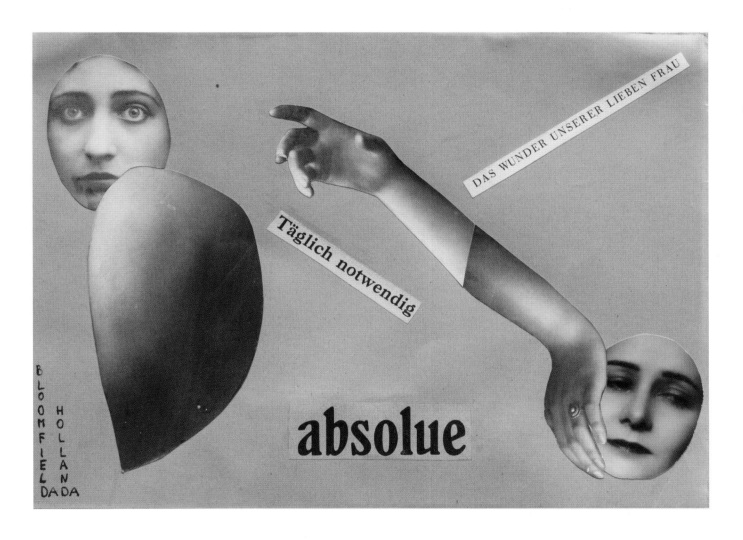

Absolue
1921-26

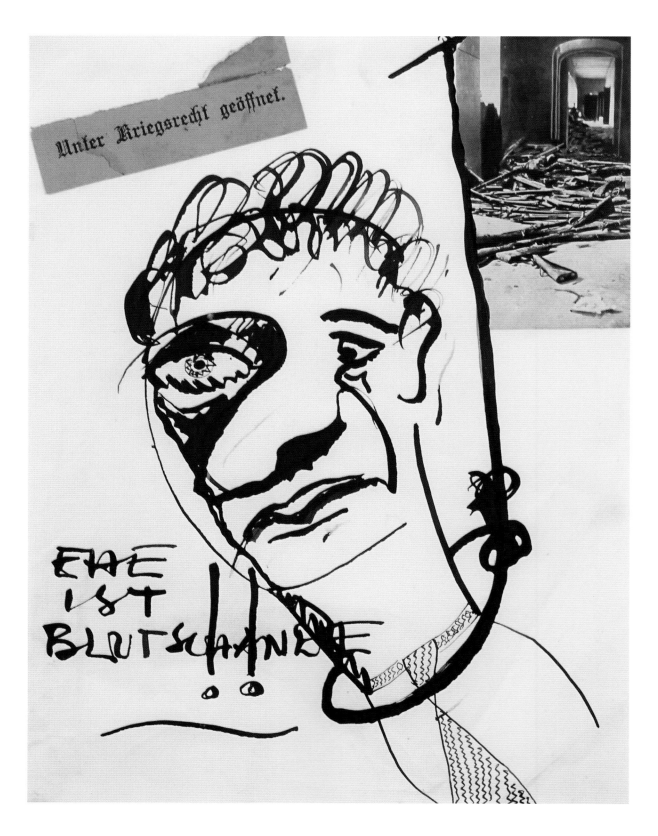

Ehe ist Blutschande!! [Wedlock is Incest!!]
1919-22

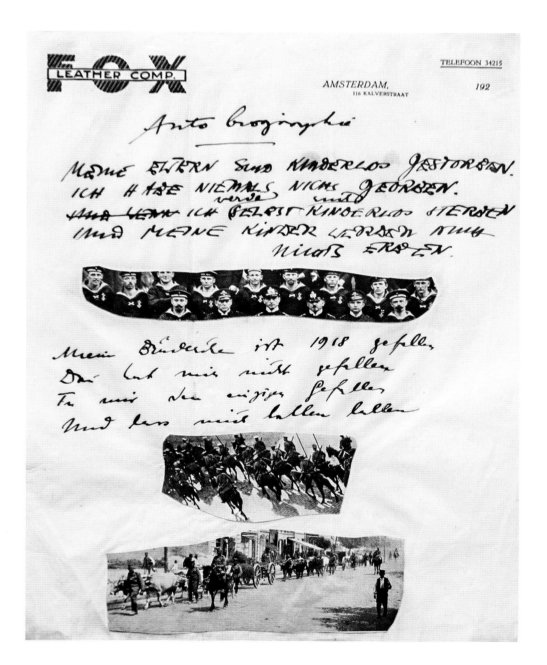

Autobiographie [Autobiography]
Amsterdam, 1923

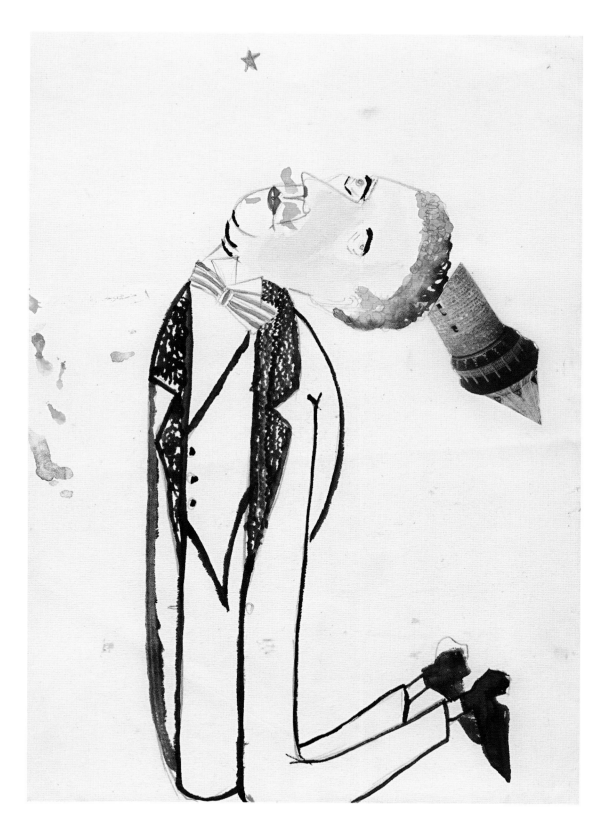

Kneeling Man (with Tower)
1920

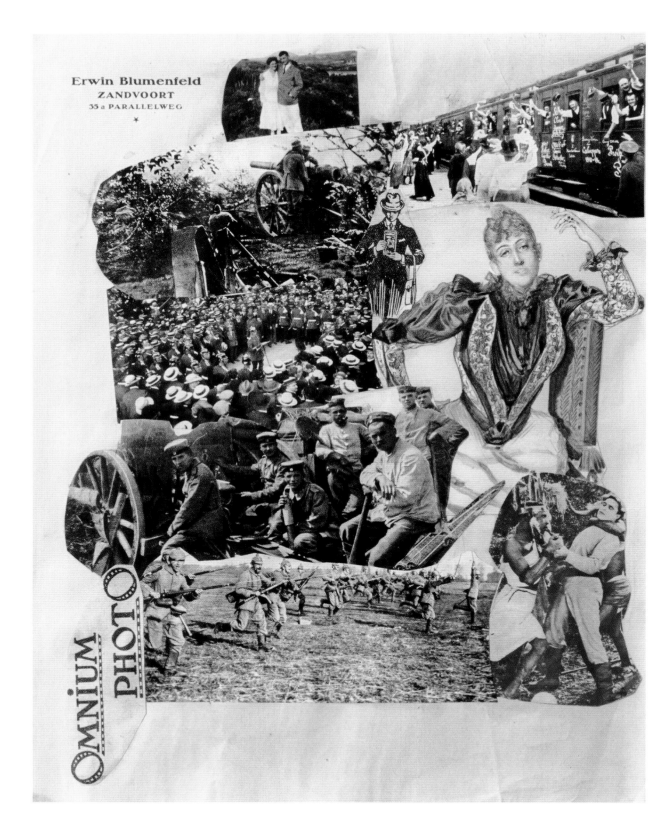

Omnium Photo
c.1923

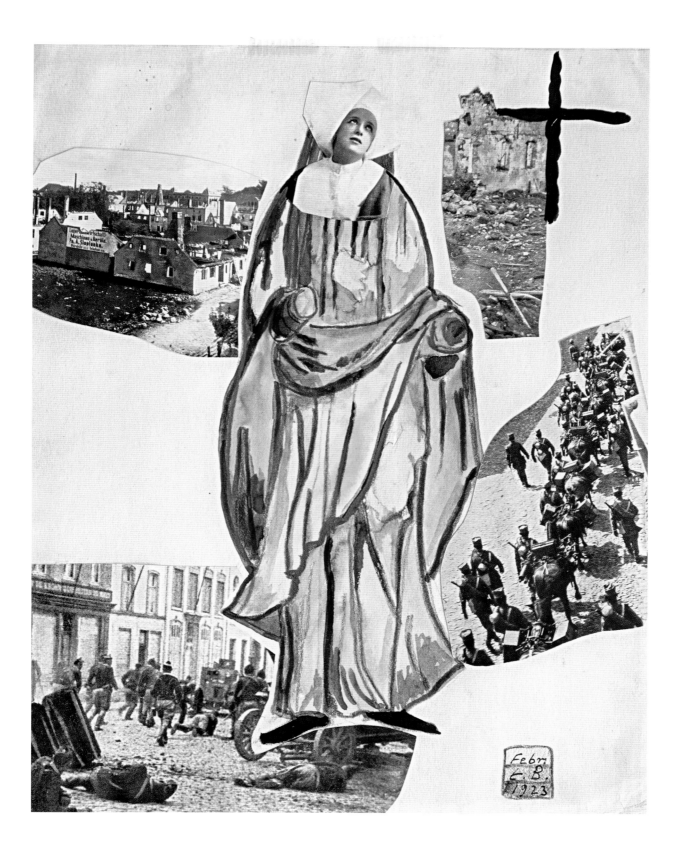

Nun [Now]
Amsterdam, February 1923

Raucherinnen [Smoking Women]
1924

Cat Woman
Amsterdam, c.1923-26

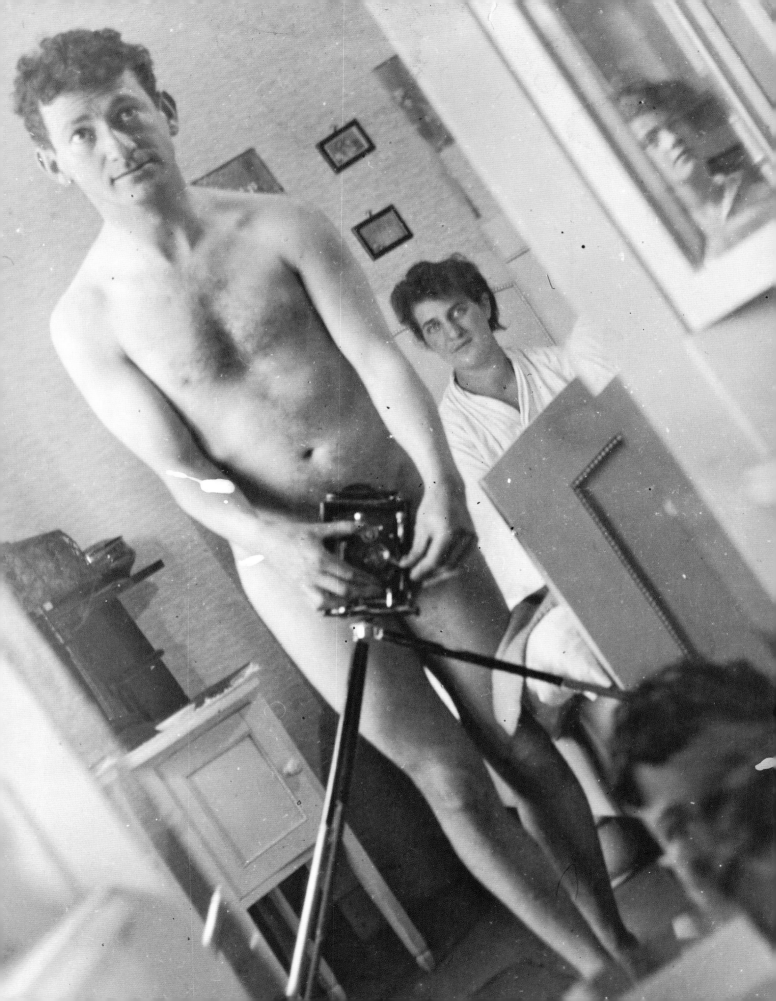

The Instant is Everything, Life is Nothing

Janos Frecot

Erwin Blumenfeld
Self-Portrait with Lena, Lisette in Mirror and Henry
Holland, 1930

Erwin Blumenfeld worked on his autobiography *Einbildungsroman* all his life, but particularly from 1955 to his death in 1969; it was first published in French translation in 1975 by the Paris-based publisher Robert Laffont as *Jadis et Daguerre*,[1] with an afterword by David Rousset. German-language editions were then published in Switzerland and West Germany in 1976, 1980 and 1988 with the title *Durch tausendjährige Zeit* [*Through a Thousand Years*], the last of the three with an afterword by Alfred Andersch. Only in 1998 did the Frankfurt-based publishers Die Andere Bibliothek bring out a German edition featuring Blumenfeld's original title and the full set of photographs he had selected for the book. The punning title *Einbildungsroman* refers to the German literary tradition of the Bildungsroman, or coming-of-age story: the prefix "Ein-" adds an ironic comment on the genre's typically excessive idealism and its pretension to stand as a significant cultural model – something Blumenfeld mistrusted instinctively. However, an alternative reading of the term "Einbildung" offers more positive connotations of fantasy, imagination and the fantastical representation of concrete reality, adding a layer of ambiguity to the title. The book is correspondingly open to several readings.

Einbildungsroman is the autobiography of a middle-class German Jew from an average well-off Berlin family. The book recounts his childhood and youth, the dark years of the First World War, and his search for a place in the world. The path he took led him to emigrate to the Netherlands, France and the United States: he struggled long and hard with all the difficulties entailed by the loss of his linguistic and social roots, until he eventually settled with his family in the land of every conceivable opportunity.

1. Translator's note: the punning title plays on the title of Verlaine's poetry collection *Jadis et naguère* [Yesteryear and yesterday] and the name (Louis) Daguerre, one of the fathers of photography.

FOX

LEATHER COMP
KALVERSTR 116

AMSTERDAM,
Telefoon 34215
Gem. Giro F 698

meer lena pv

wogen
schwellen
brechen
wellen wiegen
zwischen höhen
auf und ab
immer wieder
ab und auf
auf und nieder
schäumen schaum
wogen wellen
unter höhen
über tiefen
schwingt auf
zum steigen
mein fallen sich
verbraust
verschäumt
verträumt
versäumt
verweht
vergeht
und bleibt
willenloser wille
wasserwelle
wie ich
schwinge
durch die masse welt
steige und falle
wie das meer
will nichts gewinnen
stürze hinauf hinab
vertr)äume versäume
verwehe vergehe
flut ebbt
und ebbe flutet mein los
hin und her
tropfen im meer

tal sinkt vom gipfel
der aus dem tale stieg

Erwin Blumenfeld
meer lena pv
[sea lena pv]
After 1923

sea lena pv

billows
swell
break
waves weigh
between heights
to and fro
time and again
fro and to
up and down
foaming foam
billow waves
under highs
over lows
swings up to climb
my fall itself
unquenched
foamed
dreamy
missed

blown
elapses
and remains
will-less will
waterwave
as I
swing
through the world
rise and fall
like the sea
want to gain nothing
rush up down
dream miss
blow elapse
flood ebbs
and ebb floods my lot
to and fro
drops on the sea

valley sinks from peak
that rose from the valley

The reader is given a highly subjective version of contemporary history, recounted at breakneck pace in a compact, expressive style, in which the author's life and career feature almost incidentally; the account of his setbacks and lucky breaks does, however, make fascinating reading, from his early days as an occasional photographer to his successful attempt to turn his passion for photography into a solid career that eventually sees him become a leading fashion and advertising photographer in the 1940s and 50s.

It sounds like a fairly straightforward framework for an autobiography, if only the author were writing a typical memoir of clear chronological structure. But Blumenfeld's use of language is constantly cognisant of its own existence, of the author's thoughts and sensibility, and of the ingredients that went into this *thesaurus linguae blumenfeldiensis*. Self-analysis through language forms the heart of the book, which sets out to explore the author's aptitude for measuring the absurdity of the human condition, inversing images, beginning with the opening lines on the "The Mamasbelly Concentration Camp: a subtropical darkroom".[2] Blumenfeld takes his own conception as the starting point of a narrative arc that ends with the other extremity of human life – death; the book finishes with the account of a terrifying nightmare that concludes with the words "I was dead".

Blumenfeld's style is a heterogeneous linguistic collage of everything from scholarly literary and historical references to the slangiest street German from his Berlin roots, which he proudly maintained throughout the trials of his life. It also includes his mother's pearls of proverbial wisdom, and any reader who thinks that mother Blumenfeld's love of expressions, puns and misquoted lines of poetry are purely illustrative in intent has misjudged the author. Like François Rabelais and other great baroque authors, he abandons himself to the intoxicating charm of lists, piling up words and filling odd pages with idiomatic expressions, seducing the reader onto a journey through the delights of vernacular language that form a powerful undercurrent to German literature.

Erwin Blumenfeld's use of language grew out of a family, school and social background in which oral expression was particularly valued, and in which spoonerisms, paradoxes, parodies and shaggy dog stories were in vogue: every schoolboy was expected to learn entire poems by heart, while people commonly composed and recited their own poetry for special occasions and talked themselves silly with puns and wordplay. Children learned to enjoy talking and debating, playing with double meanings and distorting sounds and meaning into nonsense: this naïve taste for wordplay eventually spread beyond its native soil to feed into the collages and montages of the Dadaists and Surrealists.

There are not many places where people differently shaped by formal education, vernacular culture and the most wildly varying dialects are forced to rub shoulders together. One such is in the army, and in the worst-case scenario, in the trenches. Hitherto the only conflict in Erwin's life had been between him and his parents, his teachers and his foremen and colleagues at the Moses and Schlochauer manufacturing company where he was sent to work after his father was forced to retire on health grounds, leaving his business bankrupt. The aim was to achieve the imperial German goals of education, intended to "make officers, civil servants, idiots and heroes out of us". Almost half the book is taken up with an

2. Translator's note: all quotations are from the English translation of Blumenfeld's autobiography, *Eye to I, The Autobiography of a Photographer*, trans. Mike Mitchell & Brian Murdoch, London, Thames & Hudson, 1999, slightly adapted in places.

Eye to I: The Autobiography of a Photographer

Some of Erwin Blumenfeld's autobiography covers

account of how children were formatted to cope with absurdity as the new normality – an authorial decision justified by the fact that adults need to devote an abundance of time and energy to ridding themselves of the defects their education has inculcated in them.

Blumenfeld served on the Western front in 1917-18. His experiences as a medical orderly, or rather "mobile corpse-collector", shaped his feel for colourful expressions, as did his later experiences in "concentration camps", as he referred to the French internment camps, such as the notorious Le Vernet. His language draws heavily on the colour of filth and shit, still omnipresent in German jokes, swearing, and cursing, in which faeces and anality feature heavily. It is no coincidence that brown is the Nazi colour – the colour of shit.

Blumenfeld's bold verbal imagery is equally as radical as the finest graphic works of George Grosz, Otto Dix, Jeanne Mammen, Karl Hubbuch and other of his contemporaries. When he was finally granted leave during the war and could once again take his beloved Lena in his arms, he wrote, "We were almost blind to the horrors of the colourless streets when we strolled, arms round each other's waists along to the park. What did we care about the hell that was all around us, anyway? Ragged war-ghosts tussled with blind cripples in wheelchairs, as they queued, ration-cards clutched tightly in their hands, outside grocery shops that had already been plundered. We saw nothing but each other's eyes."

The work contains dazzling, phosphorescent passages alternating between ambiguity, polysemy and clinically crude bluntness, as if a floodlight has suddenly been switched on. Then there are bold judgements and the youthful pleasure in breaking taboos of all sorts. No "good taste" or conventions keep Blumenfeld from writing what one shouldn't write, the unthinkable in today's political correctness: "High above suspicion, in the starry firmament of history shines the constellation of homosexual geniuses: Socrates, Jesus, Michelangelo, Leonardo da Vinci, Shakespeare, Castor and Pollux. Deep down in the city mire hang out the hordes of Horst Wessels: arse-bandits, breech-loaders, shirt-lifters, cocksuckers and nancy boys [...] Later – from Oscar Wilde, Gide, Genet – I came to understand something of the problems of those who are different from the rest. Throughout my professional life I've had to spend too much time and effort coping with the effeminately unpredictable primadonna moods of homosexuals, an international freemasonry of arse-directors, hairdressers, psycho-analists, designers, couturiers, windowdressers, fashion photographers and other such arse-and-craftsmen."

After a lifetime spent challenging the omnipresent idiocy and cruelty of people of all countries and social classes, he concludes, "if Adolf had had the patience to keep his racialist madness at least until after the war he would never have needed to go to war. If Hitler [...] had concentrated on uniting the poor in spirit of all countries under the swastika, with stupidity as the lowest common denominator, the world would simply have fallen into his lap without a single shot being fired."

Shortly before he died, Erwin Blumenfeld was at work on the book *My Hundred Best Photos* which, significantly, includes barely any works from the period when he was one of the world's highest-paid fashion photographers. Rather, it focuses on the works which helped free photography from its obsession with objects; his studies of shades of

grey, light and shadow are closer to the textured collages of the 1920s and 30s than to his works for the fashion industry, even though the latter include numerous photographs of considerable merit in terms of form and beauty. *My Hundred Best Photos* can be taken as a second, visual autobiography, and the two books should perhaps be considered alongside each other. The *Einbildungsroman* is not merely an Expressionist-Dadaist narrative affording us glimpses into the genesis of Blumenfeld's pictorial imaginary and a detailed portrait of a world out of joint. It is far from being a tributary piece of literature.

Self-Portraits

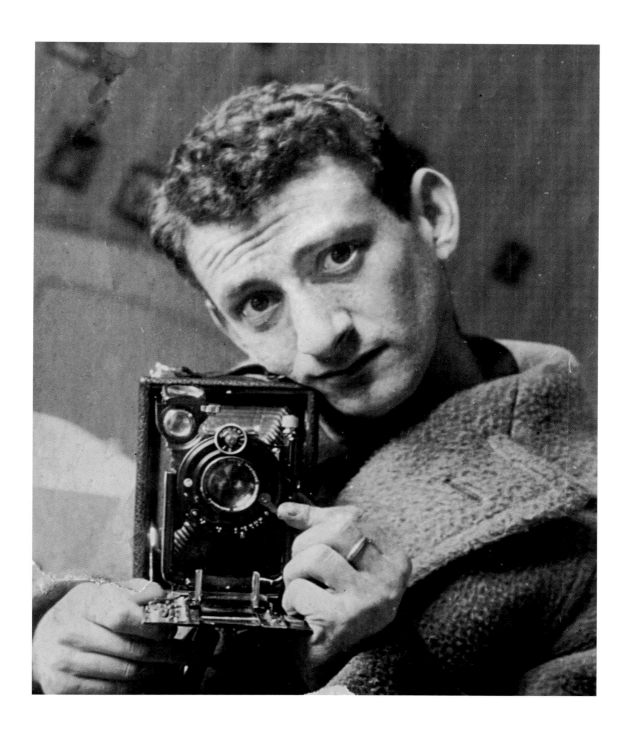

Self-Portrait
Holland, c.1930

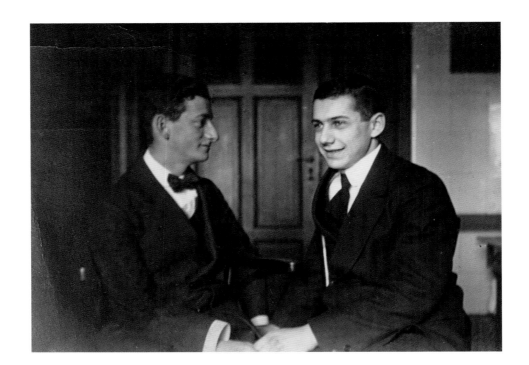

Erwin Blumenfeld and Paul Citroen
1916

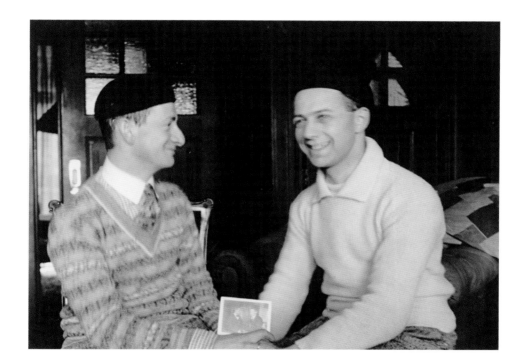

Erwin Blumenfeld and Paul Citroen
1926

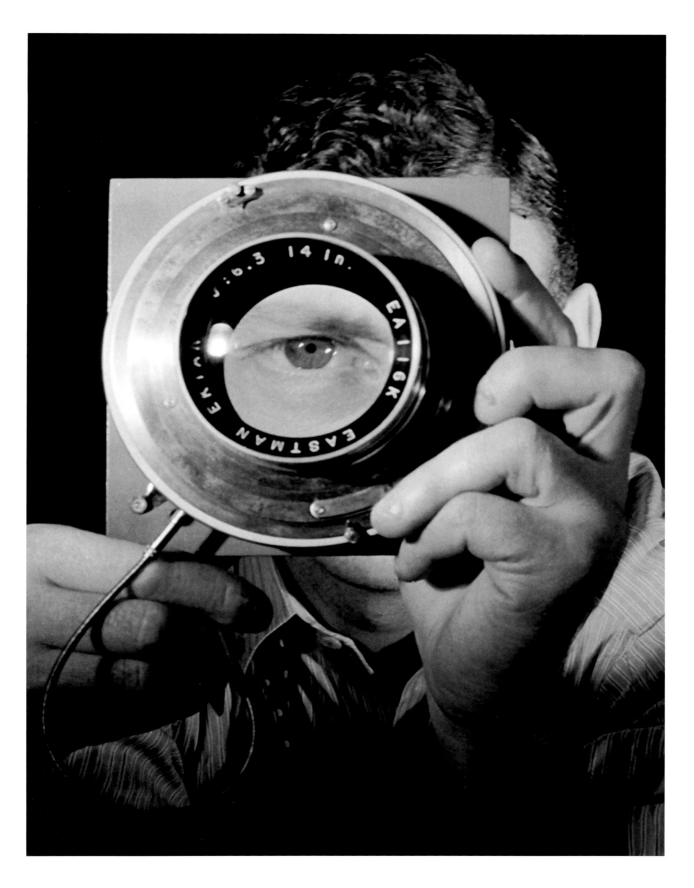

Self-Portrait with Objective
1932-37

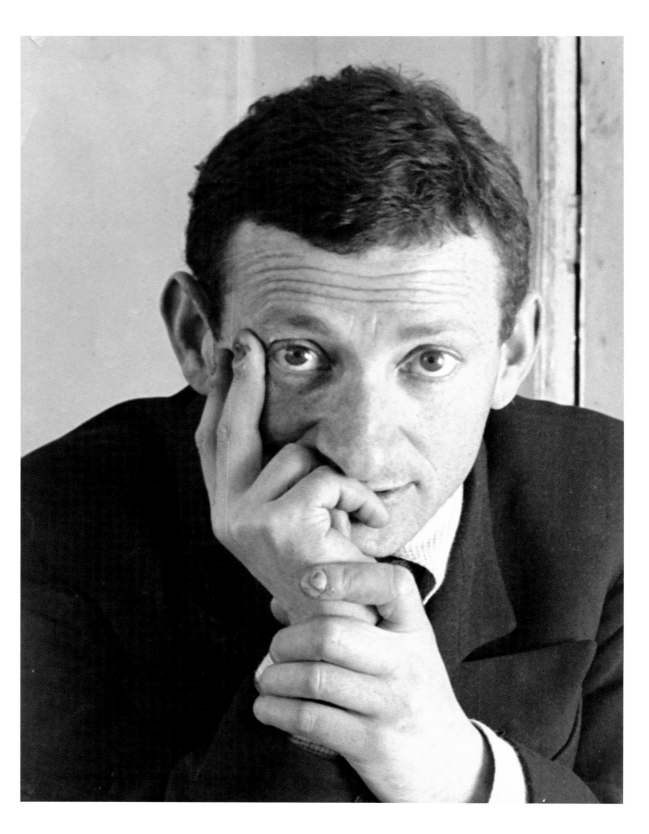

Self-Portrait
Amsterdam, c.1933

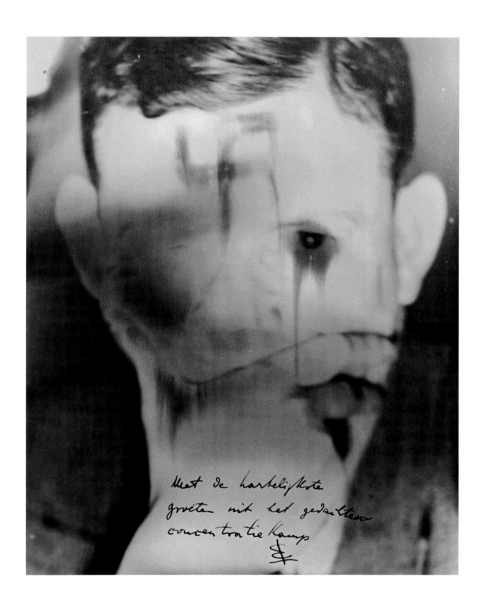

Self-Portrait
Amsterdam, c.1933

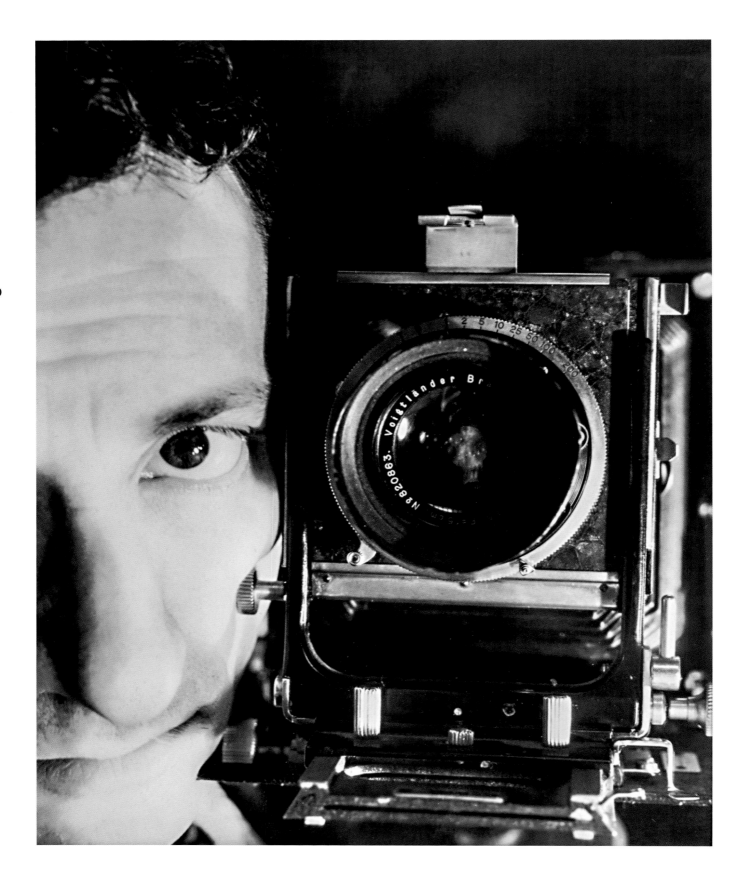

Self-Portrait
Paris, late 1930s

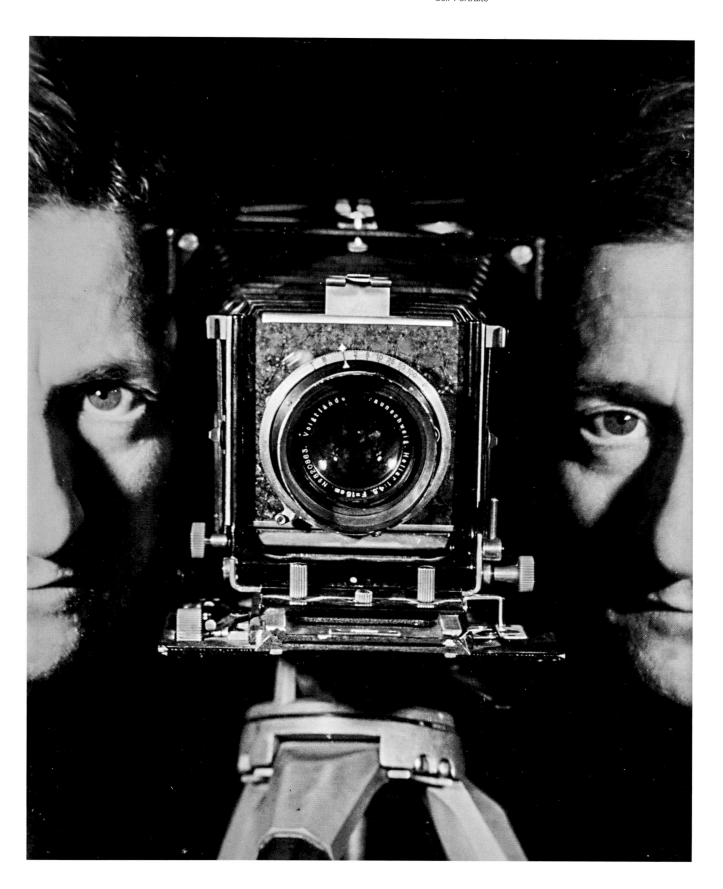

Self-Portrait
Paris, c.1938

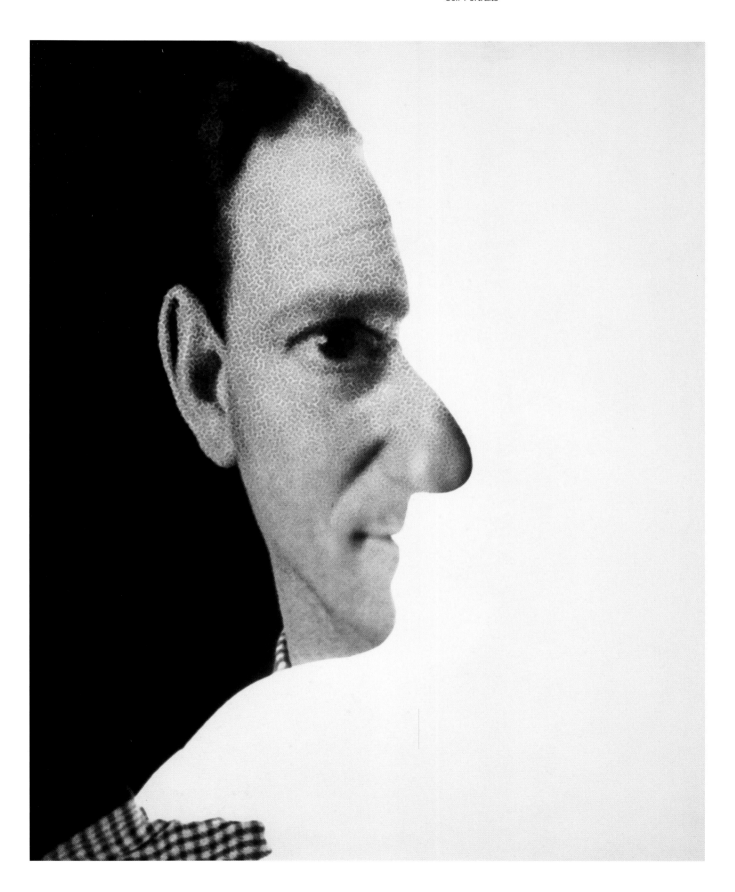

Self-Portrait
1945

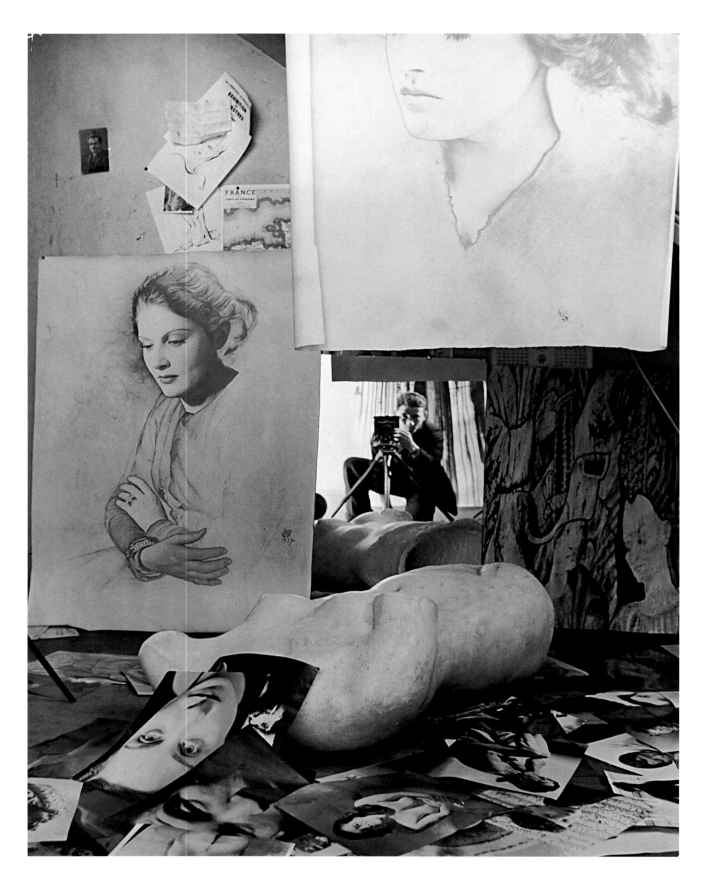

Self-Portrait in his Paris Studio
Paris, 1938

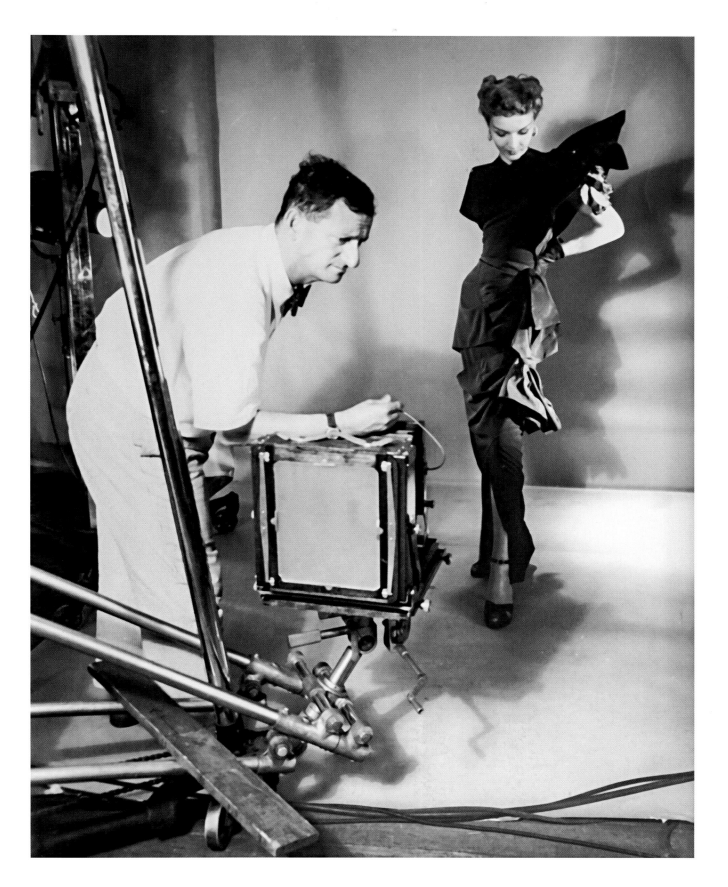

Erwin Blumenfeld Photographing Model in Black-Wing Dress
New York, 1943

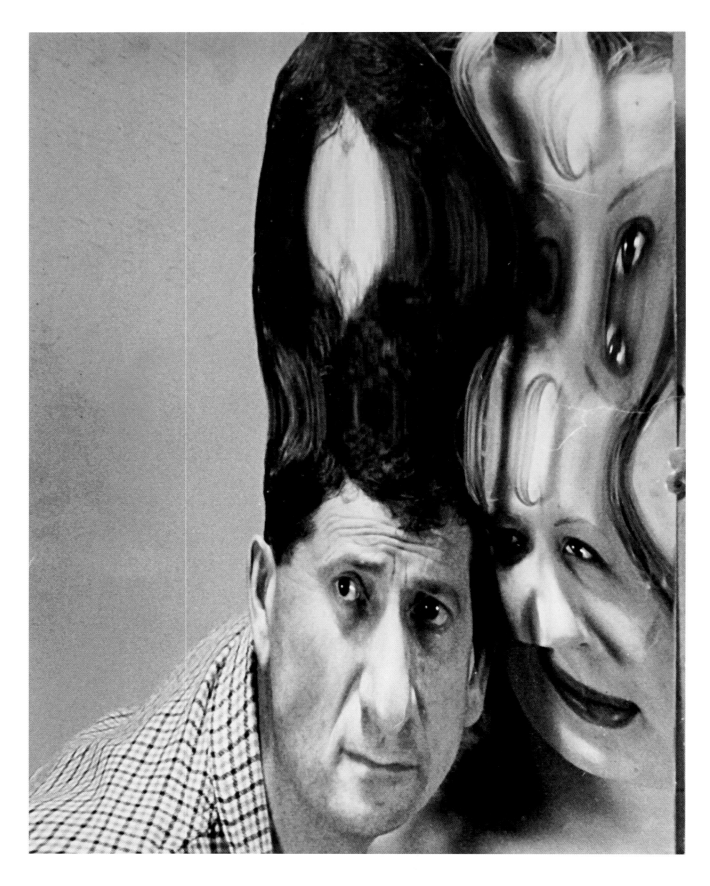

Self-Portrait with Model in Distorted Mirror
New York, c.1947

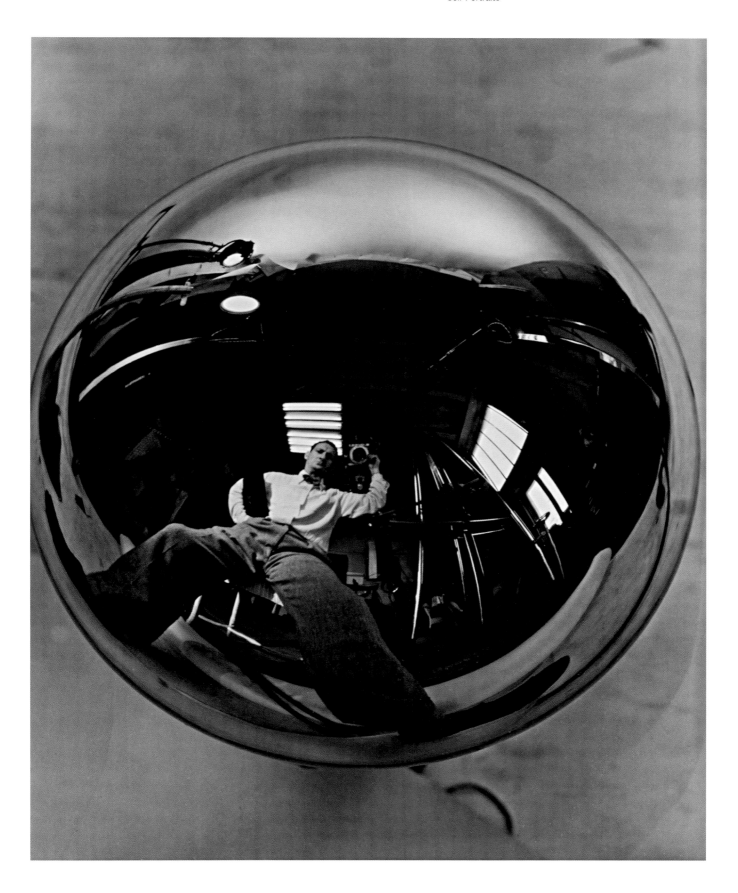

Self-Portrait in Silver Ball
New York, c.1949

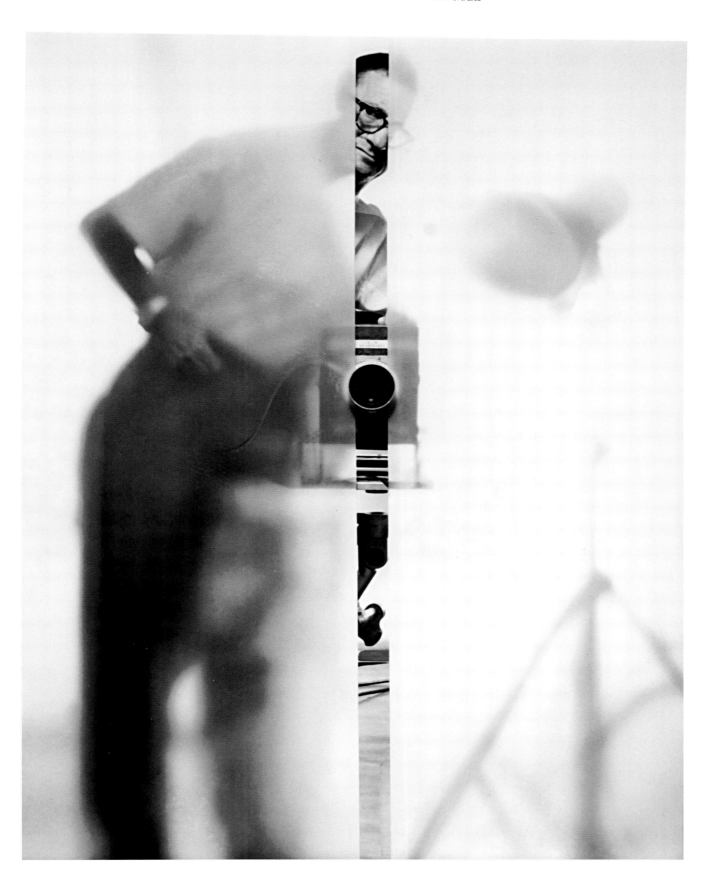

Self-Portrait
New York, c.1952-53

Portraits

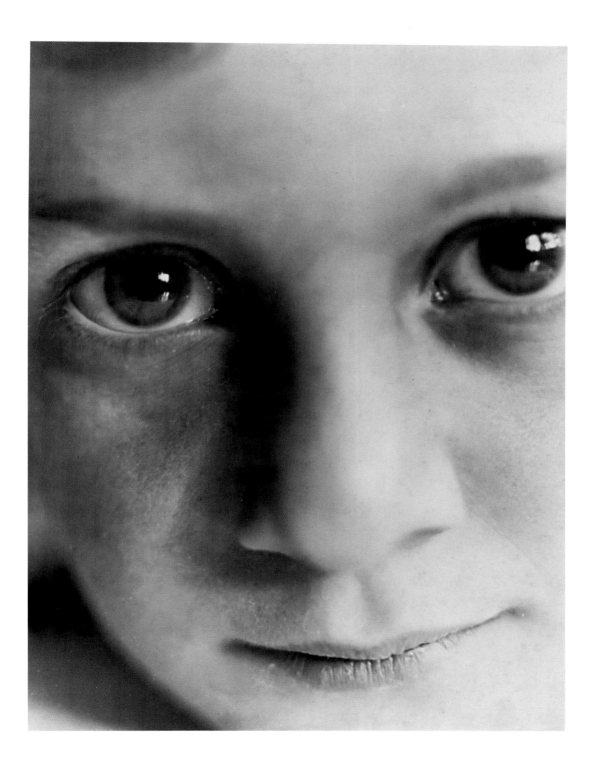

Heinz Blumenfeld
c.1930

Paul Citroen with Lena's Hair
1929

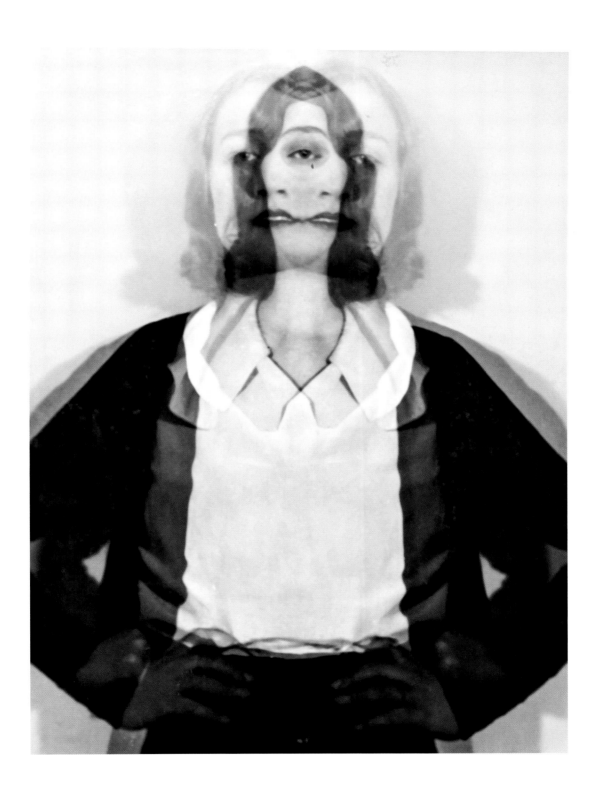

Triple Exposure
Amsterdam, c.1930

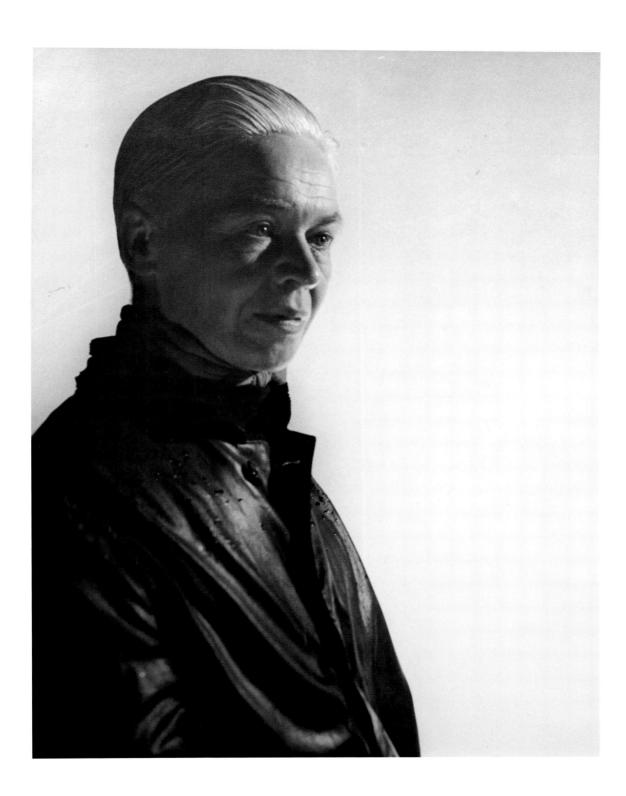

May Kalf, Kapteijn [Captain]
Amsterdam, 1934

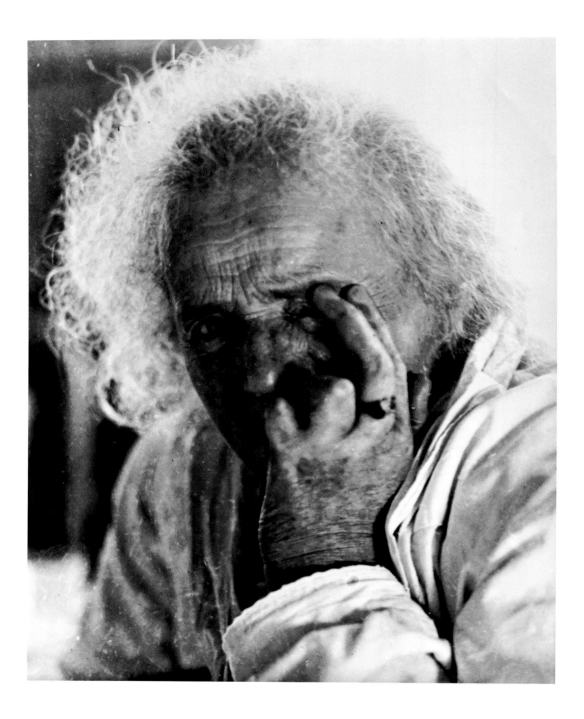

Jewish Nursing Home
Amsterdam, c.1932

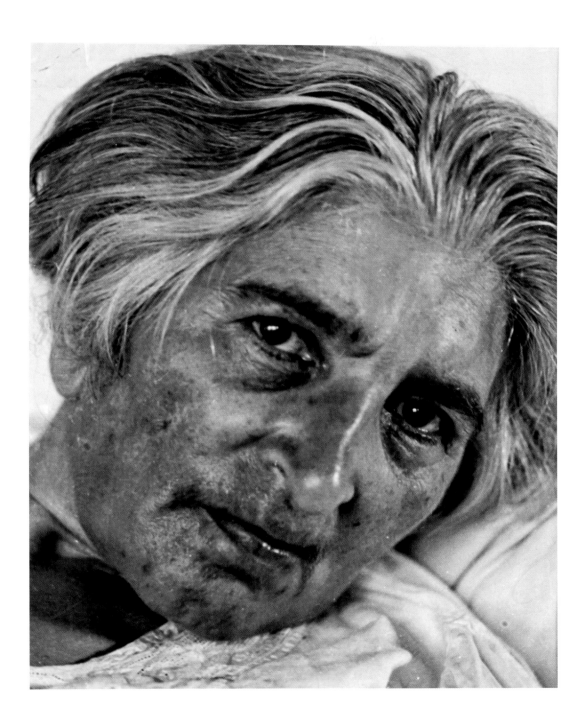

Jewish Nursing Home
Amsterdam, c.1932

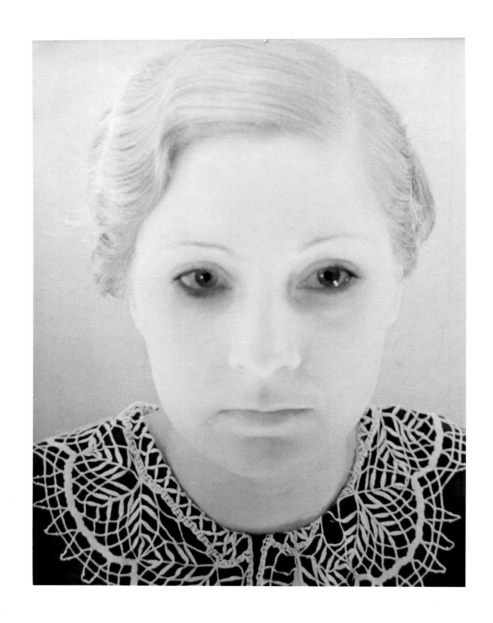

Oty Reijne-Lebeau
Amsterdam, c.1932

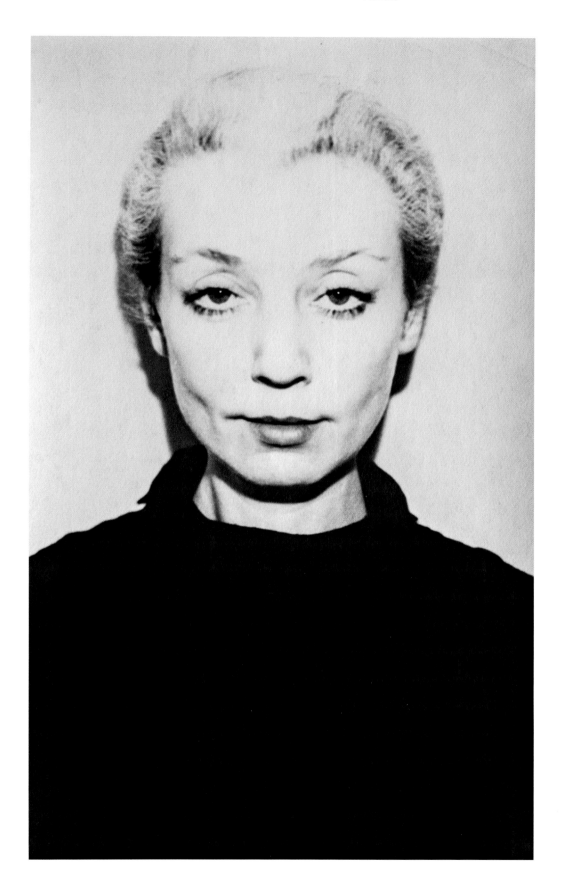

Mrs José Maria Sert (Princess Roussadana Mdivani)
Amsterdam, 1935

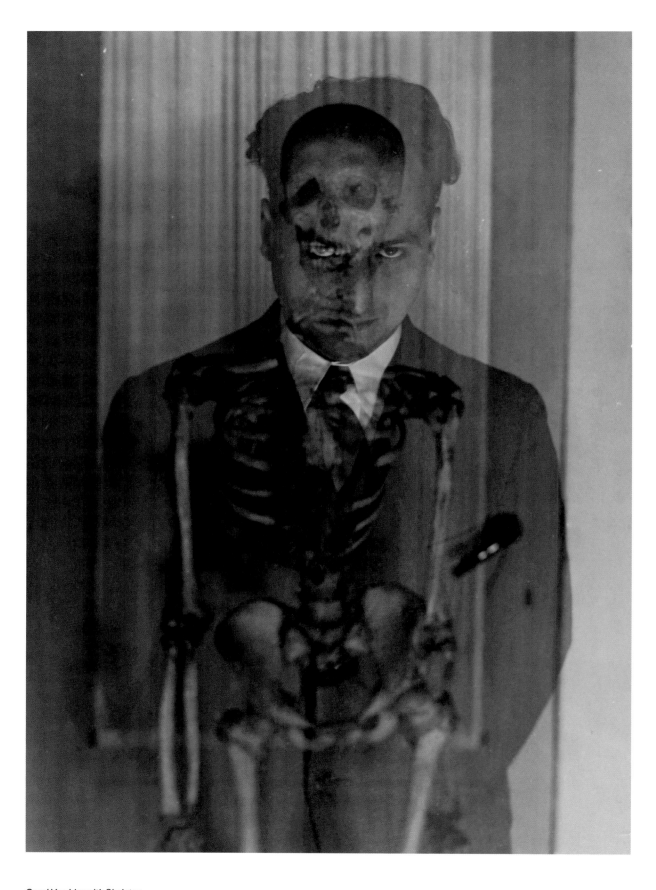

Carel Van Lier with Skeleton
Amsterdam, c.1933

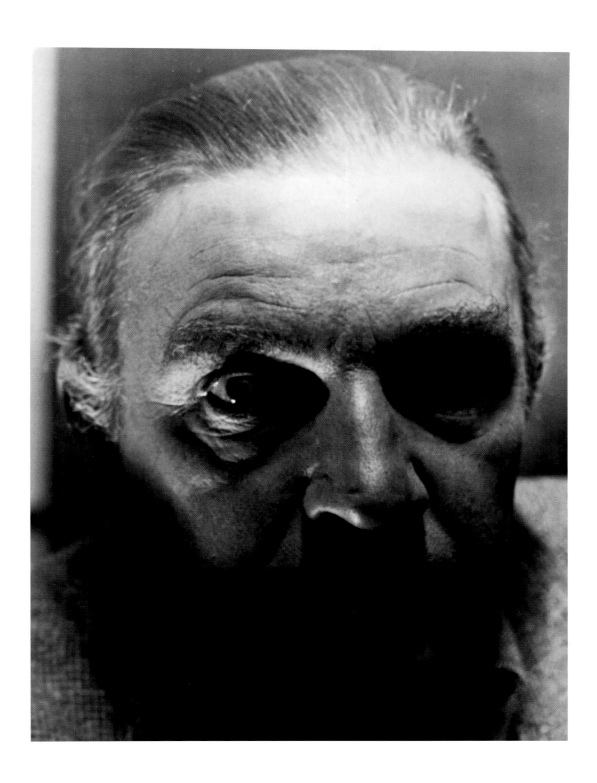

John Rädecker, Sculptor
Amsterdam, c.1932

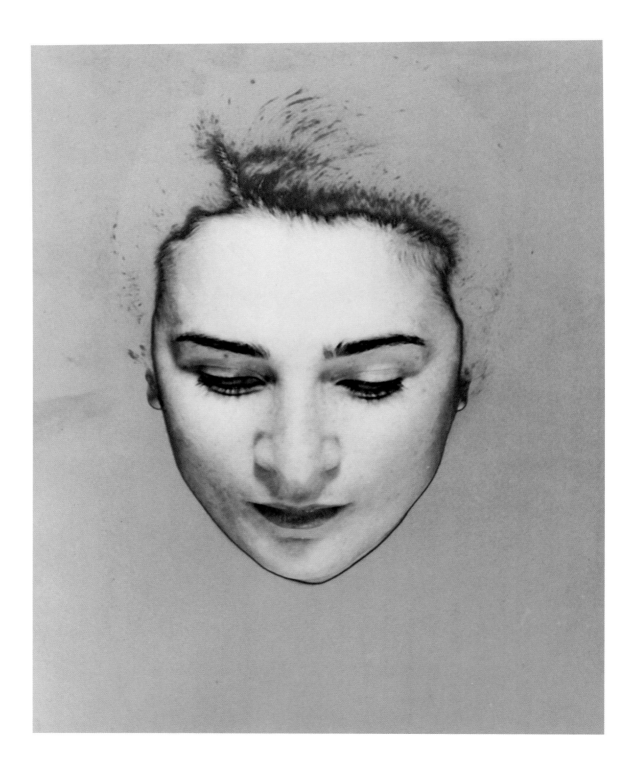

Solarized Portrait (Wilhelmina Leeuwenstein)
c.1933

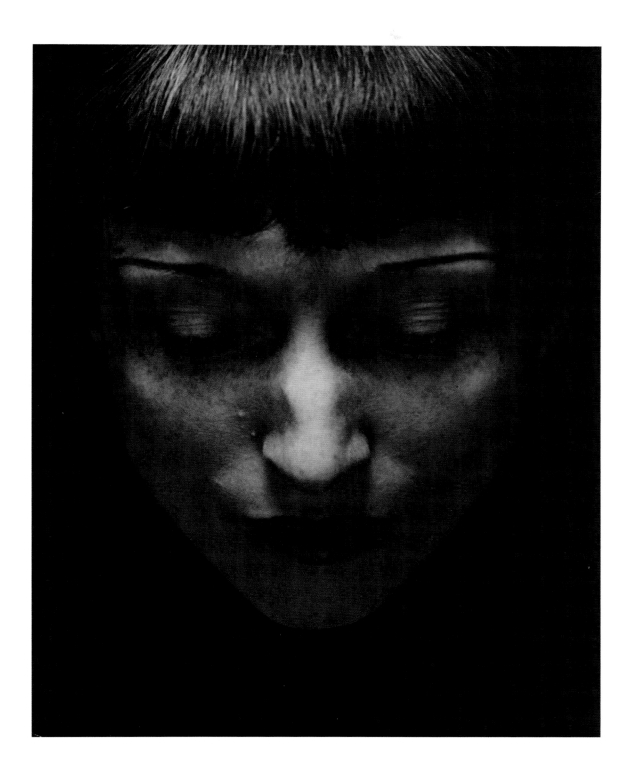

Portrait of a Woman
Holland, c. 1933-36

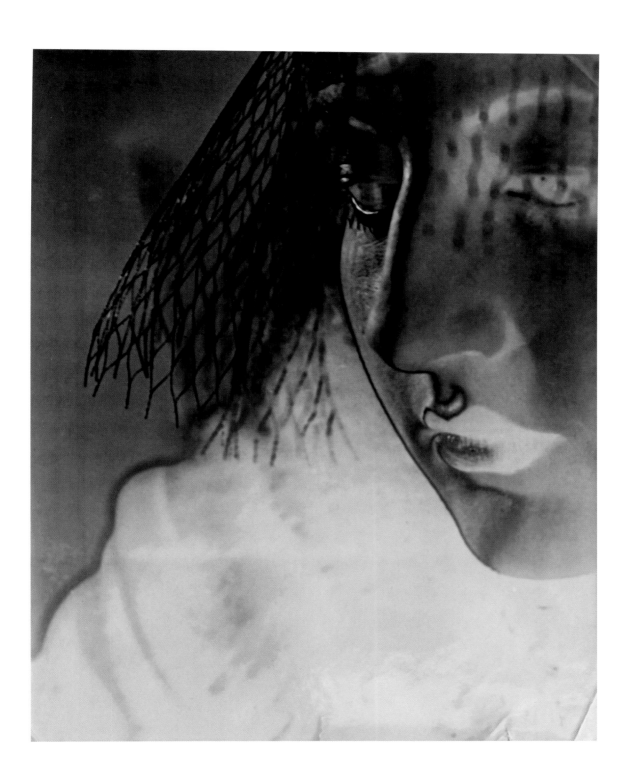

Solarized Portrait
Amsterdam, 1933

Georges Rouault, Painter
Paris, c.1936

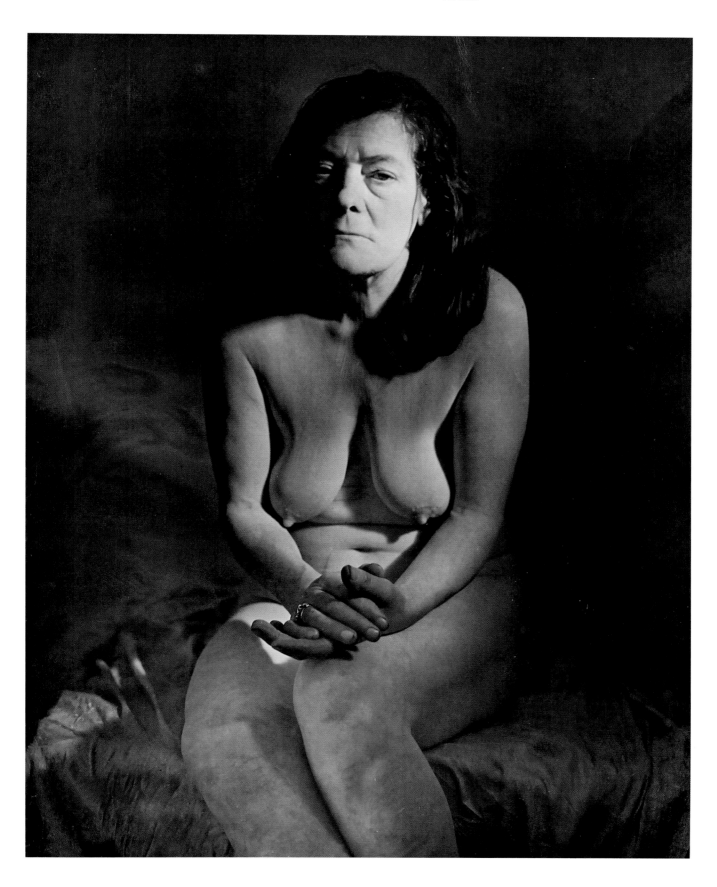

Carmen, Rodin's Model for The Kiss
Paris, 1936

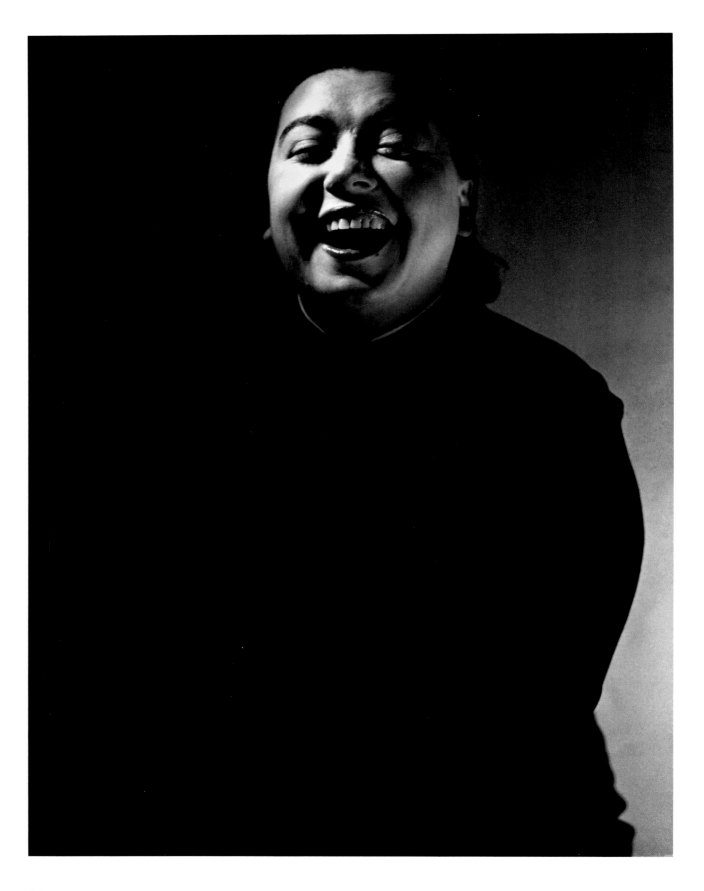

108

Spivy
1930s

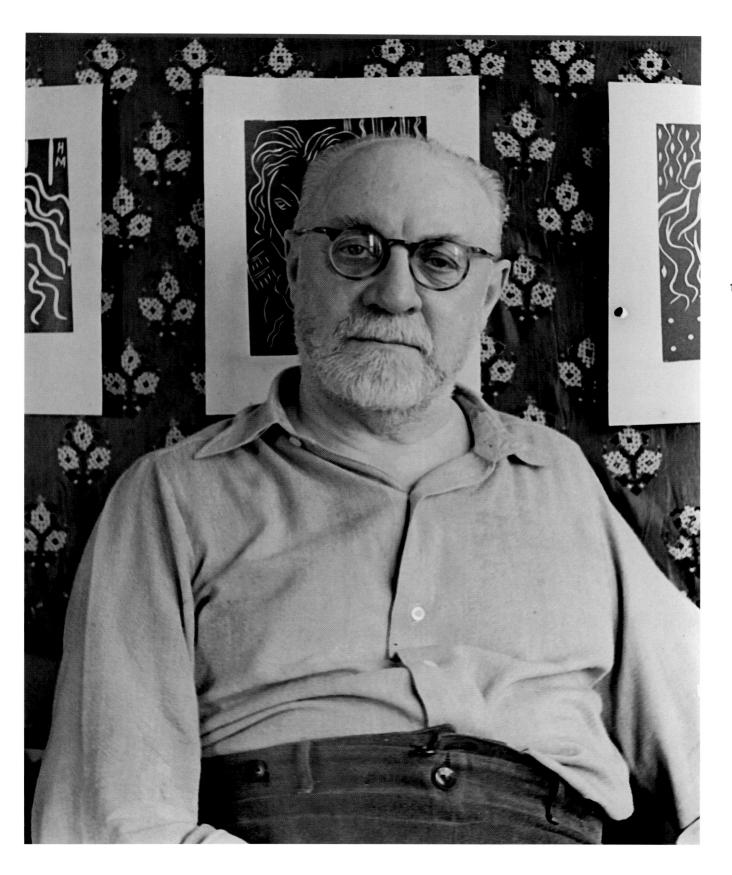

Henri Matisse, Painter
Paris, c.1936

Valeska Gert, Cabaret Performer
New York, c.1943

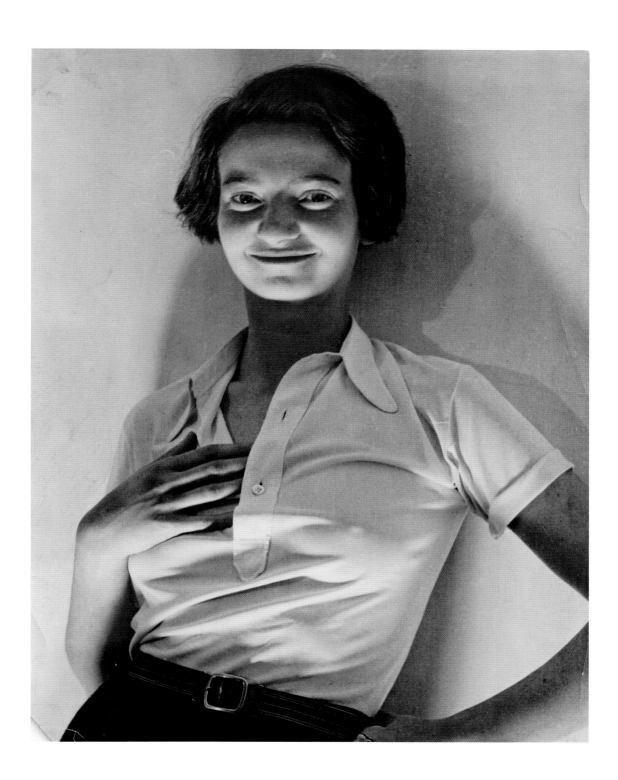

Marianne Breslauer, Photographer
Amsterdam, 1937

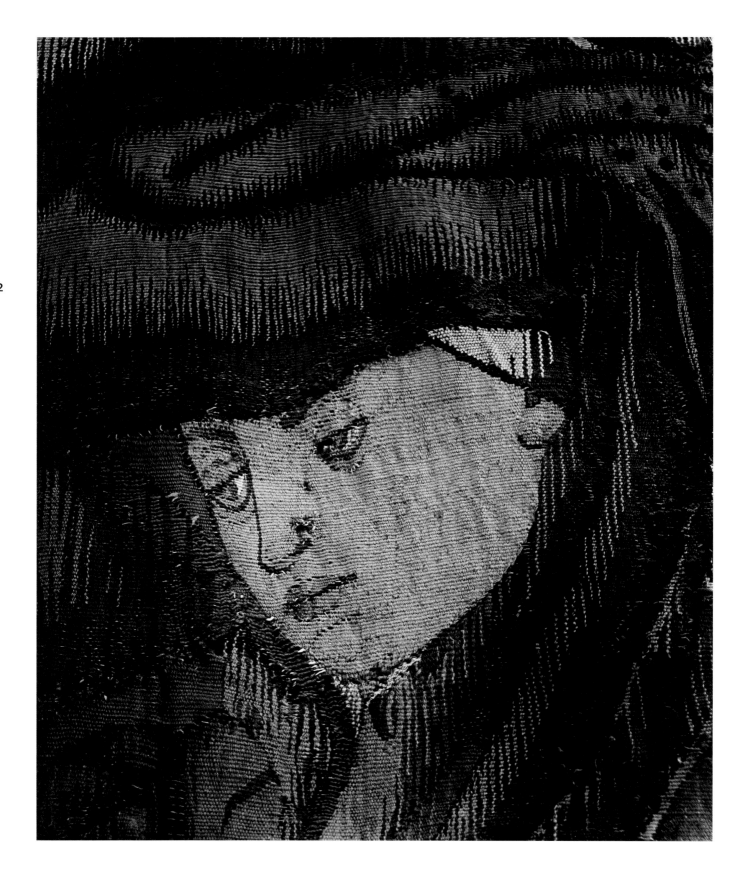

Detail of a Tapestry
Paris, c.1936

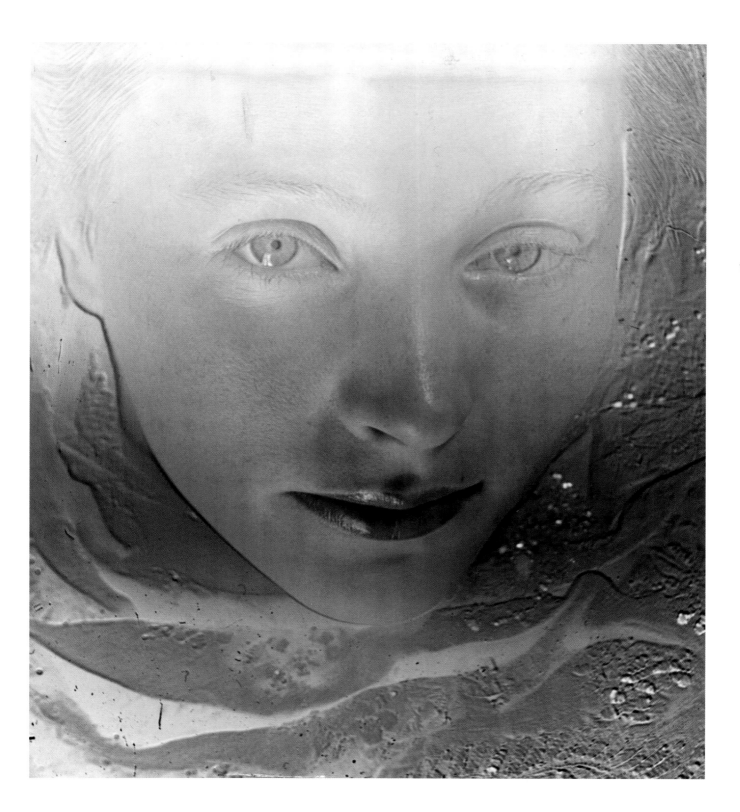

Muth
Paris, c.1938

114

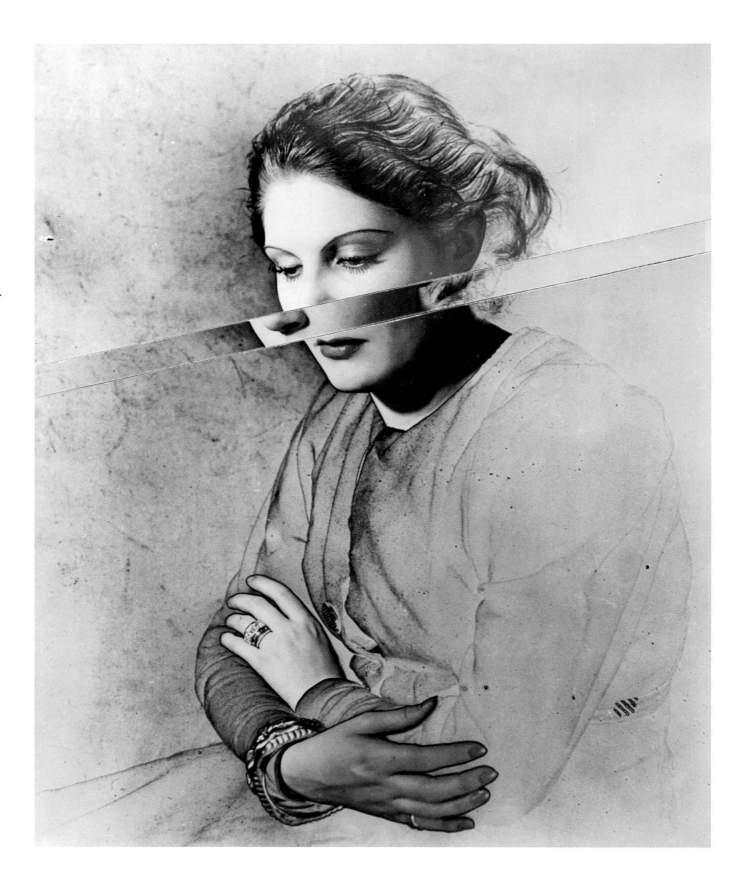

Partial Solarized Portrait
Paris, c.1938

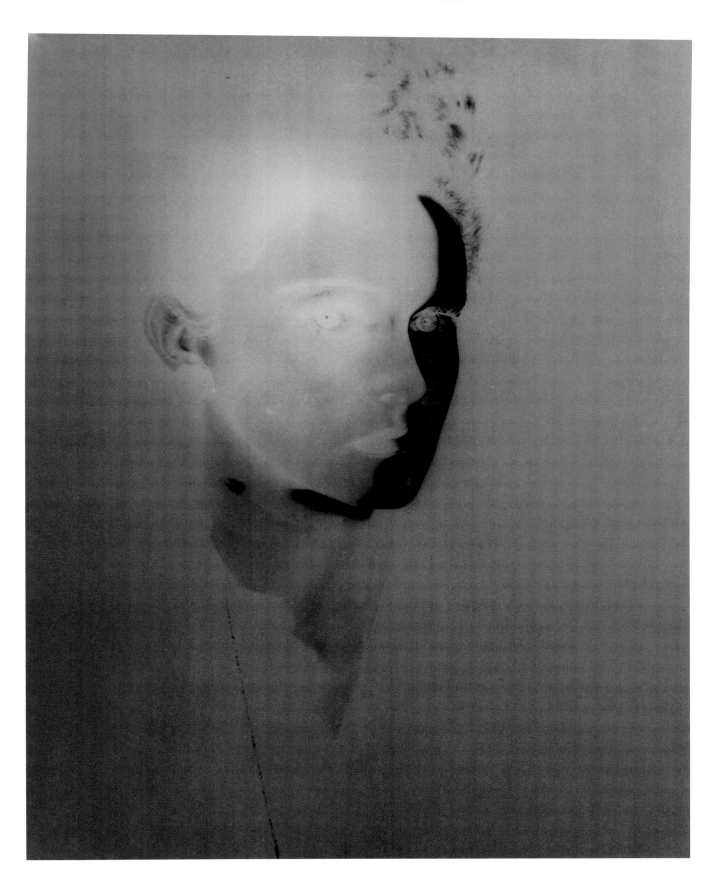

Solarized Portrait
Late 1930s

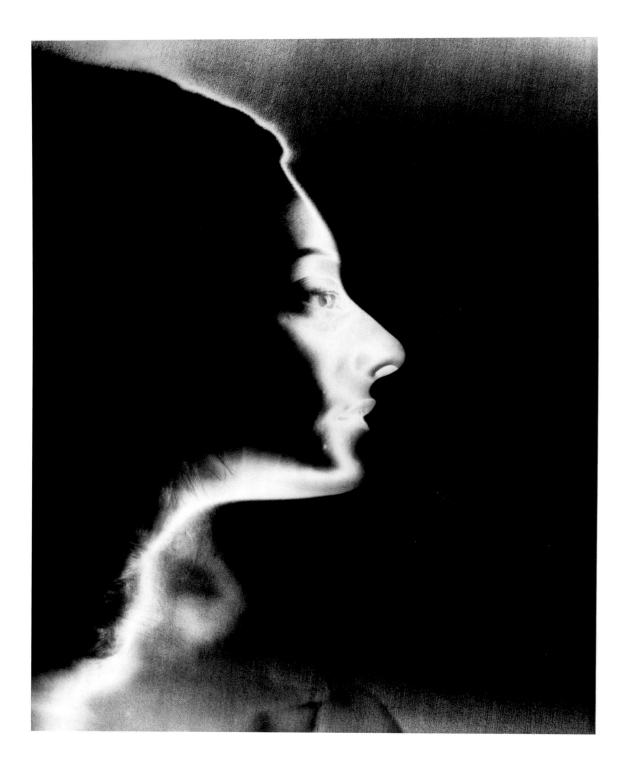

Natalia Pasco
New York, 1942

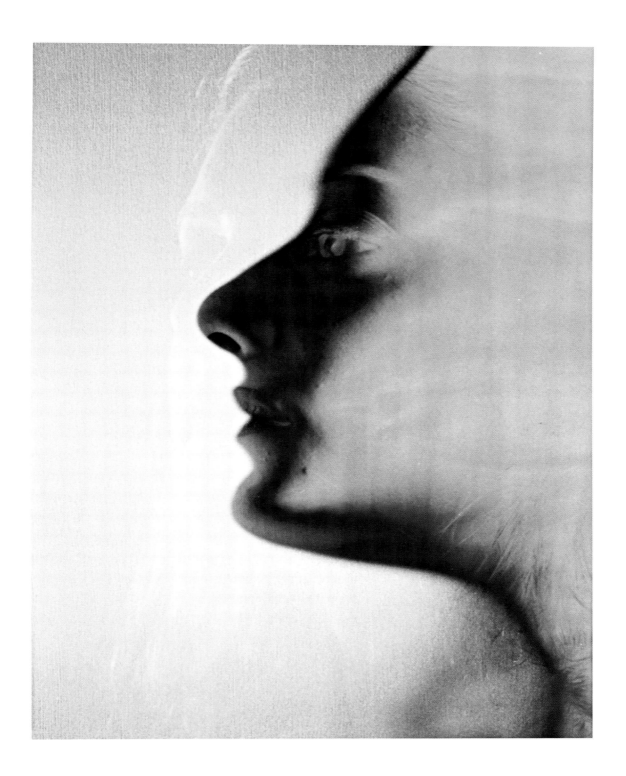

Natalia Pasco
New York, 1942

118

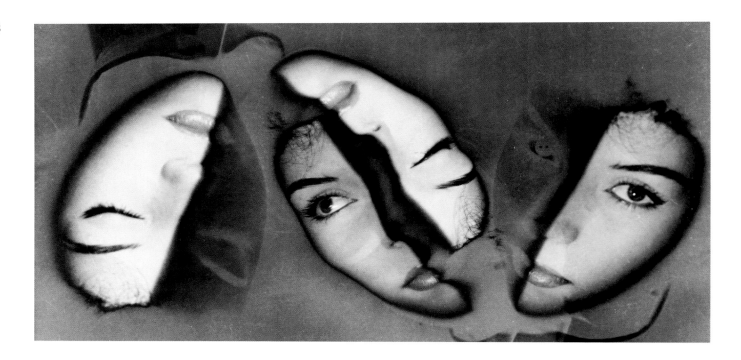

Maroua
New York, 1942

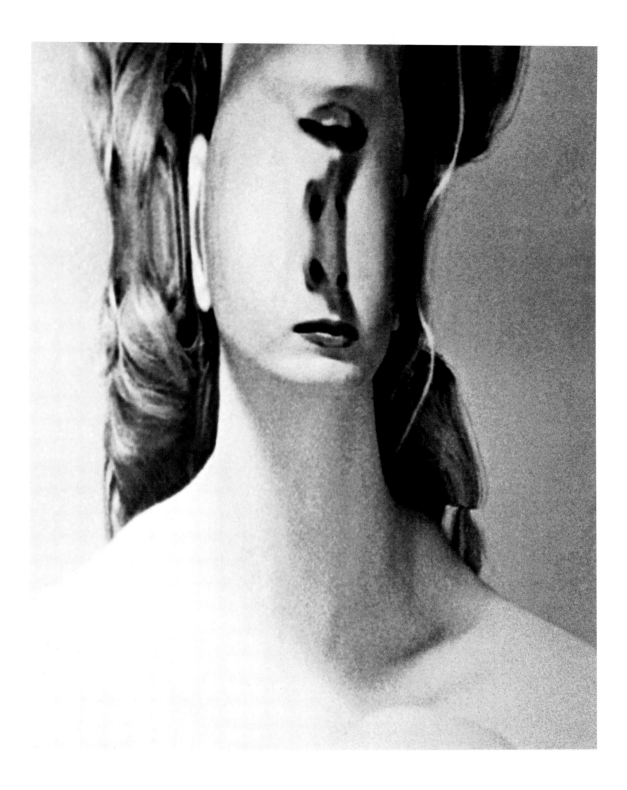

Distortion
New York, 1940s

120

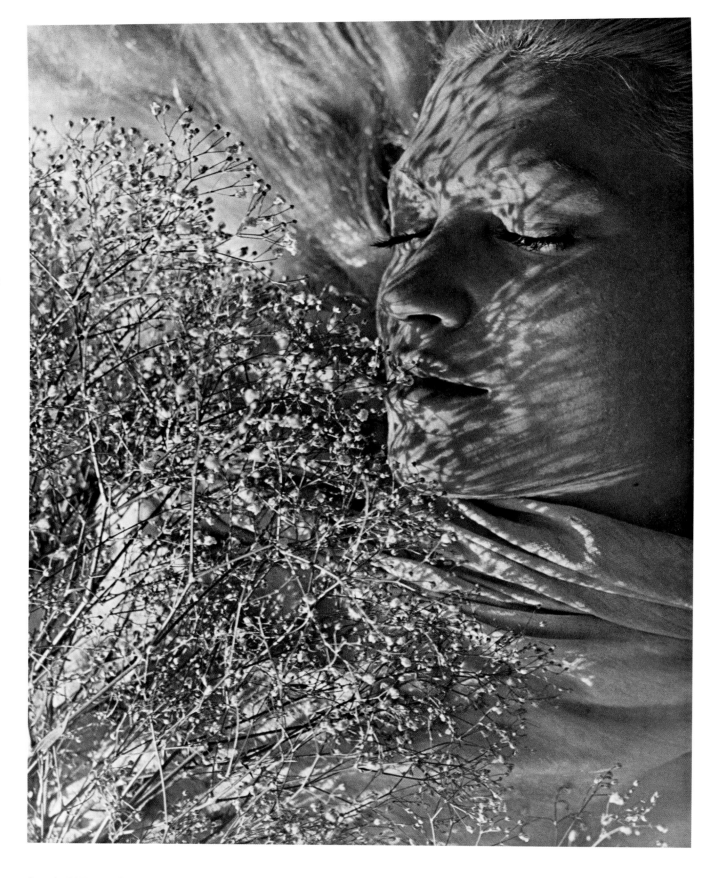

Portrait with Blossom Shadow
New York, 1944

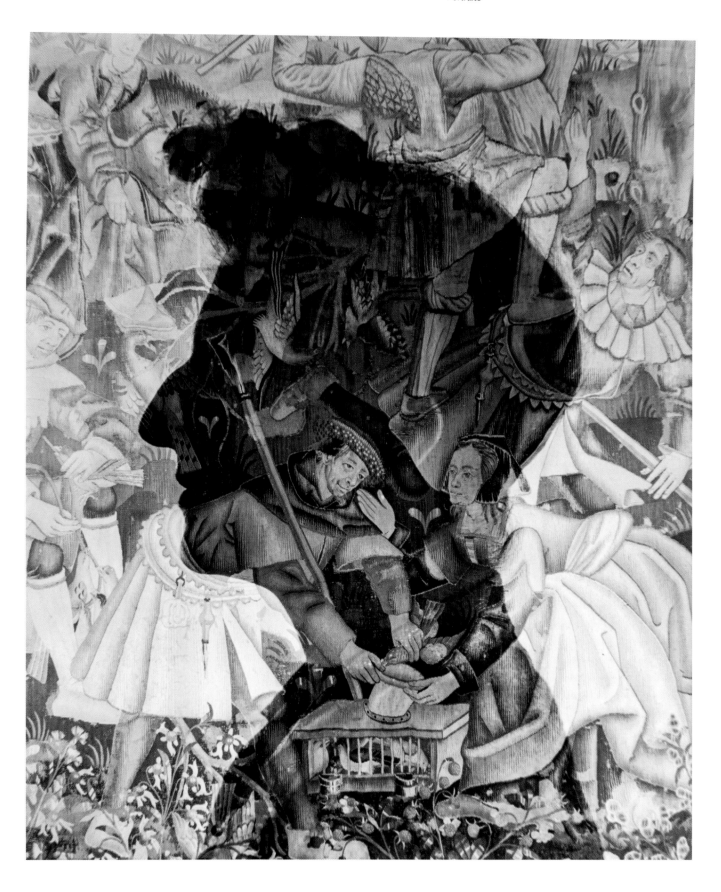

Edith Lamont, Singer
New York, 1944

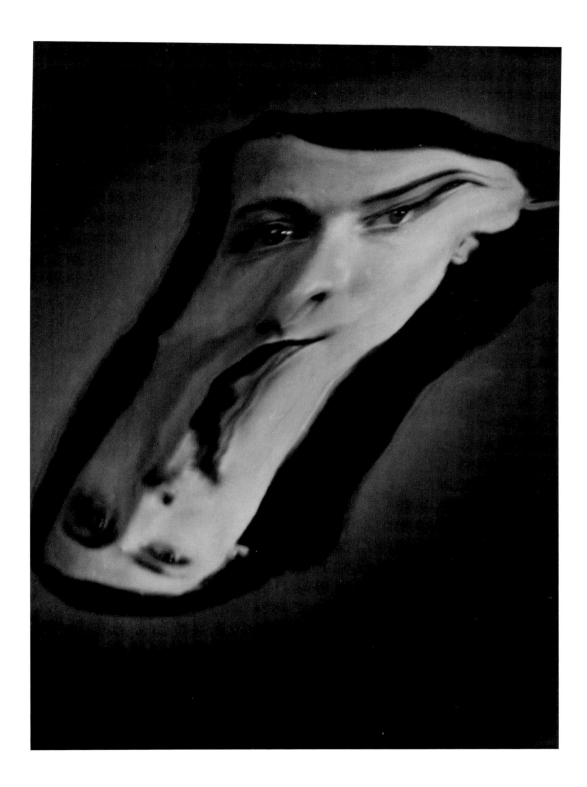

Distorted Faces II
c.1942

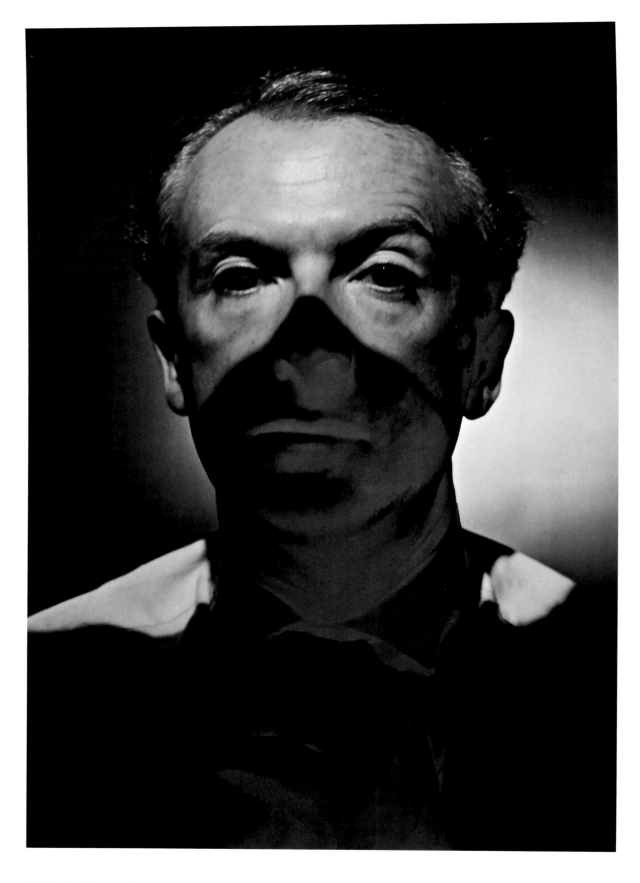

Cecil Beaton, Photographer
1945-46

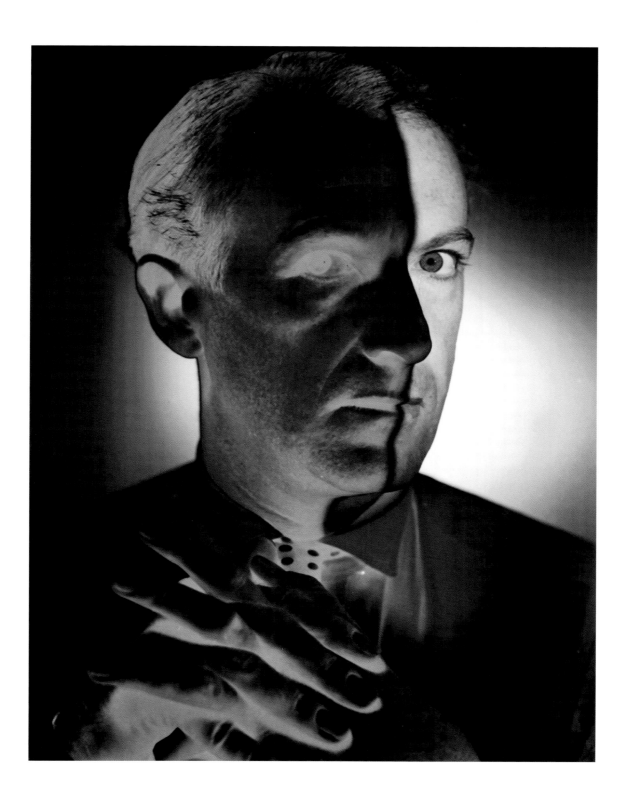

Cecil Beaton, Photographer
1946

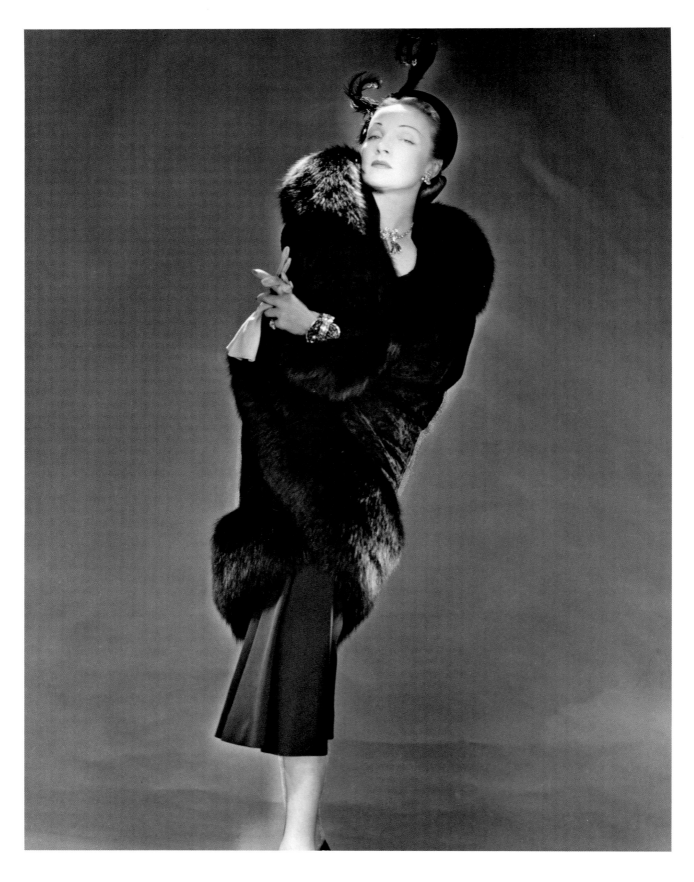

Marlene Dietrich, Actress and Singer
New York, 1950

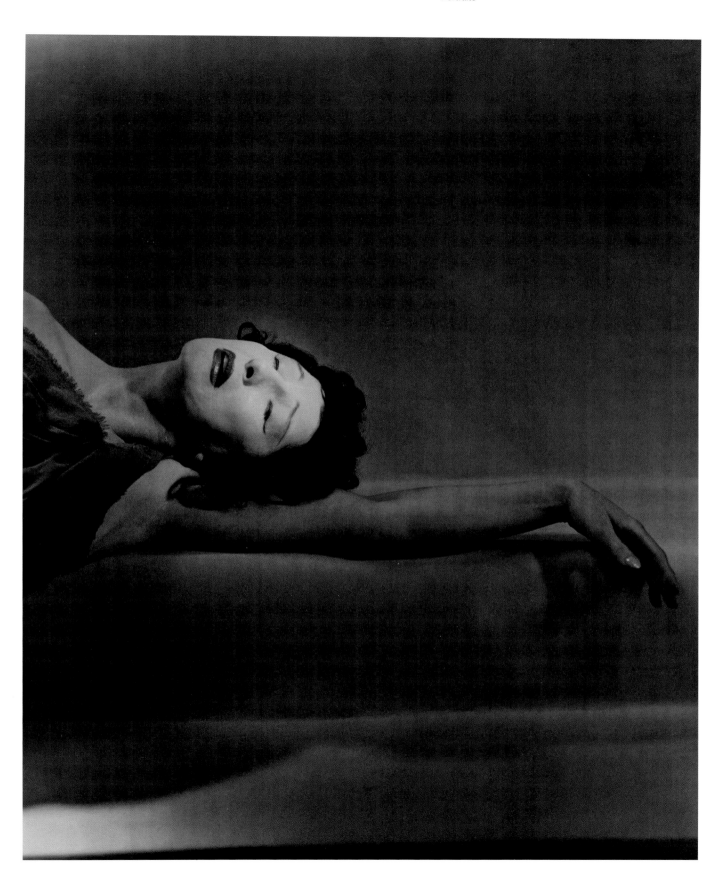

Judith Anderson as Medea
1947

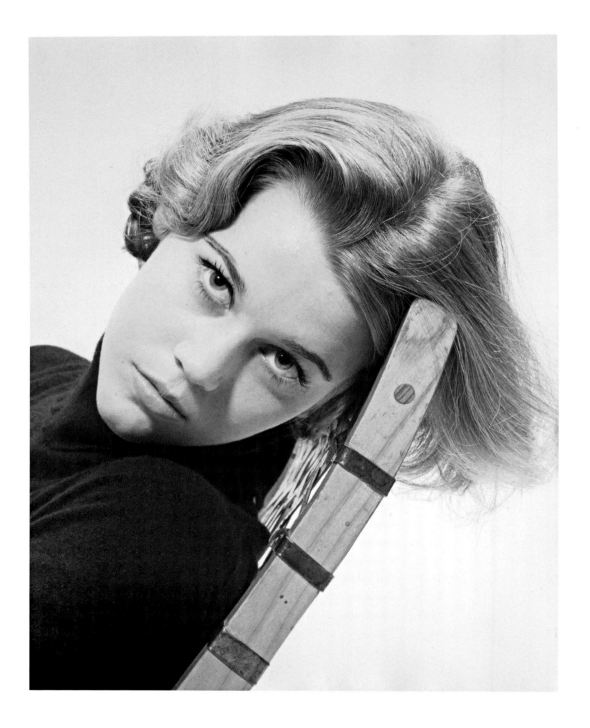

Jane Fonda, Actress
New York, 1950

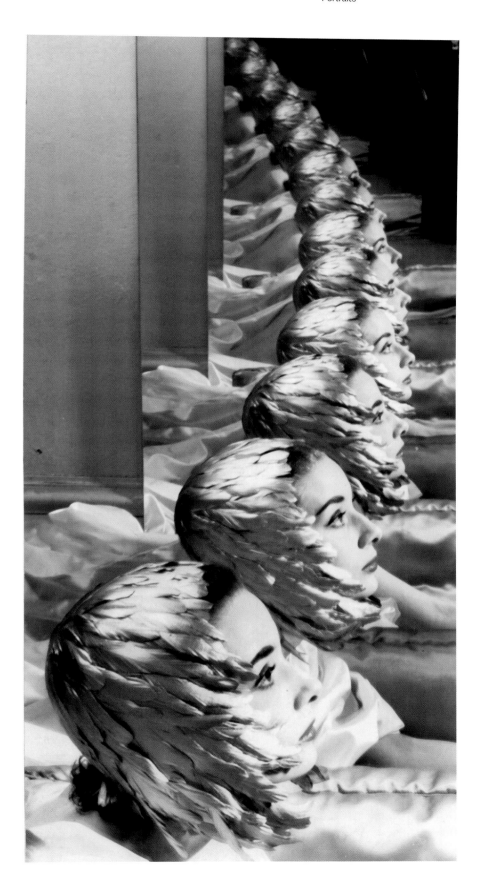

Audrey Hepburn, Actress
New York, 1950s

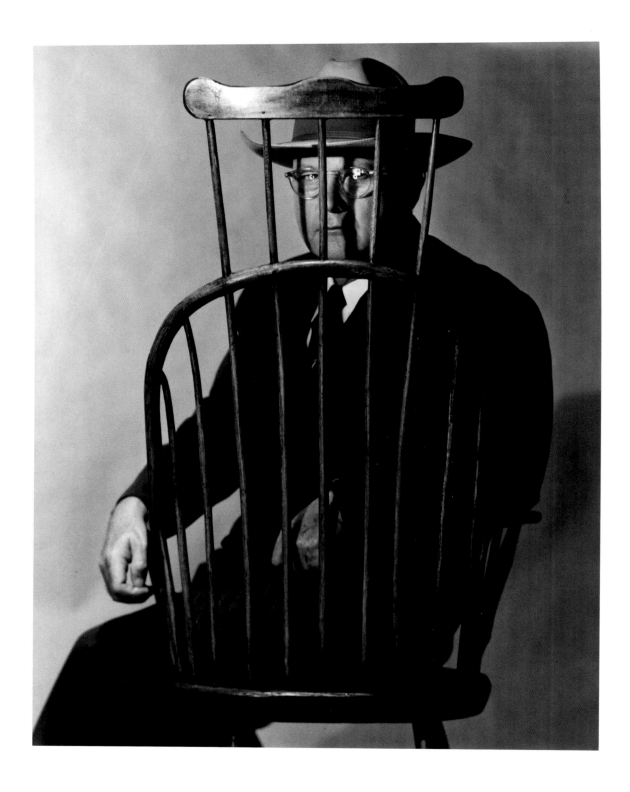

Erle Stanley Gardner (Mystery Writer)
New York, 1950s

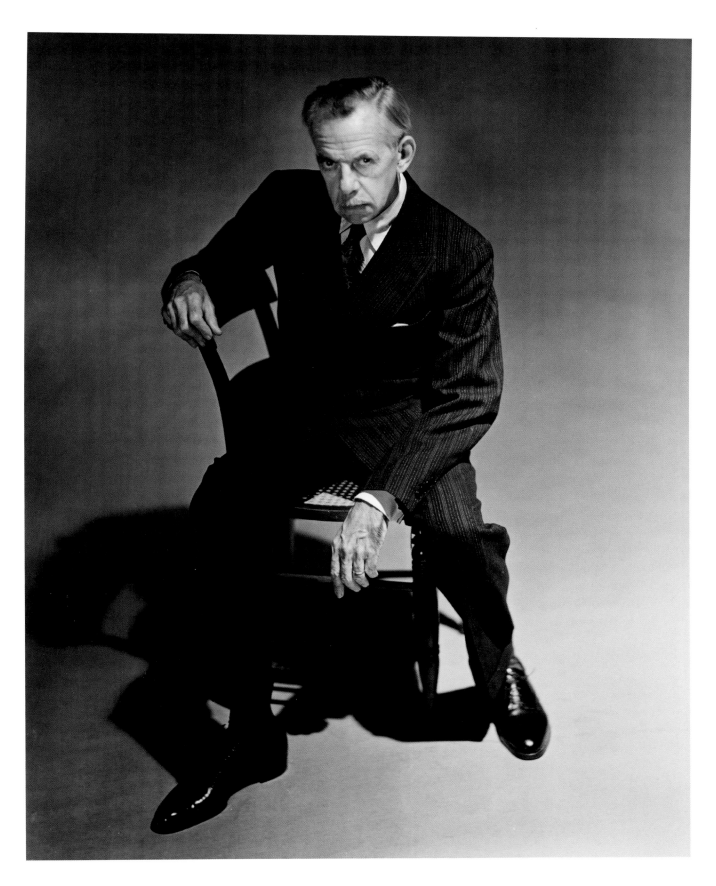

Eugene O'Neill, Playwright
New York, 1947

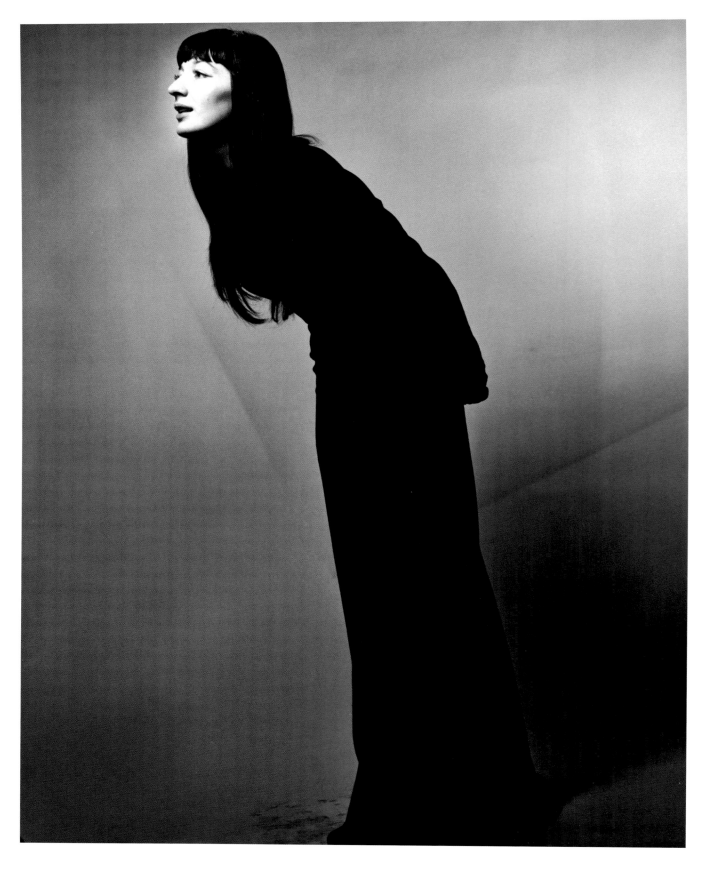

Juliette Gréco, Singer
New York, 1957

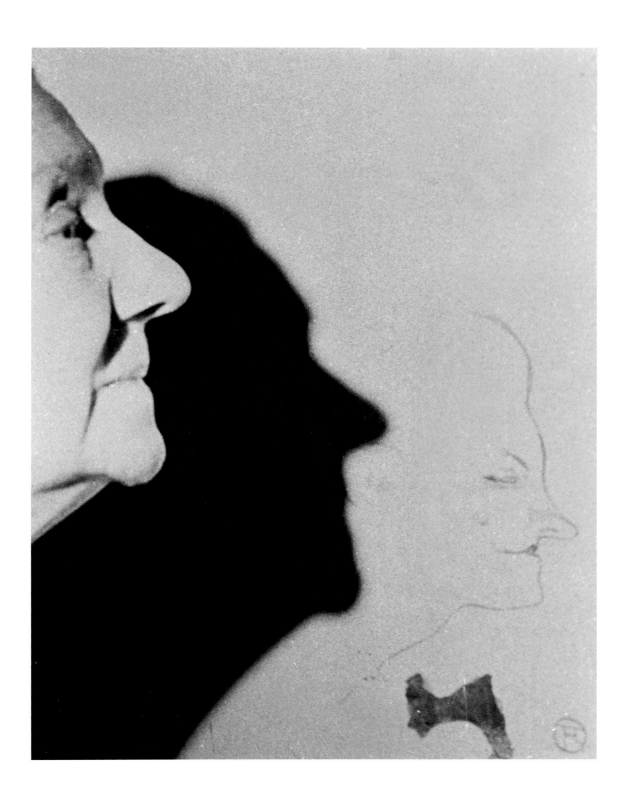

Yvette Guilbert, Singer
New York, 1940s

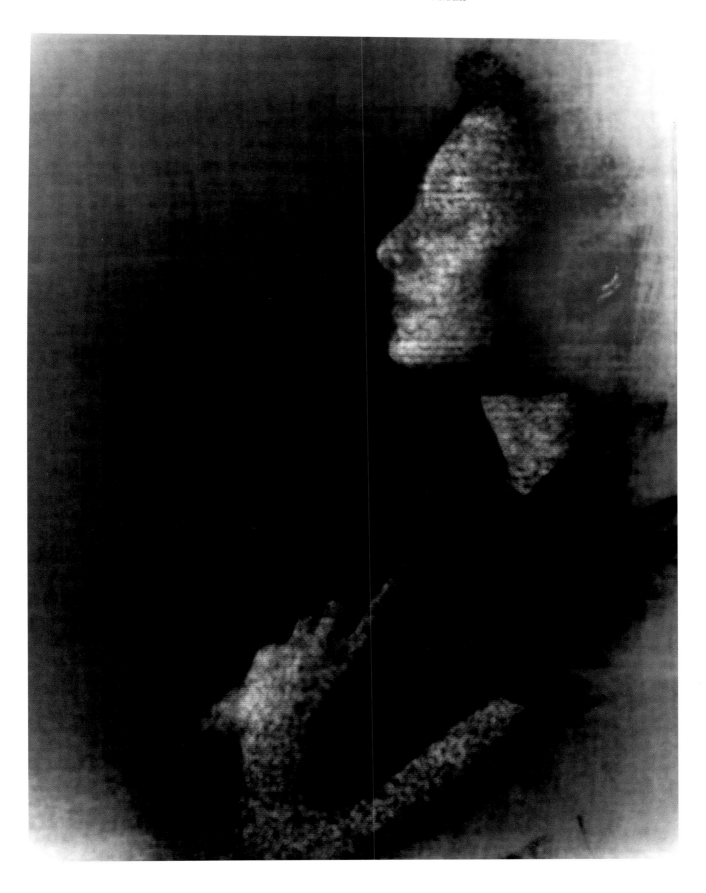

Portrait with Projection
New York, 1952

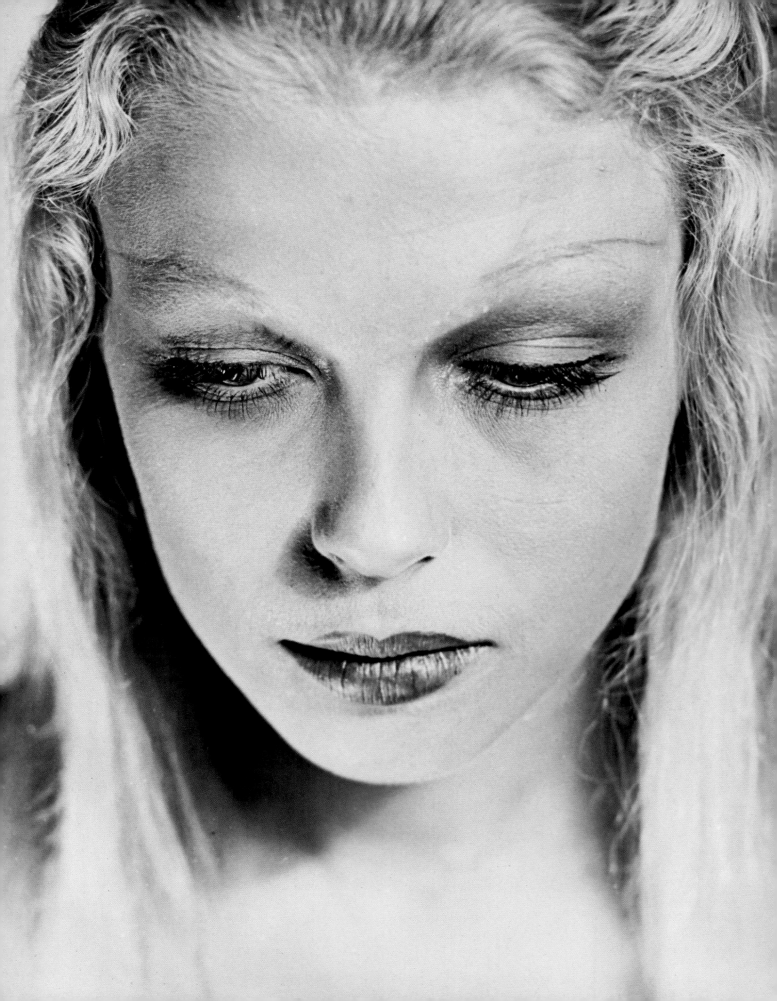

Stone Beauty:
Women as Photographic Material in Erwin Blumenfeld's Experimental Portraits and Nudes in the 1930s

Esther Ruelfs

Erwin Blumenfeld
Tara Twain, Actress
Amsterdam, early 1930s

Portraiture as experiment

A picture taken in 1935 shows a wall display in Erwin Blumenfeld's Amsterdam studio of almost one hundred portraits of women. The tightly framed close-ups show the women face on or in half or full profile. The pictures, arranged seamlessly on the wall, form a kind of visual wallpaper that functions as an art installation.

Blumenfeld's first involvement in professional photography was as a portraitist.[1] Even his early amateur photographs from 1928 on already concentrated on the faces of his family; well before he turned his hobby into a profession between 1932 and 1935, taking portraits of the women who frequented the Fox Leather Company, eventually opening a portrait studio for two months after his shop went out of business.

However, his artistic practice had little in common with the typical portrait work of other studios, whose well-heeled customers were high-ranking civil servants and officers. In the early 1930s, the more traditional portrait studios had hardly moved on from the aesthetic tastes of the beginning of the century, influenced by the pictorialist movement, aiming to produce idealised, if not "faithful", portraits that reflected the sitter's character and frame of mind. An advertisement for Blumenfeld's studio dating from 1935, just a few months before he moved to Paris, reveals his very different approach: it features a portrait of the American actress Tara Twain as the embodiment of young, modern womanhood. Her symmetrical features are framed by the edges of the shot, while there is a stark contrast in her expression between the modestly downcast gaze, reminiscent of childlike innocence, and the erotic, seductive power of the vamp suggested by her heavily lipsticked mouth. By displaying such a por-

1. Fleur Roos Rosa de Carvalho, "Germinating in the 'Dutch Swamp'. Erwin Blumenfeld's Exhibitions at the Kunstzaal Van Lier, Amsterdam", in *Erwin Blumenfeld. His Dutch Years 1918-1936*, exhibition catalogue, The Hague, Fotomuseum Den Haag, Rotterdam, Veenman Publishers, 2006, pp. 155-157, here pp. 38-49.

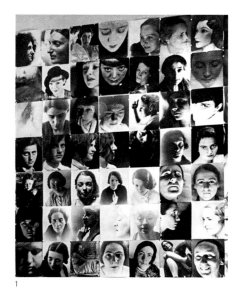
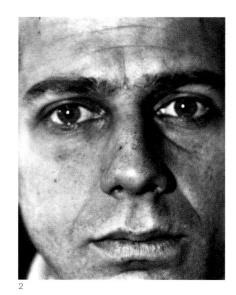

1 2 3

138

2. *Ibid.*, p. 44.

3. See Fleur Roos de Carvalho, who has identified most of the sitters: Fleur Roos de Carvalho, *"Ich will neue Menschen schaffen. Ich will alle Frauen lieben." Erwin Blumenfelds Amsterdamse portretten: 1930 – 1936*, unpublished thesis, Vrije Universiteit Amsterdam, 2007, typed, n.p.

4. *Erwin Blumenfeld. His Dutch Years 1918-1936, op.cit.*, p. 70.

5. Chronology, in *Erwin Blumenfeld. His Dutch Years 1918-1939, op. cit.*, p. 155.

6. *Ibid.*, p. 156.

7. Herbert Molderings, *Otto Umbehr Umbo 1902-1980*, Düsseldorf, Richter Verlag, 1995, p. 53 ff.

trait in the window of his Amsterdam studio, Blumenfeld was aiming to reach a modern, sophisticated, urban clientele. It is likewise no coincidence that he chose to advertise using the image of an actress, and that the portraits on his wall of photographs included other actresses, as well as window-display dummies, indicating that his approach to portraiture was experimental indeed: the aim was not to produce "faithful" portraits, but rather role portraits.

Blumenfeld's wall installation was dominated by women, and the female body became his foremost subject over the next few years. While his early experiments were devoted to portraits, by the time he moved to Paris he turned to nudes; his later work as a fashion photographer featured women almost exclusively, practically by definition. Several of the sitters for his early portraits, such as the artist Karin van Leyden (circa 1933), the fashion plate illustrator Eva Pennink (circa 1934), and Oty Reijne-Lebeau (circa 1932; p. 98), whose father was an artist, were associated with the Kunstzaal Van Lier, a leading art gallery where Blumenfeld's work was shown in 1932 and again in 1935.[2] Apart from these women from his immediate circle, the portraits on the wall included actresses such as Charlotte Köhler, Truus van Aalten, Dorothea Wieck and Françoise Rosay, in addition to Tara Twain.[3] These actresses embodied the "new woman" archetype of the 1920s and 1930s, when countless novels recounted the heroine's irresistible rise from humble shop girl to much-fêted star of stage and screen. Truus von Aalten, a Dutch actress who lived in Berlin, where she was a popular star in the Weimar film industry, was the very epitome of the young, independent woman making her own way in the world.

Such portraits of actresses, often used to accompany fiction serials in the modern illustrated press, played a key role in the rise of the "new photography" in Weimar modernity. Blumenfeld's works and his approach to photography were in step with developments in German photography in the Weimar years, forming a contrast with the American tradition of artificial, glamorous Hollywood portraits, such as Edward Steichen's portrait of Marlene Dietrich.[4]

Blumenfeld's works reflect his interest in the Neues Sehen movement. His photography often adopted unusual high-angle perspectives, while he experimented with the artistic possibilities of lighting, defamiliarising the sitters' faces through double exposures and by the use of solarisation in the darkroom. His methods bear some similarity with those of photographers in the Bauhaus circle, such as Umbo and László Moholy-Nagy, whose work he seems to have encountered through his lifelong friend Paul Citroen (who was his wife Lena's cousin). Citroen was Dutch by birth but grew up with Blumenfeld in Berlin; he studied at the Bauhaus in Weimar from 1922 to 1924. In 1920, when the two friends were living in Amsterdam, they appointed themselves directors of the Hollandse Dadacentrale and planned to open a gallery together.[5] In 1935, Citroen featured Blumenfeld's work in an exhibition he curated at his recently founded Nieuwe Kunstschool in Amsterdam, alongside works by Umbo, Moholy-Nagy and Man Ray.[6]

Umbo began his groundbreaking experiments in portraiture as early as 1926, adapting the principle of the close-up from the cinema screen, where it had already been used to powerful emotional effect in films such as Sergei Eisenstein's *Battleship Potemkin* (1925).[7] When compared with Blumen-

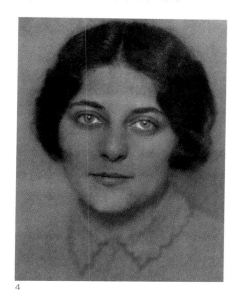

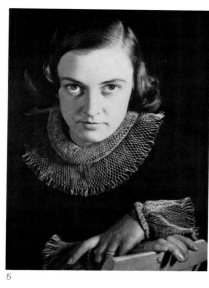

1
Studio Wall (detail)
Amsterdam, c.1934-35

2
Umbo
Paul Citroen
1926

3
Erwin Blumenfeld
Self-Portrait and Family Portraits
Contact sheet
c.1928

4
Franz Fiedler
Hungarian Woman with Devil Eyes

5
Andreas Feininger
Young Woman with Lace Collar

4

5

feld's self-portrait from the same period, Umbo's 1926 portrait of Paul Citroen clearly shows the artistic kinship between the two photographers, who were also in personal contact through Citroen. Both shots are tightly framed, cutting off part of the forehead and limiting the range of the portrait to the eyes, nose and mouth. The camera fosters a sense of intimacy by bringing the photographer unusually close to the sitter's face.

By 1932, when Blumenfeld turned professional, close-ups had become part of the repertoire of avant-garde photography. The popularity of such new perspectives is also apparent from contemporary guides to amateur photography.[8] Franz Fiedler's *Porträt Photographie* (1934) includes an entire chapter on close-ups of headshots, complete with sample photographs. The book also features a "Hungarian woman with devil eyes", the whites of whose eyes shine brightly out of a dark background. This could almost be the reverse of Blumenfeld's "demonic" shot of Oty Reijne-Lebeau (p. 98). Fiedler's chapter on physiognomy likewise reflects the considerable influence that the concept of the archetype had on portraiture from the late 1920s on, as evident from the countless physiognomic studies of portraits in magazines and illustrated books from the period. Blumenfeld's portrait of Tara Twain is reminiscent of Fiedler's "libidinal archetype", which his book illustrated with a photograph of a woman with downcast eyes.[9] There are also analogies with Blumenfeld's technique in Andreas Feininger's 1934 *Menschen vor der Kamera. Ein Lehrbuch Moderner Bildnisfotografie*, which draws on items of clothing, such as a lace collar, to create a very similar graphic effect to Blumenfeld's use of openwork lace to create a black-and-white pattern.[10]

Blumenfeld's work is to be understood in the context of a wide range of practices in early 1930s German portrait photography. These included cutouts, perspective, playing with the distance between camera and sitter, and lighting – techniques often used by members of the Bauhaus circle to create defamiliarising effects – and the concept of the archetype, that strives to grasp the individual as part of a social group. Blumenfeld set out to experiment with form and the expressive potential of the human face in his early portraits. His experiments with female models proved highly successful and innovative, as the selection of works in the present exhibition demonstrates. The photographs he exhibited at the Galerie Van Lier in 1933, many of which must have come from the aforementioned wall display in his studio, were shown under the title *Cinquante têtes de femme*. The punning title alluded to Max Ernst's 1929 *Femme 100 tête*, a collage novel whose illustrative material was compiled from engravings of women from the 19th-century popular press. Ernst's title plays on a phonetic pun between "cent têtes" (one hundred heads) and "sans tête" (headless), the women of the title serving as blank surfaces onto which the artist could project his creative imagination. The same is true of Blumenfeld, who shows no interest in the portrait's potential dialogic structure or in exploring the character of the sitter through his or her interaction with the photographer. For him, the women sitting for him were just material for his experiments in portraiture as an art form. In this sense, all his models have something of the actress: they appear as individuals, but the aim is not to reflect their "true character"; rather, their faces are to serve as a canvas for whatever Blumenfeld chose to project onto them.

8. Franz Fiedler, *Porträt Photographie*, Berlin, Photokino-Verlag, 1934; Andreas Feininger, *Menschen vor der Kamera. Ein Lehrbuch Moderner Bildnisfotografie*, Halle, Dr Walther Heering Verlag, 1934.
9. Franz Fiedler, *op. cit.*, p. 192.
10. Andreas Feininger, *op. cit.*, p. 53.

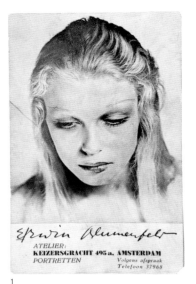

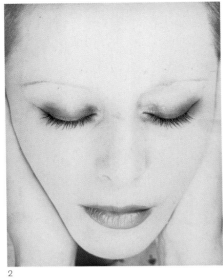

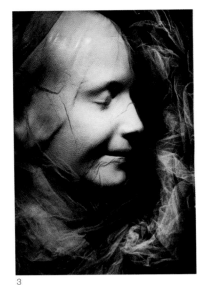

1
Erwin Blumenfeld's Business card, with Tara Twain's portrait
Amsterdam, 1932

2
Erwin Blumenfeld
Der Augenblick [The Instant]
Paris, 1937

3
Willy Zielke
L'Inconnue de la Seine
1934

11. Hendel Teicher explores this motif in "How to become a Photographer", in *Blumenfeld: My One Hundred Best Photos*, p. 11.
12. See Erika Mayr-Oehring, "Schlafende Mädchen. Die Verführung des Auges als künstlerische Stategie", in *Süßer Schlummer. Der Schlaf in der Kunst*, ed. E. Mayr-Oehring, exhibition catalogue, Residenzgalerie Salzburg, Salzburg 2006, p. 49.
13. Blumenfeld's reception of Surrealism has been explored by various researchers. See Fleur Roos Rosa de Carvalho, *op. cit.*, p. 47, and Sarah Debatin, "Im Einflussbereich des Surrealismus. Die Fotografien von Herbert Bayer, Erwin Blumenfeld und Herbert List", in *Gegen jede Vernunft. Surrealismus Paris – Prag*, exhibition catalogue, Wilhelm-Hack-Museum Ludwigshafen, Kunstverein Ludwigshafen, eds. Reinhard Spieler and Barbara Auer, Stuttgart, Belser Verlag, 2009, pp. 312-315. Blumenfeld published his nudes alongside works by Man Ray, Brassaï, Ubac and Bravo in *Verve* in December 1937: see William A. Ewing, *Blumenfeld, A fetish for beauty, Sein Gesamtwerk 1897–1969*, Zurich, Stemmle Verlag, 1996, p. 84.
14. Ernst Benkard, *Das ewige Antlitz. Eine Sammlung von Totenmasken. Mit einem Geleitwort von Georg Kolbe* (1926), Berlin, Frankfurter Verlagsanstalt, 1929 / *Undying Faces: A collection of death masks*, London, 1929.
15. The death mask also plays a key role in Louis Aragon's 1944 novel *Aurélien*. See Hélène Pinet, "L'eau, la femme, la mort. Le mythe

Woman, asleep

The portrait of Tara Twain is representative of an entire series of pictures of women with downcast gazes or their eyes shut as if asleep, or whose faces are transformed into masks.[11] The slumbering woman is a gendered stereotype in art history. Sleep means a loss of control:[12] the sleeping woman is observed but cannot in turn see who is watching her. The passivity of the reclining, resting woman, unaware of her surroundings, is coupled with lasciviousness, sensual abandonment, and the promise of sexual fulfilment. Two further portraits, one from 1933 (p. 102) and the other from the late 1930s, bear an even clearer resemblance to a mask. The space of the photograph is dematerialised and the facial features abstracted through solarisation. The eyelashes, hairline and lines of the mouth are coordinates on the surface of the picture. The cheeks and chin are outlines separating the head from the body, leaving it floating on the surface of the photographic paper like a mask. The motif of sleep and the sphere of dreaming that it evokes can be associated on the one hand with the canon of Surrealist motifs,[13] while on the other Blumenfeld's contemporaries would certainly have seen it as reminiscent of the loveliest, most famous corpse of the age: the *Inconnue de la Seine*, an unknown woman presumed to have committed suicide in the Seine, whose death mask was cast in the Paris morgue. The *Inconnue de la Seine* owed her name to the author Ernst Benkard, who was the first to popularise the photograph of her death mask in his book on the subject:[14] she was a source of particular fascination for artists and writers in the 1920s and 1930s in Germany and elsewhere, inspiring artists such as Albert Rudomine (1927), Yvonne Chevalier (1929) and Willy Zielke (1936).[15] The theme also fea-

tures in modified form in the work of Herbert List, another German emigrant in Paris, connected to Blumenfeld through his contacts with the Surrealists. The *Inconnue de la Seine* is doubtless the twentieth-century's finest example of the aestheticisation, eroticisation and mythification of death; however, death masks were still seen in the 1930s as the final, "true", commemorative portrait of an individual and were the focus of much discussion in artistic discourse on portraiture.[16]

The beautiful, slumbering woman is typical of Blumenfeld's photographic handling of women. He fetishises the female body, giving himself the status of creator. A 1933 self-portrait provides an ironic image of this myth of creation, depicting him as a nude in the act of childbirth, giving birth to a doll's head.[17]

The mortification of the woman as sculpture echoes the photographic play with masks. Blumenfeld stages female bodies swaddled in fabric, draping their torsos in silk cloth, stylising his sitters as mummies and statues. None of his nudes show the individuality of the sitter. He avoids showing their faces, giving the models a timeless, generic character. This is apparent even in such an atypical work as the back view taken by Blumenfeld from the viewpoint of a lover observing the woman lying next to him in bed (p. 143). The bodies of his models remained disjointed in Blumenfeld's nudes until the 1960s, splintered in mirrors or fragmented through the use of experimental double exposures.

The artistic climate that Blumenfeld found when he moved to Paris in 1936 was one of euphoric engagement with antiquity. H. K. Frenzel's 1932 study of George Hoyningen-Huene's portraits describes the Paris art world, heavily influenced by

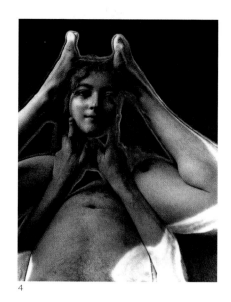

4

4
Erwin Blumenfeld
Self-portrait

neo-Classicism, as "the renaissance of antiquity in the spirit of the machine age".[18] Blumenfeld challenged this chilly anonymity with his obsession with the female form, his fetishistic relationship with "eyes, hair, breasts, mouths", as he wrote in his autobiography *Eye to I*.[19] This is what sets his work apart from the icily flawless perfection of portraits by Hoyningen-Huene and Cecil Beaton, bringing him closer to the Surrealists and their photographic treatment of women. The obsessive nature of his creations, excessively reshaped through solarisation and double exposures to turn them into unearthly figures, is reminiscent of Man Ray's photographs of women. Blumenfeld's nudes reveal a profoundly haptic fascination with his sitters, the camera substituting for direct touch; the sensual softness of the skin and draped silk can almost be felt. Blumenfeld is a worthy heir to Pygmalion, whose power of imagination and desire breathed life into his stone sculpture. The viewer is drawn into his game in turn.

When Blumenfeld arrived in New York in 1941, he devoted himself almost exclusively to fashion photography, becoming one of the highest-paid specialists in the field. His 1930s experiments in photomontage and the graphic potential of nudes fed into his new career, now in colour. His postwar works embody the archetype of the all-American woman. While they can be seen as an expression of his patriotic sentiments in the 1940s and 1950s, his portraits and fashion photography for magazines in the Condé Nast stable nonetheless reflect the legacy of his experiments from the 1930s in the studio settings, which are unusually minimalist for fashion photography. In this light, they can be read as the continuation of his series of role portraits, begun with Tara Twain.

As a genre, fashion photography sets out to sell us individuality, uncoupling it from clearly defined characters by using models. Blumenfeld's postwar photography successfully transferred his ability to turn women into blank canvases, onto which the viewer can project whatever he wishes, into a career in magazine and advertising photography.

de L'Inconnue de la Seine", in *Le dernier portrait*, ed. Emmanuelle Héran, exhibition catalogue, Paris, Réunion des musées Nationaux, 2002, pp. 175–190.
16. The modern taboo surrounding pictures of the dead only emerged after the 1930s, when portraits of well-known people in their coffins were still regularly printed in the press. On death masks, see Susanne Regener, "Physiognomie des Todes. Über Totenabbildungen", in *Bilder vom Tod. Kulturwissenschaftliche Perspektiven*, ed. Dorle Dracklé, Berlin, Lit Verlag, 2001, pp. 49-65, here p. 56, Claudia Schmölders, "Das ewige Antlitz. Ein Weimarer Totenkult", in *Gesichter der Weimarer Republik*, eds. Sander Gilman and Claudia Schmölders, Cologne, DuMont Buchverlag, 2000, pp. 256 ff., and Katharina Sykora, *Die Tode der Fotografie I, Totenfotografie und ihr sozialer Gebrauch*, Paderborn, Verlag Ferdinand Schöningh, 2009.
17. See Katharina Sykora, *Unheimliche Paarungen. Androidenfaszination und Geschlecht in der Fotografie*, Cologne, Walther König, 1999, p. 247 ff. On dolls in photography, see also *Puppen Körper Automaten. Phantasmen der Moderne*, eds. Pia Müller-Tamm and Katharina Sykora, Cologne, Oktagon Verlag, 2000.
18. Hermann Karl Frenzel, *Hoyningen-Huene – Meisterbildnisse. Frauen, Mode, Sport, Künstler. Mit einer Einführung von H. K. Frenzel*, Berlin, Dietrich Reimer, 1932, p. 13.
19. Erwin Blumenfeld, *Eye to I, The Autobiography of a Photographer*, London, Thames & Hudson, 1999.

Nudes

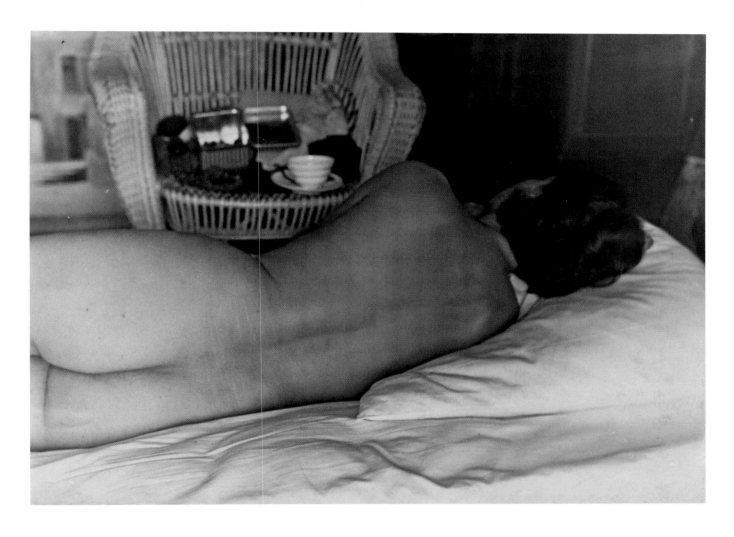

Nude
Late 1920s

144

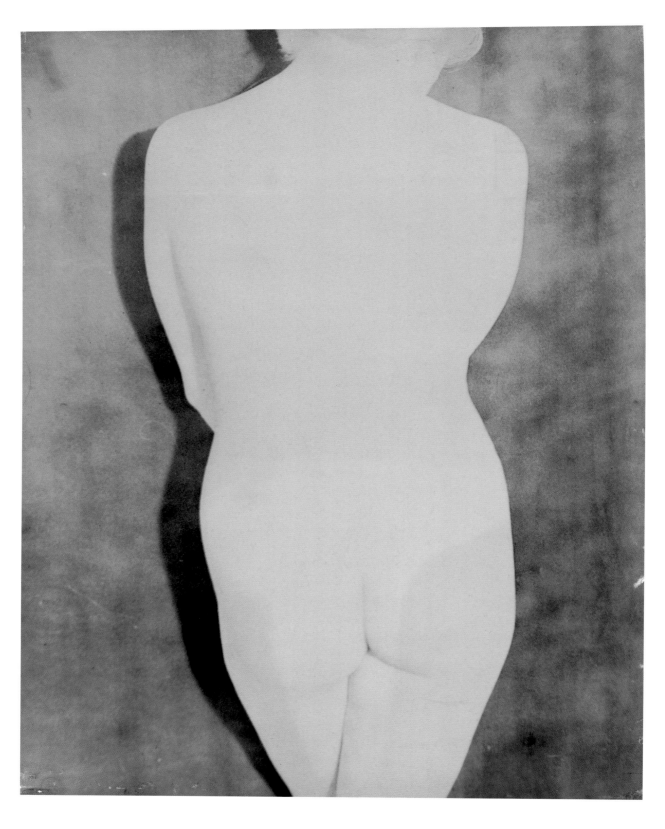

Nude
Amsterdam, c.1935

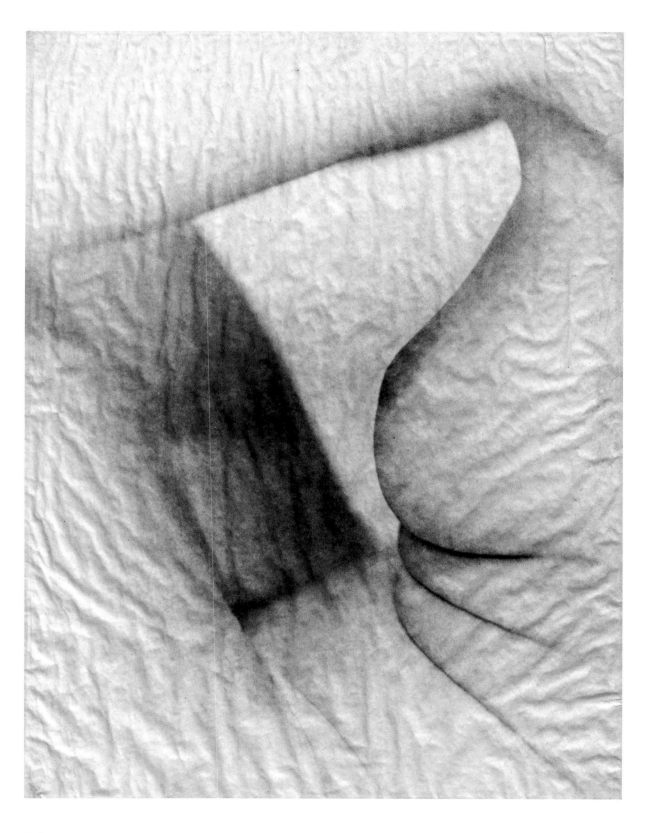

Nude
Amsterdam, c.1935

146

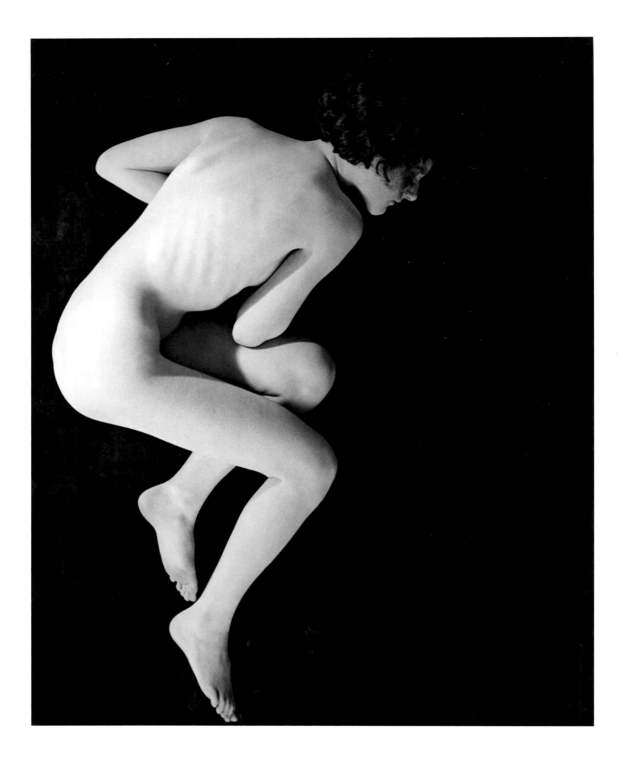

Nude (Lisette)
Paris, 1937

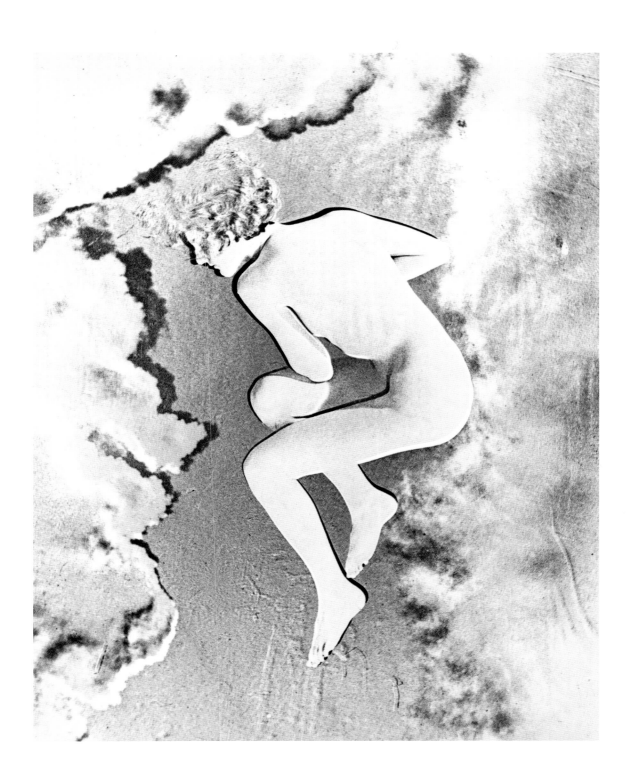

Nude (Lisette)
Paris, 1937

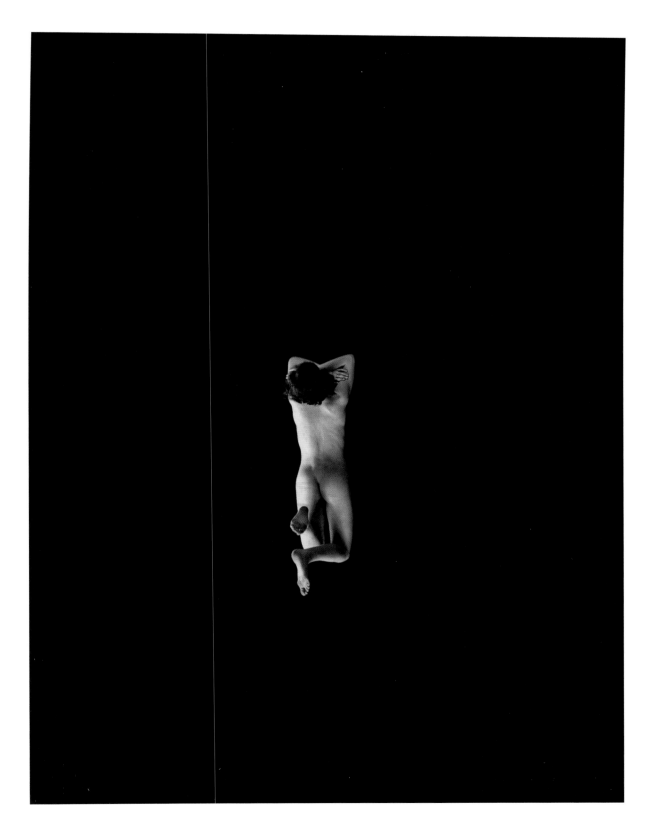

Nude (Lisette)
Paris, 1937

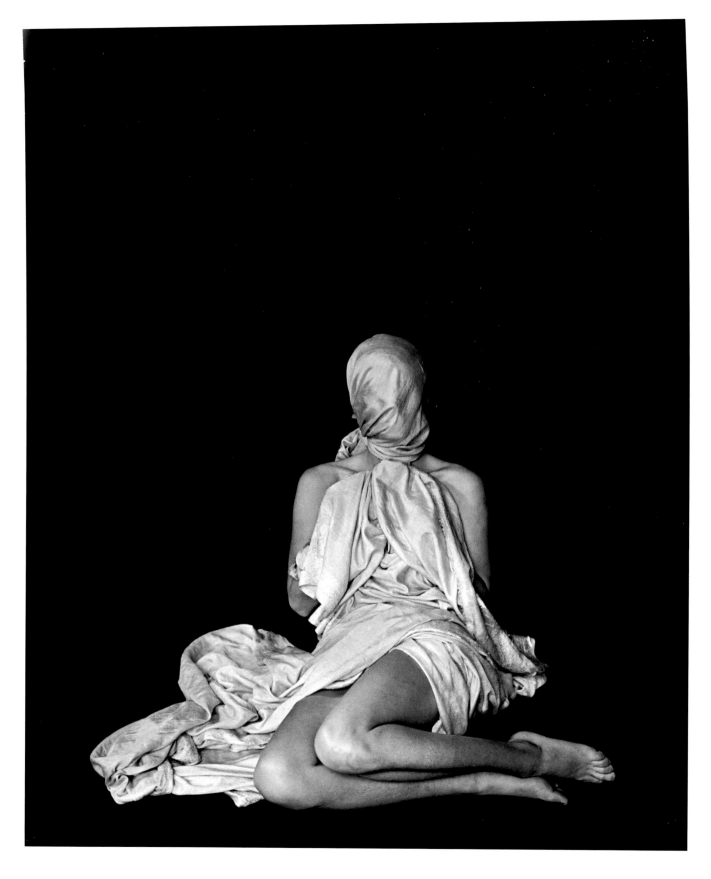

Margarete von Sivers
Paris, 1937

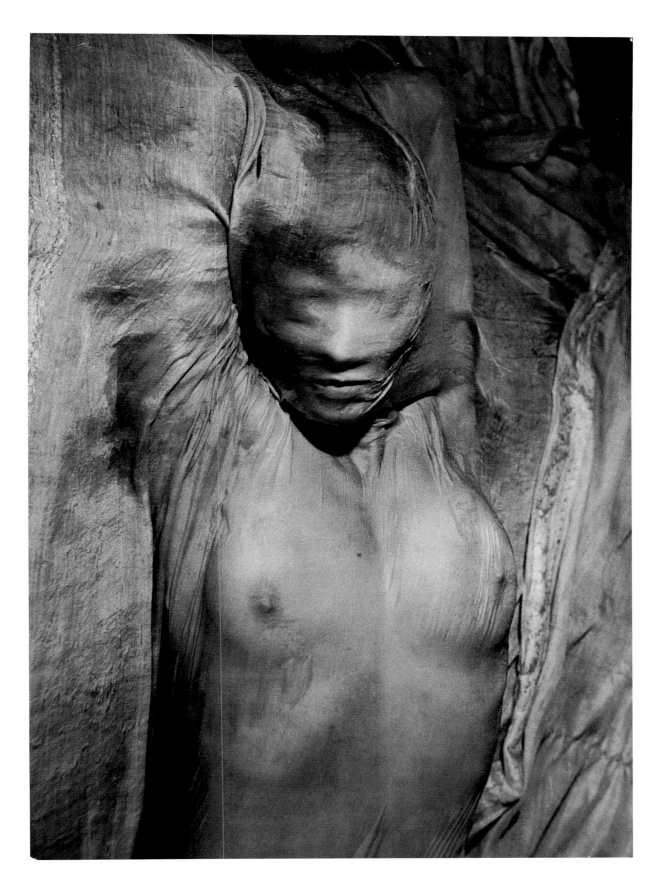

Nude Under Wet Silk
Paris, 1937

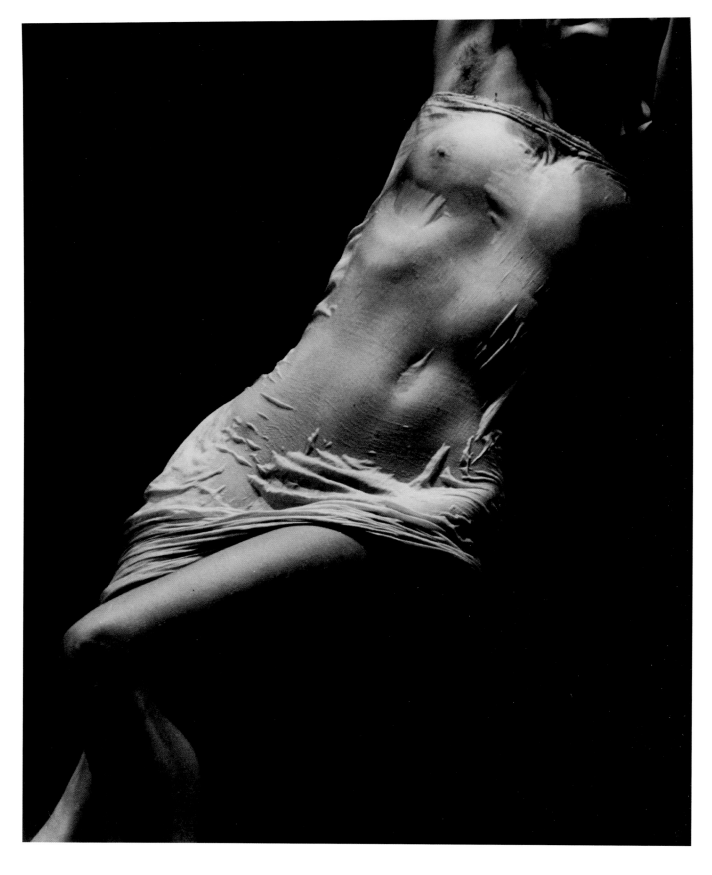

Nude Under Wet Silk
c.1937

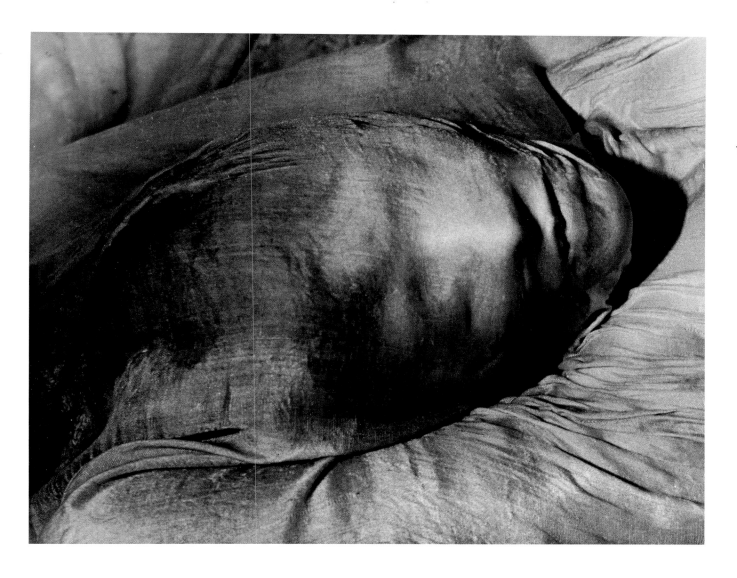

Nude Under Wet Silk
c.1937

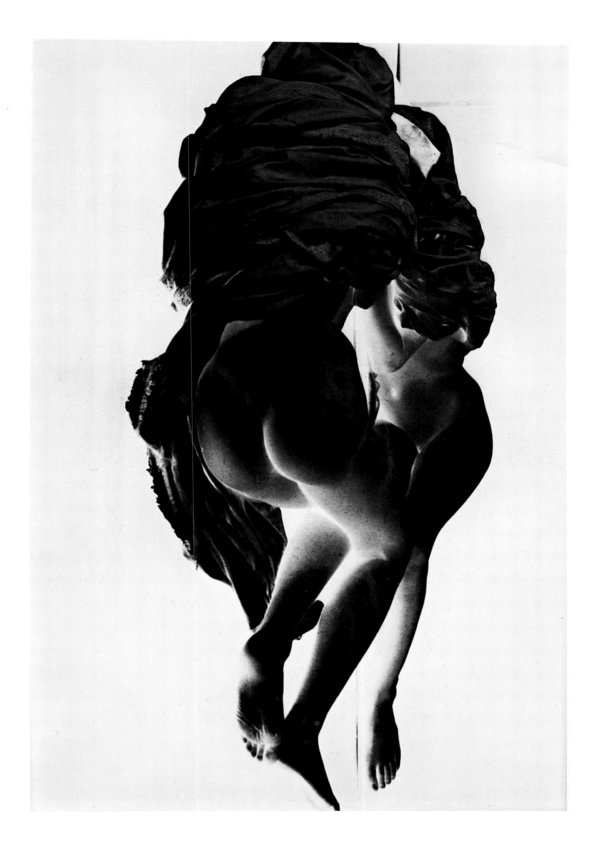

Nude
1936

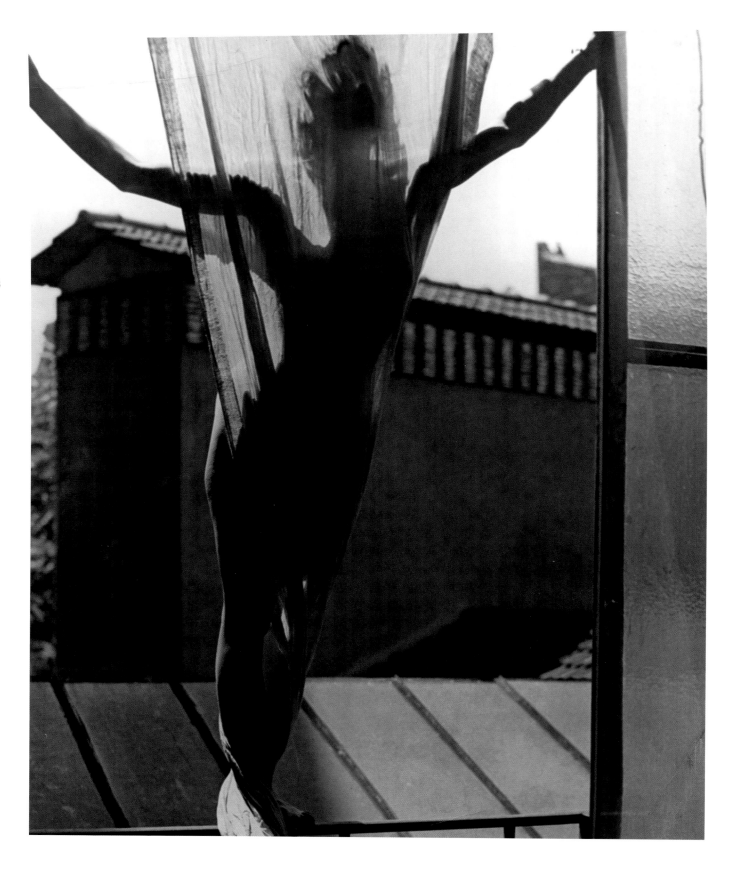

156

Marguerite von Sivers on the Roof of Blumenfeld's Studio at 9 Rue Delambre
Paris, 1937

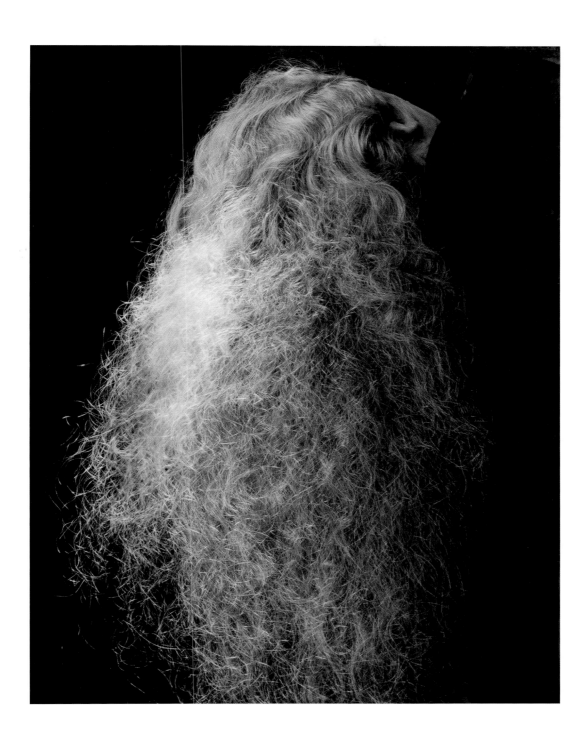

Hair
Paris, 1936

158

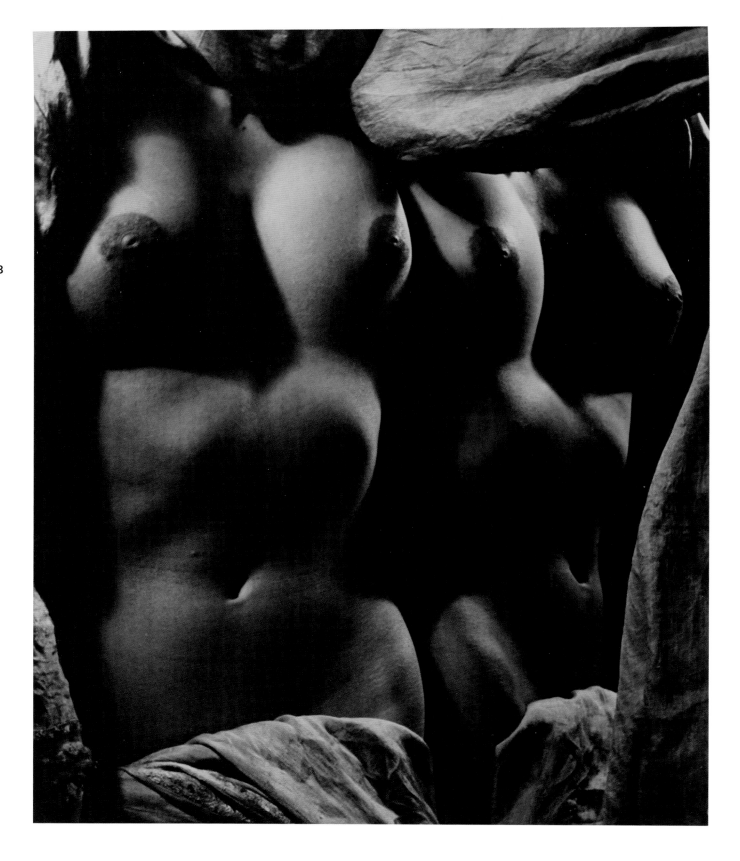

Nude
Paris, 1938

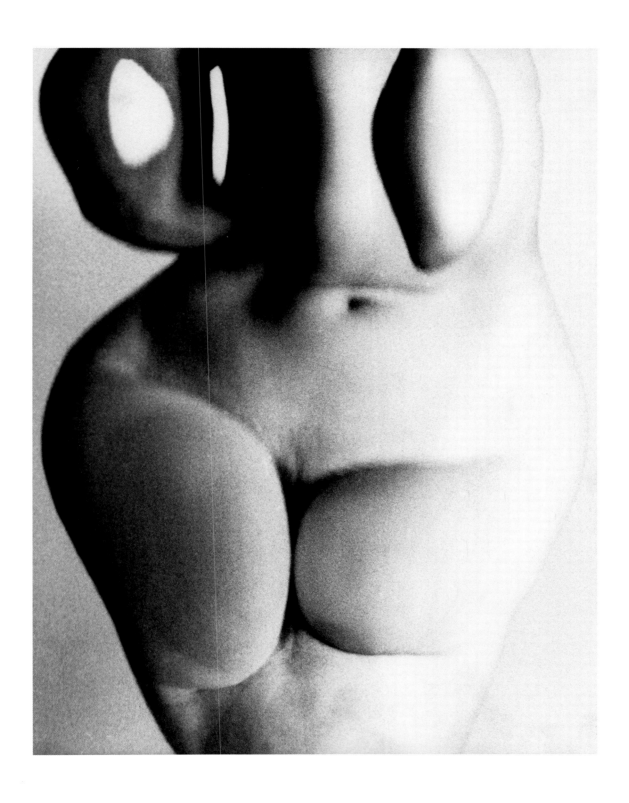

Distorted Nude
New York, 1940s

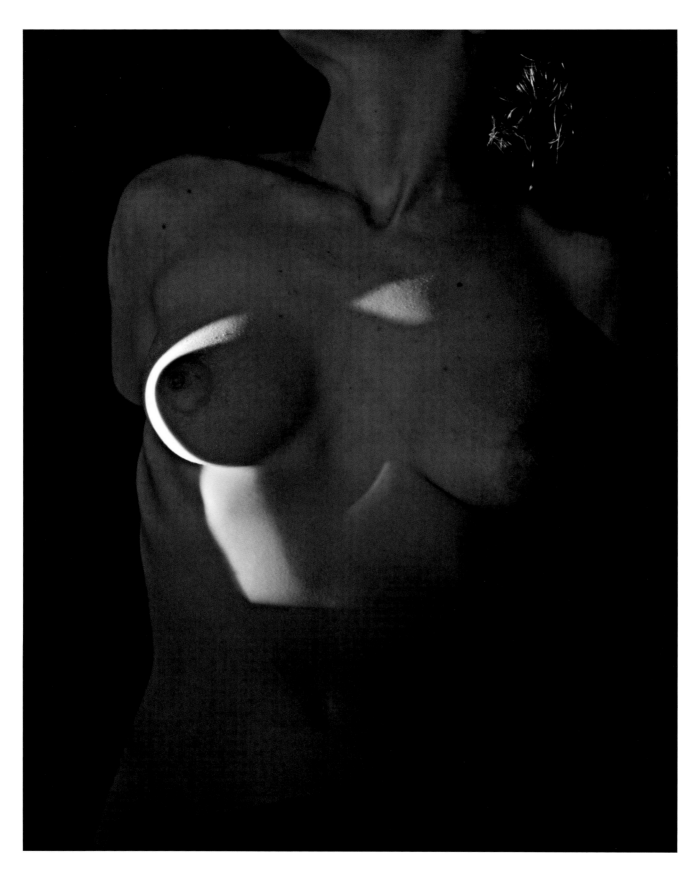

Low-Key Nude
Paris, 1937

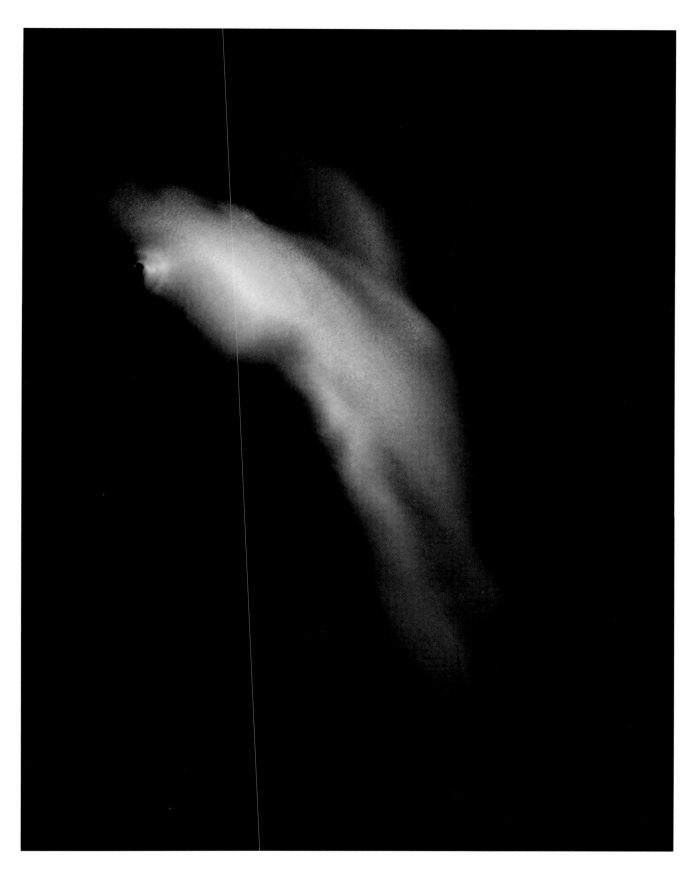

Torso
1940

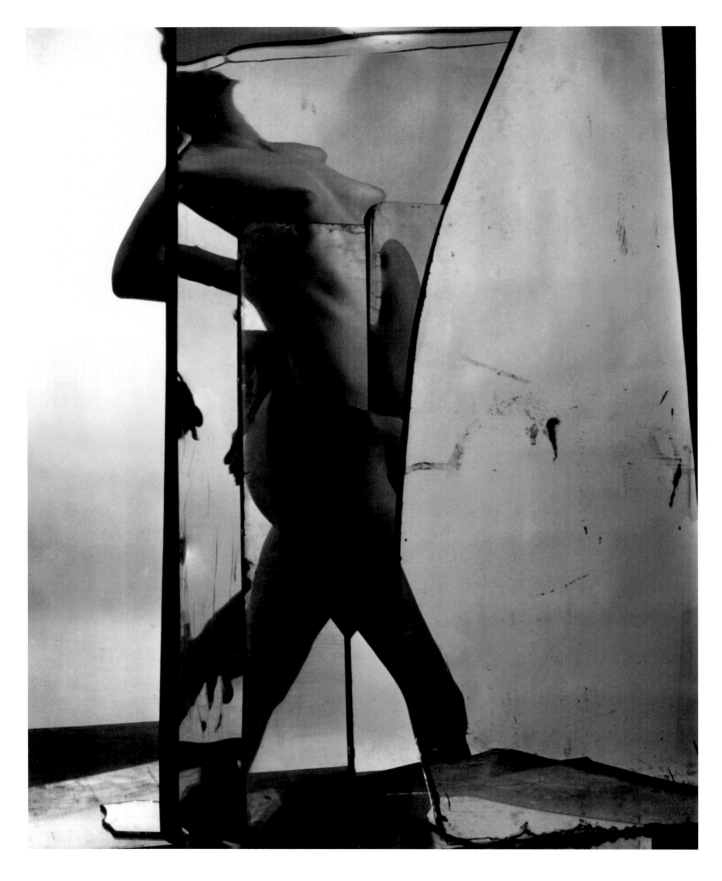

Broken Mirror Nude
New York, c.1947

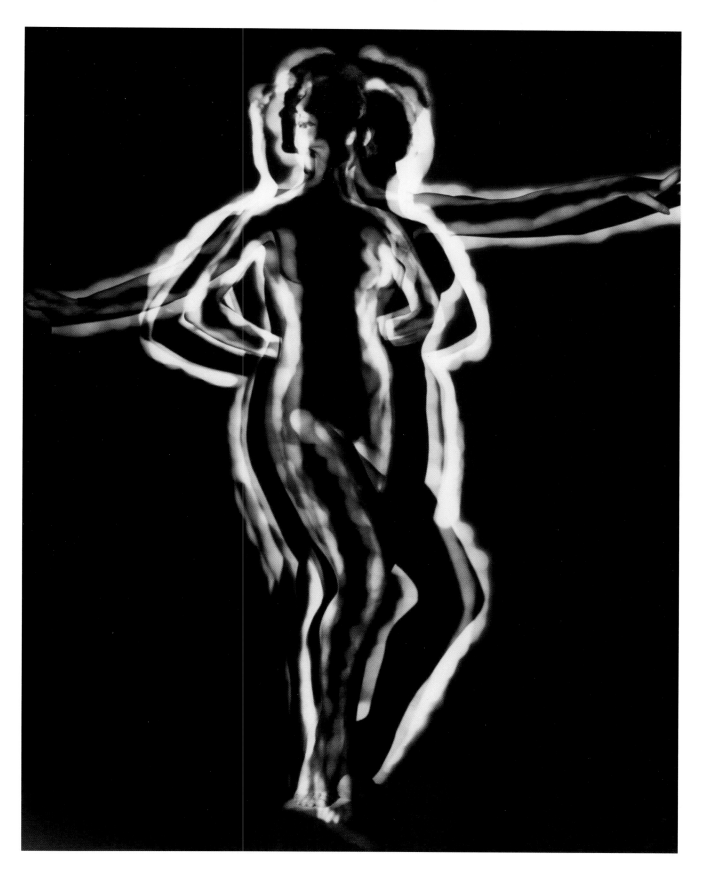

Nude
c.1949

164

Nude
Paris, late 1930s

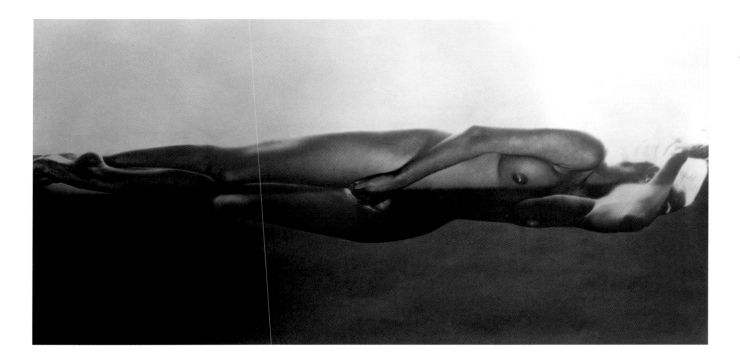

Resting Nude
New York, 1949

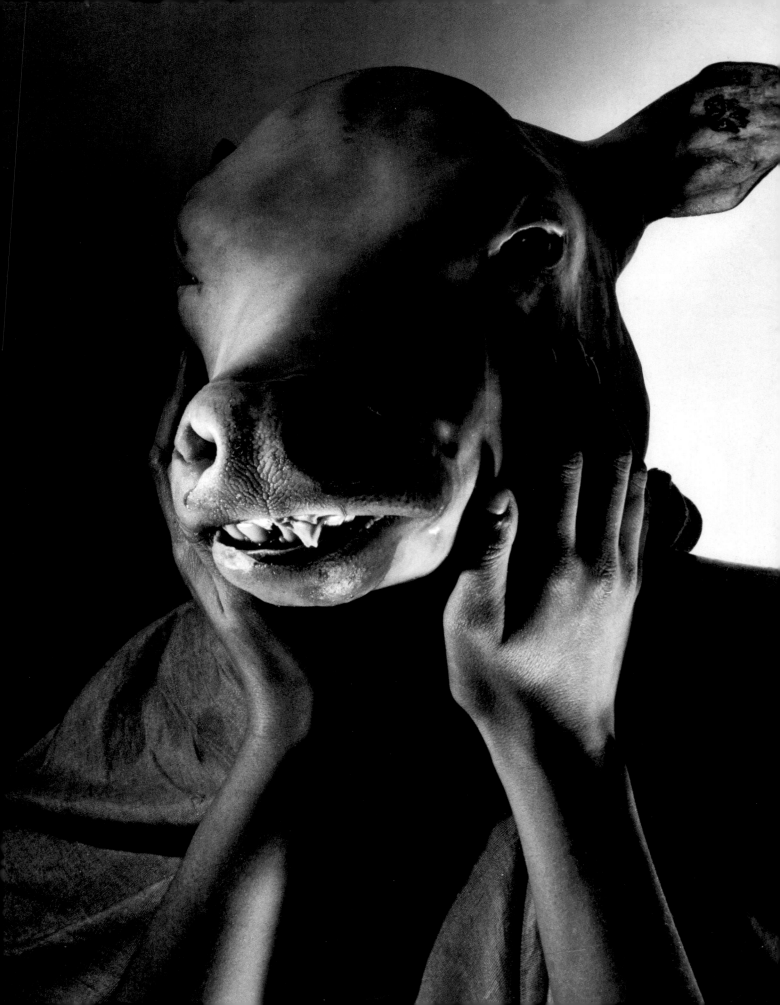

Rearranging the Dictator's Face: Erwin Blumenfeld's Last Political Photographs

Wolfgang Brückle

Erwin Blumenfeld
The Dictator
c.1937

Adolf Hitler's face was a source of fascination for his contemporaries, much described and discussed by his admirers and opponents alike. It is hardly surprising that no consensus emerged over the meaning of his appearance, given the grave threat that many soon recognised he posed to Europe and the blind faith that many others placed in his ability to save Germany. Some pointed to his considerable charisma, particularly the power of his gaze: even a sceptical commentator such as William L. Shirer noted its impact, appreciating as he did Hitler's refusal to adopt theatrical poses. Others heaped scorn on his drearily banal features. The Führer's first significant biographer claimed that he displayed "a pedantic striving after the bourgeois normal face"; perhaps as a result of these efforts, George Orwell was forced to admit in 1940 that Hitler's "pathetic, dog-like face" meant that there was "something deeply appealing about him".[1] There are plenty of other similar examples. Most such accounts are by eyewitnesses, but Hitler's cult of leadership and the Nazi propaganda machine also ensured that his face was omnipresent in public life. As a result, many artists who set out to attack the Nazi movement and regime made Hitler's face the focus of their work. Erwin Blumenfeld was one of them. His early Dada collages already reflect his disdain for the German petty bourgeoisie in general and for the right-wing camp in particular. One of his collages included a swastika as early as 1920. It seems that Blumenfeld also scorned the bourgeois society he came across in Holland.[2] Yet it was his native country that he continued to comment upon in his critical artistic practice. His works on paper reflected the wrong-headedness of German racial politics, military ideology and the habits displayed by leading power-mad politicians in their self-representation.[3] Hence, it is hardly surprising that

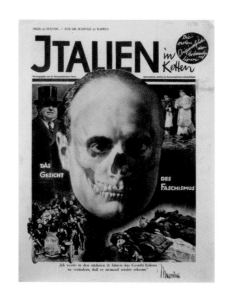

John Heartfield
Das Gesicht des Faschismus,
cover for *Italien in Ketten*
Kommunistische Partei
Deutschlands (ed.)
Berlin, Vereinigung
internationaler
Verlagsanstalten
1928

when Blumenfeld started his artistic encounter with darkroom photography in a room above his leather goods shop in Amsterdam, Hitler's face was one of the subjects he explored at length. Yet this was apparently, at least to begin with, simply the point of departure for photographic experiments, with no ulterior motive. There is no evidence that Blumenfeld's choice of subject was inspired at this point by any intention to make the resulting work public in any form.

Blumenfeld produced several portraits of Hitler from around 1933.[4] He had found a human skeleton intended for anatomical studies belonging to Carel van Lier, who owned the gallery he worked with, and had used it for a double-exposure portrait of the owner, who resembles an X-ray or a ghostly apparition in the picture (p. 100). However, Blumenfeld did not leave it at that. Other double exposures brought together a woman's head – maybe that of Oty Reijne-Lebeau, who sat for a portrait for him at around the same time – and the skull from the skeleton to make a hideously grimacing face (p. 182). Blumenfeld carried out other similar experiments with other heads. They invite comparison with traditional vanitas iconography, especially if we consider the cult of beauty emerging in his early portraits of women. This link is most obvious in, but not limited to, two photographs probably dating from around the same time, in which the skull, held in two hands, hovers above an hourglass. However, Blumenfeld's semantic field expanded when he thought of combining the skull with Hitler's face. The message of this arrangement is clear: Hitler deals in death, and he deserves death. This idea was certainly not exclusive to Blumenfeld alone. John Heartfield had depicted Benito Mussolini in a very similar way in 1928.[5] Yet there is no evidence that Blumenfeld was familiar

with this montage when he started experimenting with Hitler's face, taking as his model a page from an as yet unidentified Nazi propaganda book or magazine.[6] He is known to have created at least three such pictures, differentiated by how tightly framed they are and the presence in one instance of a swastika painted on Hitler's head (p. 175 and 176). In yet another attack on the Führer, who represented everything Blumenfeld loathed about his native Germany, the artist painted blood in his eyes and dripping from his mouth, turning him into a kind of zombie or vampire (p. 177). These works were not just targeted at Hitler as an individual, of course: for Blumenfeld's contemporaries, metonymic associations of individual faces, on the one hand, and the metaphorical face of the nation or race, on the other, came naturally, and the faith in Hitler as Germany's saviour further encouraged the metaphorical connection between this particular person and the people at large. Blumenfeld used this association in at least two more depictions of Hitler's and the death's head. What is particularly interesting, however, is how Blumenfeld further explored the semantic playground that makes the face a vehicle for various semiotic, and indeed literal, inscriptions. Leaving traditional iconography behind, he placed a swastika on the forehead of his self-portrait and let the eyes dribble so that it seems to the viewer as if blood were streaming from them (p. 79). On this picture, he wrote that he was thinking of concentration camps, and sent it to van Lier. The face was now "marked". By careful chemical manipulation of the photographic paper, he also blurred the facial features, making them seem as if they were masked by a kind of mourning veil.

Blumenfeld's portrait of Hitler with a swastika on his forehead, which he described in his own words

```
MASEREEL
    24. Actualité.                              Dessin
    25. Civilisation.                              »
    26. Marche funèbre.                            »
    27. Sur la terre.                              »
André MASSON
    28. Pas assez de terre.                     Dessin
    29. La nouvelle hostie.                        »
    30. Amateurs de cadavres.                      »
    31. Jamais rassasiés.                          »
MAYO
    32. Dessin.
    33.      »
    34.      »
    35.      »
PICASSO
    36. Peinture.
    37. Dessins.
    38. Tête.                                   Eau-forte
    39. Songe et Mensonge de Franco.
    40.  —        —
PRASSINOS
    41. La jeune fille qui rêve                 Peinture
Suzanne ROGER
    42. Les empalées.                           Peinture
ROUAULT
    43. Peinture.
VULLIAMY
    44. Les Alyscamps.                          Peinture

Léopold CHAUVEAU
    45. Iratok.                                 Bronzes
    46. Merloupe.                                  »
    47. Akrokis.                                   »
    48. Griminche.                                 »

BLUMENFELD
    49. Photos.
```

WER EIN VOLK RETTEN WILL
KANN NUR HEROISCH DENKEN

Page of the exhibition catalogue *L'Art Cruel*
Galerie Billiet-Vorms
Paris, 1937

Stamp booklet counterfeited in Switzerland to be sent to Germany, c.1942

as a *Grauenfresse*, or "face of horror", has come to worldwide fame as the *Hitlerfresse* although it appears the artist never used this title. It is hard to determine when the picture first came to the attention of a wider audience. Shirer briefly noted in a 1960 essay that the picture was shown in public in 1937, and he has it that it provoked an angry outburst by the German ambassador, upon which it was removed from the exhibition. However, there are no other sources to confirm this claim. From all we know, Blumenfeld's work was shown in only two exhibitions between his departure from Holland and his arrival in America. One of them took place in March 1936 at the Galerie Billiet in Paris, that is, well after the supposed date of the photograph in question. Yet while this exhibition is mentioned in passing in Blumenfeld's autobiography, he makes no reference there to any political difficulties in connection with it.[7] Another selection of Blumenfeld's works was shown as part of an exhibition organised by the same gallery in December 1937 featuring pictures representing the concept of "art cruel". This event has largely been overlooked in research on Blumenfeld's career, doubtless because his own role was largely marginal. A small leaflet gives the individual titles of almost all of the works on display while Blumenfeld's are laconically listed as "Photos". It is reported that one of his Hitler montages was among the exhibits.[8] This being said, there is no evidence that any of his works were removed from the show, let alone that the show was forced to close. There are known to have been official complaints from the German government in other cases, however, such as the Danish artist Marinus Jacob Kjeldgaard's photomontages for the Paris-based magazine *Marianne*.[9] Whatever the dubious origin of the anecdote, then, it is at least not entirely beyond the bounds of historical plausi-

bility. It must be said that Blumenfeld claimed a yet higher impact for his picture in his autobiography where he records that millions of copies were air-dropped over Germany in 1942. Again, no other source backs up his claim, and he may have made up the story.[10] However, it is equally possible that he misremembered the details of the actual use the image was eventually put to or that he had no accurate information about the activities of the American propaganda units, which actually do appear to have used his motif. Hundreds of thousands of stamps depicting Hitler's face as a death's head were poured into the Reich in 1942 and subsequent years. The little effigy is so similar to Blumenfeld's montage that it is tempting to see the former's model in the latter, and to read Blumenfeld's claim relating the distribution of the *Grauenfresse* in the light of this instance of "applied" art. It seems that the design was provided by Raymond A. Schuhl, who worked in Switzerland under the pseudonym Robert Salembier during the war.[11] Schuhl was French by birth and may have met Blumenfeld in Paris. Whatever the case, the connection between death and the face of a murderous dictator was an easy one to make, as the earlier Heartfield example shows.

Having moved to Paris, Blumenfeld seems to have turned to political iconography again in around 1937 when he produced a photograph now generally known under the title *The Dictator*. Plain and simple as Blumenfeld's political intention seems to be if assessed with this caption in mind, it, however, deserves more scrutiny. The photographer's Paris property was home to a partial plaster cast modelled on the Venus of Capua, which he used in several of his photographs, including a studio still life depicting the torso and the portrait of a woman leaning her cheek on the statue's bare shoulder against a dark

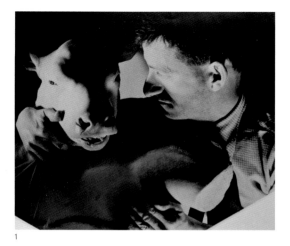

1

2

background.[12] The same cast is draped in a toga in three other images. Blumenfeld went to the butcher where he fetched a calf's head to replace the missing head. One of his photographs of this strange hybrid creature features two hands caressing the calf's cheeks in an affectionate gesture that seems strangely out of place. Another variant has Blumenfeld hugging the torso and grasping its breast. A third variant depicts only the forbidding monster (p. 178) in which the masculine and feminine, beauty and horror, and, to a certain extent, the Apollonian and the Dionysian collide in one compelling visual paradox. Blumenfeld managed to have this shot featured in two Paris magazines simultaneously, and it is worth noting how different titles and contexts were used to trigger different interpretative readings. *Paris Magazine*, on the one hand, chose to call the picture *Surréalisme* and to show it in splendid isolation, unless the adjacent illustrations accompanying an essay on the French Foreign Legion were placed there deliberately. *L'Amour de l'Art*, in contrast, published the image as one in a series of several Blumenfeld photographs, using *Le Minotaure* as a title. The editors thus deliberately set out to create a connection between this work and the aforementioned photograph of the sculpture's torso with the woman's head, which was printed on the facing page. This work was given the title *L'Âme du Torse* [*The Torso's Soul*]. It is safe to assume that the author of the accompanying article was consulted in the process as he argues in his text that the torso represents "the despair of a maimed work of human creativity" and the lament of its inconsolable soul against the man who forged it only to murder it thereafter. In the face of this flight of lyrical fancy, it almost comes as a surprise that the same author hopes the Minotaur will not become "the symbol of our barbarism and

brutality".[13] Whether this alludes to the human condition in general or to daily politics is not clear. Be this as it may, it must not be overlooked that the Minotaur was a popular motif and theme in French art in the 1930s. In Surrealist circles, it virtually came to assume emblematic status. Georges Bataille, Michel Leiris and other intellectuals made the motif of the bull a screen onto which they projected their aesthetic imagination and cultural theory in the course of their debates on the role of lust and violence. What is more, the Minotaur's hybrid nature – half man, half bull – linked the creature to the world of dreams. A text by Michel Leiris, published to mark a Paris exhibition "Espagne 1934-1936" which covered André Masson's recent travel experiences, refers to bullfighting as quasi-mythical "hostile gravitation of man and beast, murder and merger at one and the same time".[14] This merger is taken to its logical extreme in the Minotaur, who even lent his name to a Parisian avant-garde art journal in the early 1930s. René Magritte designed a cover for the only 1937 issue of the magazine, draping the monster in a toga in very similar vein to Blumenfeld's imagery. There is room to think that Blumenfeld took his inspiration from Magritte, though it is equally possible that Magritte was at the receiving end. It is also possible that the photographer, who had been invited to contribute to another magazine produced by the same publisher, created his own version of the Minotaur in the hope that it would likewise be used for a magazine cover.[15] This, of course, cannot be anything more than a hypothesis. However, it does seem extremely likely that Blumenfeld's image owes much to the Surrealists' interest in imbuing the Minotaur myth with new meaning for the modern world. It would appear that there is no other way of explaining the erotically charged dialogue in which, on one of

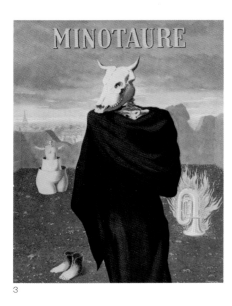

3

1
Erwin Blumenfeld
Self-portrait with Minotaur
c.1937

2
Double-page of the magazine
L'Amour de l'art
1937
vol. 29, No. 5, p. 206-207

3
René Magritte
Cover for *Minotaure*
1937
No. 10

his pictures, the Minotaur and a self-portrait of the artist engage.

So is the *Minotaure* an instance of political iconography or not? I mentioned the alleged clash at the Galerie Billiet earlier in this essay. However, the gist of the matter is even less clear than it may have seemed there. Not only was Blumenfeld's Minotaur picture published with the title *The Dictator* in 1946; it was also hinted in the caption that the picture was displayed in a 1937 show and removed at the insistence of the German ambassador.[16] Unfortunately, there is again nothing in the way of evidence to back up the claim. It is likely that Blumenfeld himself was the source for both the title and the anecdote in this instance. He may have recounted the same story on censorship about various photographs, either because he could not recall the precise details of the event or because it was a pure invention in which accuracy counted for little anyway. If the anecdote is true and actually refers to the later of the two works, it must be presumed that this picture was already displayed with the title *Le Dictateur* when the German embassy stepped in. Even if that were the case, however, the reference to Hitler would not have been sufficiently obvious to spare the ambassador's complaint an unwelcome air of self-accusation. Anyway, it is not beyond the realms of belief that Blumenfeld's intention was political at the time he produced his Minotaur images, one of which seems to have been included in the "L'Art cruel" show in 1937 alongside the Hitler portrait. There was not even any need for explicit political references in their titles. A flexible approach to the chain of signifiers was typical of artistic practice amongst the Surrealists. When, towards the end of the war, Pablo Picasso was asked if his 1938 depiction of a bull's head symbolised Fascism, he answered in the negative, insisting that his intention was to stimulate more general thoughts about "brutality and darkness". At the same time, however, he did not shy away from using bulls in pictures that were deeply, and straightforwardly, political in intent. Masson's art likewise returned to the subject of Spain, where civil war was now raging, after the aforementioned exhibition: a series of drawings from 1936 focuses on the Minotaur in order to embody the pitiless cruelty of Franco and the Catholic church. The drawings were initially not accepted for publication anywhere, being deemed "too horrible". More significant yet is a 1941 or 1942 painting by Francis Picabia entitled *L'Adoration du veau* [*The Adoration of the Calf*], which depicts a frenetic crowd worshipping a calf's head.[17] The picture's political message is as unambiguous as the influence of Blumenfeld's *Minotaure*. This is further evidence that Blumenfeld's work was read in political terms and that the standard interpretation can be retained, though not without taking into account the wider backdrop of Surrealist cultural theory. It is often argued that Blumenfeld's monster is intended to represent Hitler. If he did intend the work to be read in political terms, he almost certainly hoped for it to allow for ruminations about Mussolini and, more importantly, about Franco no less than about the situation in Germany, providing as he did an allegory of the general nature of tyranny.

1. See Konrad Heiden, *Hitler: A Biography*, New York, 1936, p. 306; William L. Shirer, *Berlin Diary. The Journal of a Foreign Correspondent, 1934-1941*, New York, 1941, pp. 16 ff. George Orwell, "Review of Mein Kampf, by Adolf Hitler, unabridged translation" [1940], in: George Orwell, *The Complete Works, Vol. 12. A Patriot After All, 1940-1941*, ed. Peter Davison, London, Secker & Warburg, 1998, p. 117. For a fascinating study of the impact of Hitler's appearance, see Claudia Schmölders, *Hitler's Face. The Biography of an Image*, Philadelphia, University of Pennsyvania Press, 2009, pp. 69 ff.

2. See Wim Van Sinderen, "A Rowdy Preamble: Erwin Blumenfeld, His Dutch Years 1918-1936", in *Erwin Blumenfeld, His Dutch Years 1918-1936*, ed. Wim van Sinderen, The Hague, Fotomuseum Den Haag, Rotterdam, Veenman Publishers, 2006, pp. 26 ff.

3. See Helen Adkins, *Erwin Blumenfeld: I was Nothing But a Berliner: Dada Montages 1916-1933*, Ostfildern, Hatje Cantz Verlag, 2008, pp. 98 ff. (For the aforementioned work, see this catalogue p. 52).

4. The caption in *Blumenfeld. My One Hundred Best Photos*, New York, Rizzoli, 1981, p. 37, gives the year as 1932. However, Hendel Teicher's introduction refers to 1933 on p. 22, probably basing this information on Erwin Blumenfeld, *Eye to I. The Autobiography of a Photographer*, London, Thames and Hudson, 1999, p. 251. Almost all subsequent references have given the later of the two dates.

5. See *John Heartfield Dokumentation*, ed. Arbeitsgruppe Heartfield, Berlin 1969, p. 20. See also p. 64 for an iconographically related work from 1933 that refers to Hitler.

6. See Adkins (cf. note 3), p. 156, for an illustration of one page from Blumenfeld's own picture atlas. The portrait of Hitler stuck on this page is surrounded by writing, which leads Adkins to draw a rather implausible parallel on p. 155 with Albrecht Dürer's self-portrait of 1500.

7. See William L. Shirer, "Hitler's Last Days. Defeat, Despair, Madness, and Death", in *Look*, 10 May 1960, pp. 81–89, p. 83, and Blumenfeld (cf. note 4), p. 251 f. William A. Ewing, *Blumenfeld 1897-1969. A Fetish for Beauty*, London, Thames and Hudson, 1996, p. 84 and p. 250. note 13, suggests that the incident could have taken place at Blumenfeld's exhibition at the Galerie Billiet. However, Blumenfeld himself pointed out that the exhibition was "an immediate success" in an article that predates his autobiography: see Erwin Blumenfeld, "I Was an Amateur. Blumenfeld as Told to Mildred Stagg", in *Popular Photography* 43.3 (1958), p. 88. Ewing grants the alternative possibility that the work might have been shown in a group exhibition in Paris in 1937 and briefly mentions "L'Art Cruel", yet without exploring the possibility any further.

8. On the exhibition's conceptual focus, see François Moulignat, "L'Art cruel", in *Cahiers du Musée national d'art moderne* 9 (1982), pp. 50-59. For the photographs Blumenfeld reportedly contributed, see p. 52, p. 55, and p. 57, albeit without source references. Mouglinat based his information on conversations with the gallerist Pierre Vorms, who organised the 1937 show (private communication, 6 May 2013).

9. Gunner Byskov, "Marinus, der vergessene Fotomonteur 1880-1964. Spurensuche in Dänemark und Paris", in *Marinus Heartfield. Politische Fotomontagen der 1930er Jahre*, eds. Gunner Byskov and Bodo von Dewitz, Cologne, Museum Ludwig, Göttingen, Steidl, 2008, pp. 20-42 and pp. 226-227, p. 33. Kjeldgaard's later work for *Marianne* included a 1940 montage seguing Hitler's face into a death's head, doubtless inspired by Blumenfeld: see *ibid.*, p. 136. As early as 1934, the German ambassador in Prague complained about several caricatures on display at the Kunstsalon Mánes, prompting their removal. An exhibition held in Paris in 1938 with the title "Cinq ans de dictature hitlérienne" also ran into difficulties with the authorities, again under pressure from the German ambassador. See Gilbert Badia, "Heurs et malheurs d'une exposition sur le IIIᵉ Reich", in *Les bannis de Hitler. Accueil et luttes des exilés allemands en France, 1933-1939*, Paris, Éditions de l'Atelier, 1984, pp. 261-286, 268 ff. On press reactions to the Prague controversy, see *John Heartfield Dokumentation* (cf. note 5), pp. 78 ff.

10. Erwin Blumenfeld (cf. note 4), p. 285. Kjeldgaard also reported that several of his photomontages were used by French propagandists. A leaflet with one of his pictures was indeed produced, although it is not known how it was used, if at all. See Byskov (cf. note 9), pp. 34 ff., and catalogue 28, p. 113.

11. See Jean-Robert Bruce, "La guerre des imprimés", in *Revue de la pensée française* 8.3 (1949), p. 82, which has a hitherto overlooked confirmation of Schuhl's role, and Jan Kindler, "Hitler Skull Issues of World War II", in *The Cinderella Philatelist* 3.2 (1963), p. 31. There was also a variant showing Hitler in profile with the words "Futsches Reich" [Ruined Reich] instead of the customary "Deutsches Reich" [German Reich]. Claudia Schmölders, "'Hitlerfresse'". Die visuelle Demontage des Hitler-Mythos", in *Das Jahrhundert der Bilder*, ed. Gerhard Paul, Vol. 1, Göttingen, Vandenhoeck & Ruprecht, 2009, p. 439, gives what must be an erroneous date of 1937 for stamps showing Hitler as a death's head. Actually, this was only the date of the stamp used as a model for the propaganda stamp.

12. A second version of the same arrangement, which must date from the same time, is included in Edouard Jaguer's *Les Mystères de la chambre noire. Le Surréalisme et la photographie*, Paris, Flammarion, 1982, p. 97 and p. 99. He dates the work to 1936.

13. Michel Florisoone, "Le mystère de la réalité redécouvert par la photographie", in *L'Amour de l'art* 19 (1938), p. 207. Erwin Blumenfeld is credited as the sole author of this essay on his work, though only the second part of the text is his. The work referred to as *L'Ame du torse* was reprinted in Anon., "Speaking of

Pictures... Blumenfeld's are the Tops", in *Life* 7.1 (1939), pp. 5–6, with the title *Manina* given on page 6. The Minotaur features with the title *Surréalisme* in *Paris Magazine* 82 (1938), p. 260. In *Photographie ouverte* no. 118 (2001), n. p., the title *Le Dictateur* is attributed to Blumenfeld's picture of the calf head carressed by two hands. The editor of the journal informed me that "Le dictateur-philosopher" is written on the verso of the print he reproduced (private communication from Xavier Caronne, 26 July 2013).

14. See Michel Leiris, "Espagne 1934–1936. Exposition André Masson à la Galerie Simon", in *La Nouvelle revue française* 25 (1937), p. 135. The invitation card featured a bull's head on a spike. Masson's early fascination with the Minotaur is recorded in Jean-Paul Clébert, *Mythologie d'André Masson*, Geneva 1971, pp. 37 f. Christa Lichtenstern, *Metamorphose. Vom Mythos zum Prozeßdenken, Ovid-Rezeption, surrealistische Ästhetik, Verwandlungsthematik der Nachkriegskunst*, Weinheim, VCH Acta humaniora, 1992, pp. 141 ff., has a detailed discussion on the significance of the Minotaur theme for the Surrealists.

15. Ewing (cf. note 7), p. 83, refers to Blumenfeld's contacts with the publisher E. Tériade. Blumenfeld provided him with images for *Verve*, see Blumenfeld (cf. note 4), p. 264. Blumenfeld also records on p. 250 that he read *Minotaure* while he was still living in Holland. Hendel Teicher, "Chairs nocturnes, délices photographiques", in *Regards sur Minotaure. La revue à tête de bête*, exhibition catalogue, Geneva, Musée d'art et d'histoire, 1987, pp. 201-219, esp. pp. 202 f., underlines the importance of photography in what was a lavishly produced magazine. On pp. 11-15, the same catalogue includes several rejected cover designs by various artists associated with the magazine.

16. Anon., "Great American Photographers 2. Erwin Blumenfeld", in *Pageant* 3.9 (1947), pp. 106-121, p. 115, with a reproduction of the photograph on p. 114, without the title *Minotaure*. There is no mention of where the exhibition is supposed to have taken place, but it was certainly Paris the author had in mind. Henry and Yorick Blumenfeld recall their father telling them about Nazi sympathisers disrupting the opening in 1936, leading to the immediate closure of the exhibition. They presume that the cause of the disturbance was *The Dictator* (private communication from Yorick Blumenfeld, 22 March 2013). This would mean that the work dates from immediately after Blumenfeld's arrival in Paris and before he became acquainted with Tériade.

17. See Véronique Bouruet-Aubertot, "Le Minotaure ou Le Dictateur d'Erwin Blumenfeld", in *Connaissance des arts Photo* 21 (2009), pp. 106 ff. On Masson's 1936 drawings, see Robin Adèle Greeley, *Surrealism and the Spanish Civil War*, New Haven and London, Yale University Press, 2006, pp. 134 ff., André Masson, *Entretiens avec Georges Charbonnier*, Paris: René Julliard, 1958, pp. 176 ff., and Clébert (cf. note 14), p. 57. On Picasso's exegesis of his own works, see Jerome Seckler, "Picasso Explains," in *The New Masses* 54.11 (1945), p. 5. See also Wolfgang Brückle, "Tiervergleich", in *Handbuch der politischen Ikonographie*, eds. Uwe Fleckner, Martin Warnke, Hendrik Ziegler, vol. 2, Munich, C.H. Beck, 2011, pp. 430-439, p. 436.

The Dictator

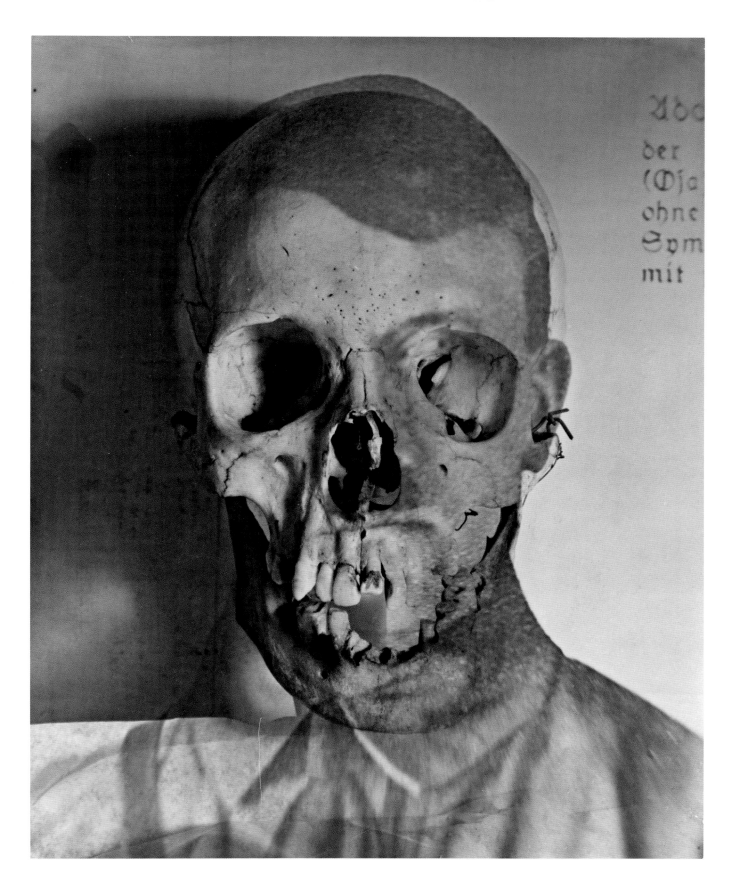

Hitler, Grauenfresse [Hitler, Face of Terror]
1933

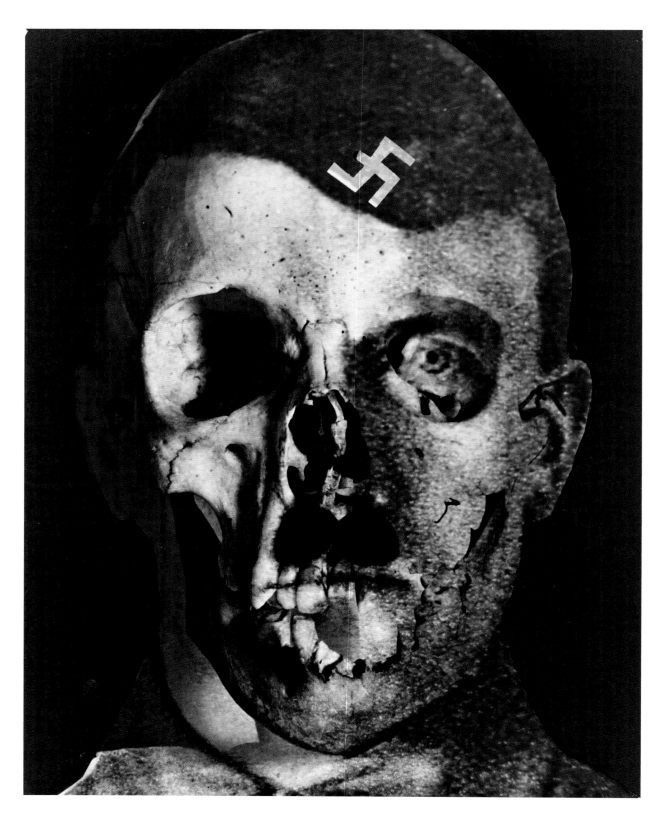

Hitler, Grauenfresse [Hitler, Face of Terror]
Holland, 1933

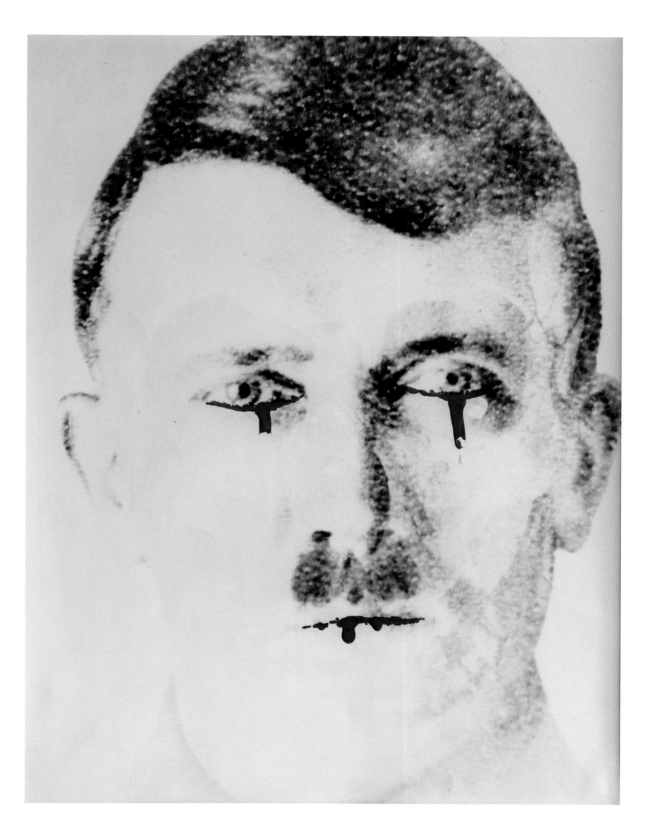

Hitler with Bleeding Eyes
Holland, c.1933

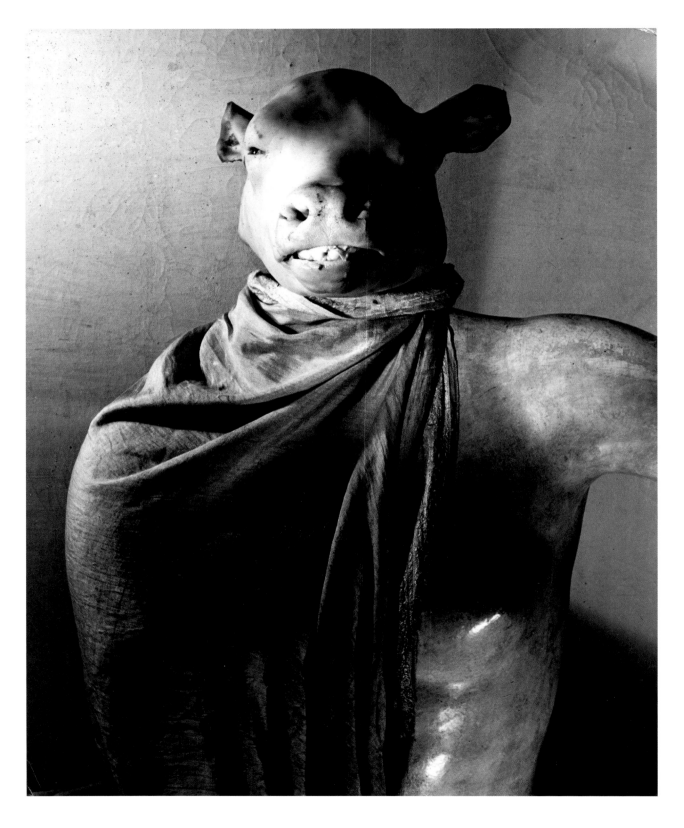

The Minotaur or the Dictator
Paris, c.1937

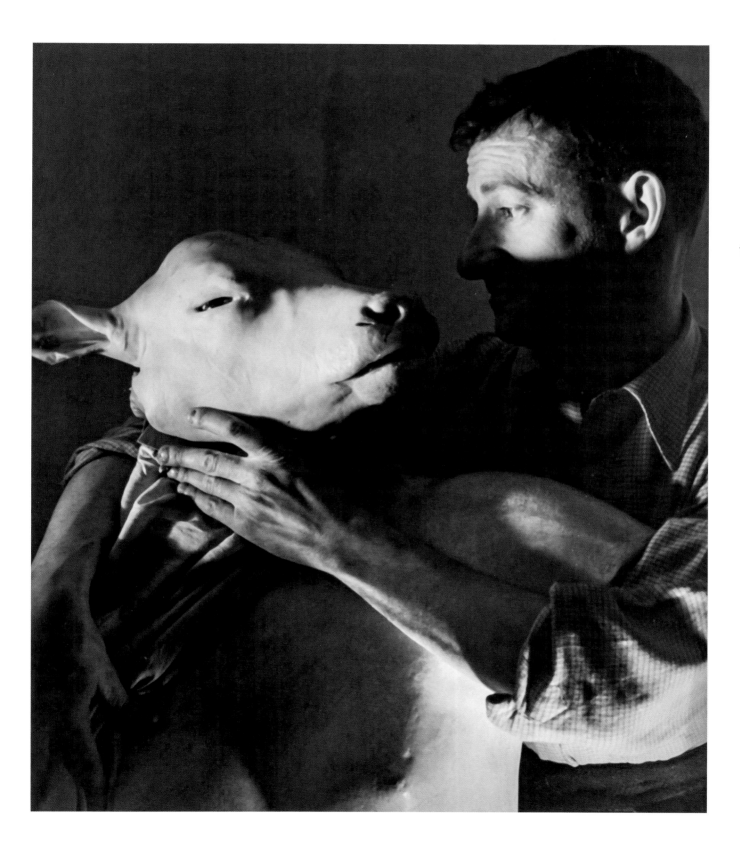

Self-Portrait with Calf´s Head
Paris, 1937

Masks

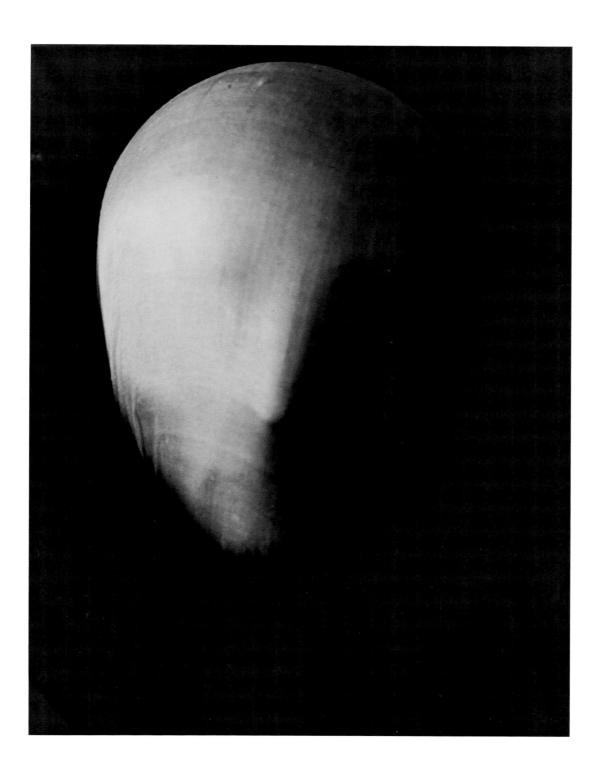

Covered Face
Amsterdam, c.1932

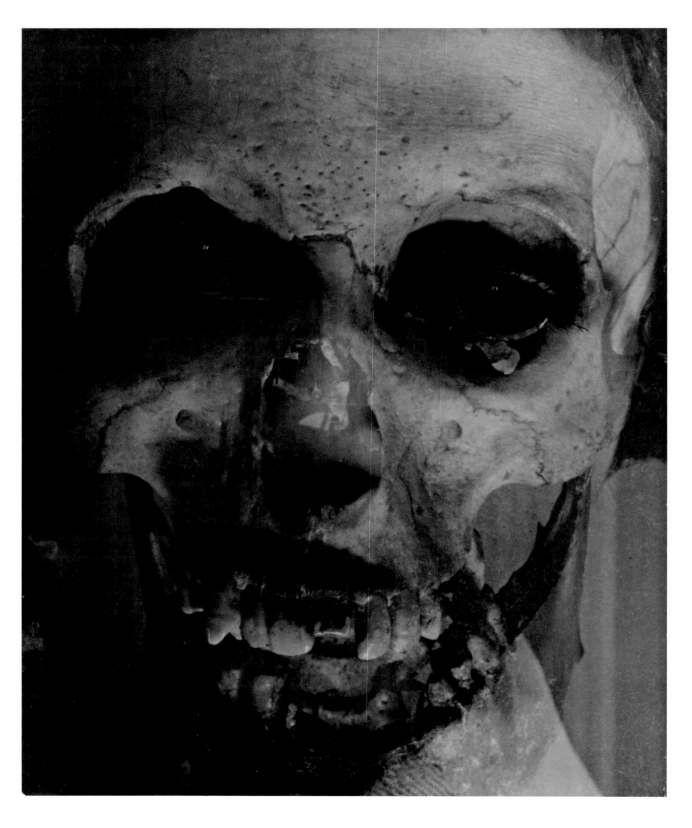

Superimposed Portrait
1932-33

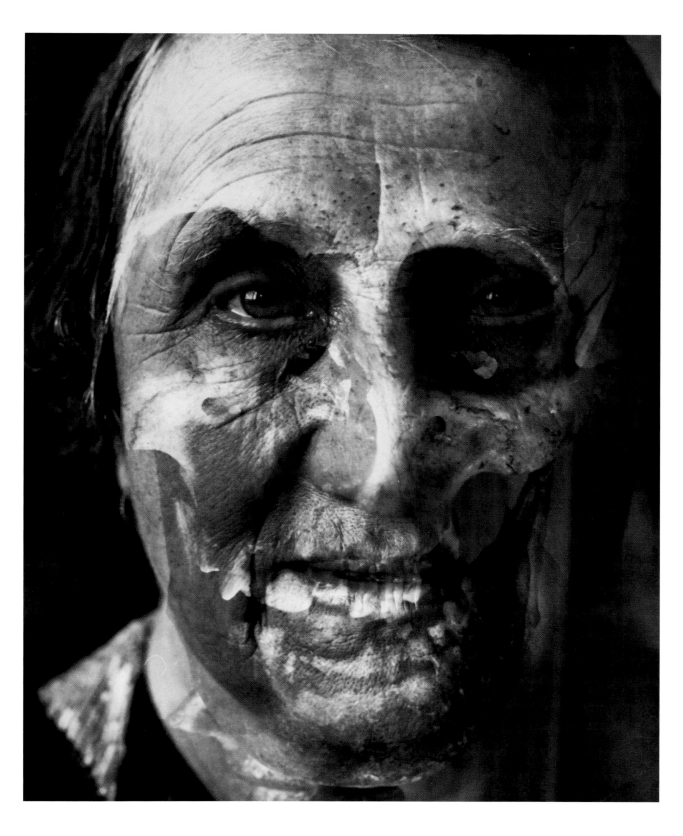

Superimposed Portrait
Amsterdam, c.1933

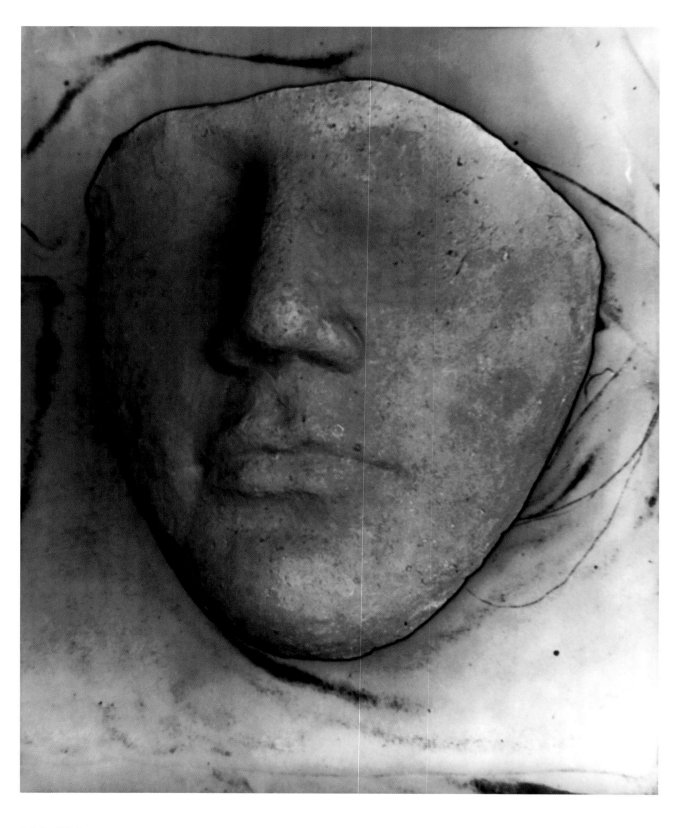

Solarized Mask
Paris, 1938

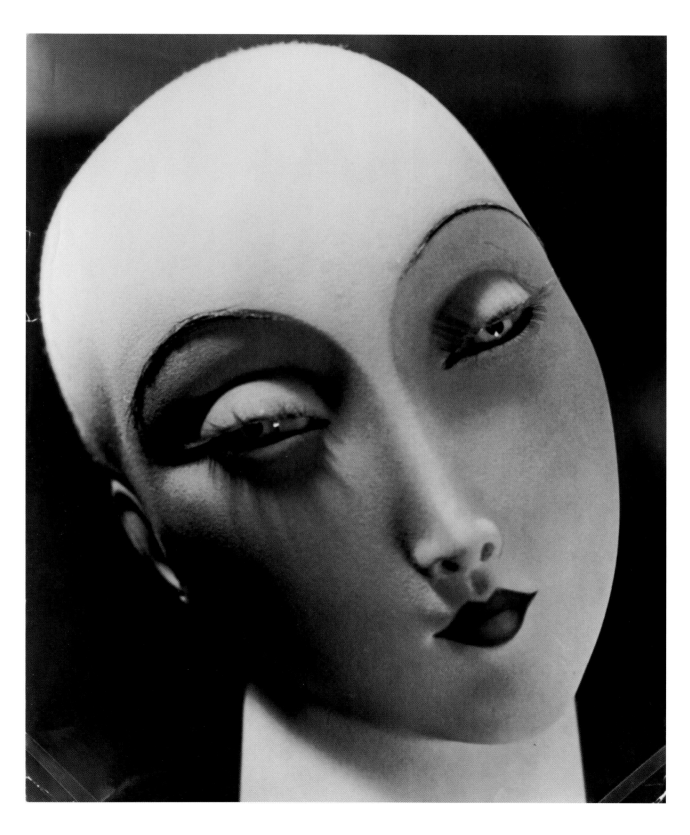

Mannequin
Amsterdam, 1932

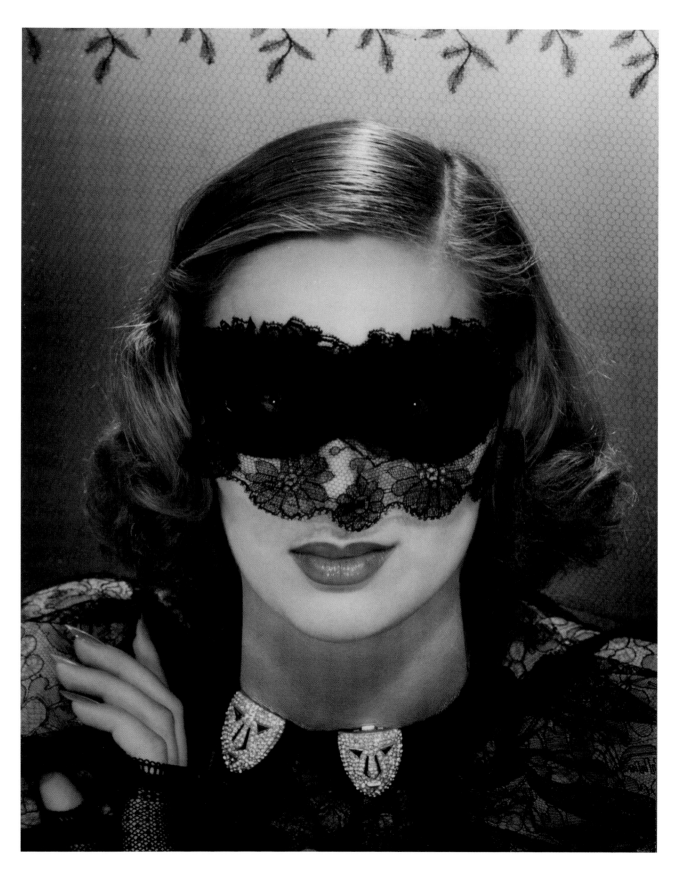

Fashion Shot for Vogue
Paris, 1937-39

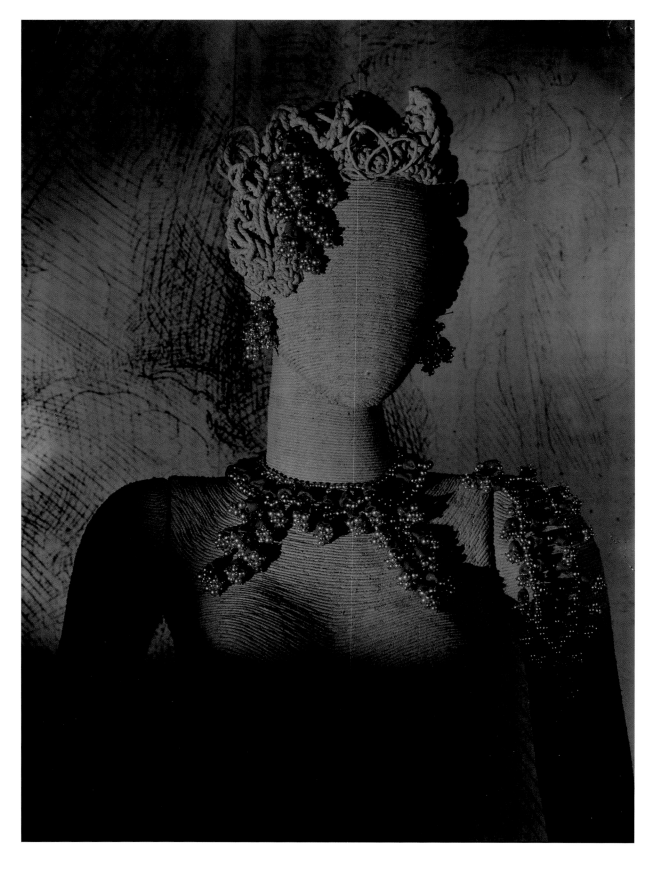

Jewels
Paris, 1936-39

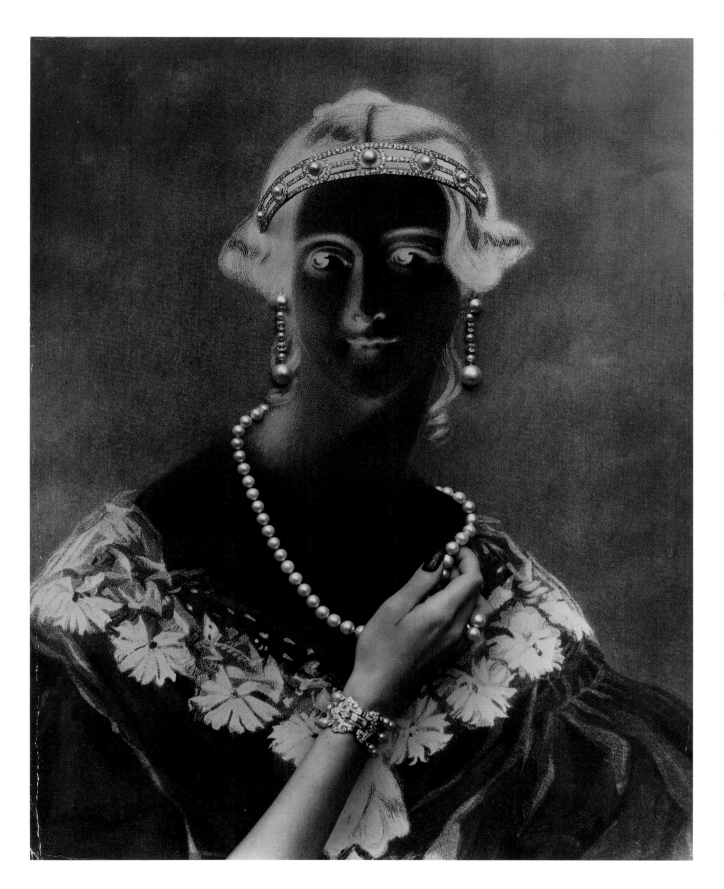

The Princess of Pearls (Advertisement for Cartier jewels)
Paris, 1936-39

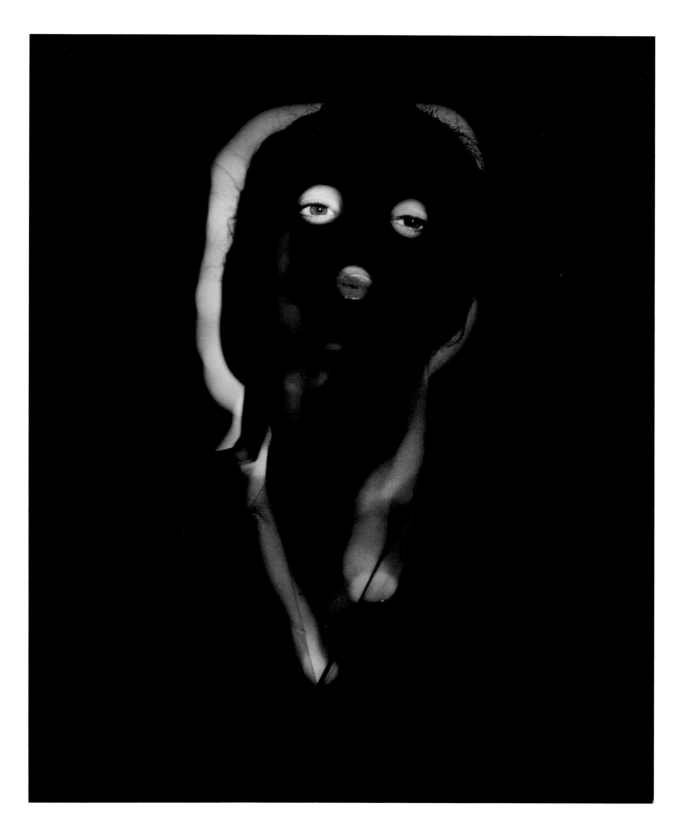

New York, 1944

Fashion Magazines

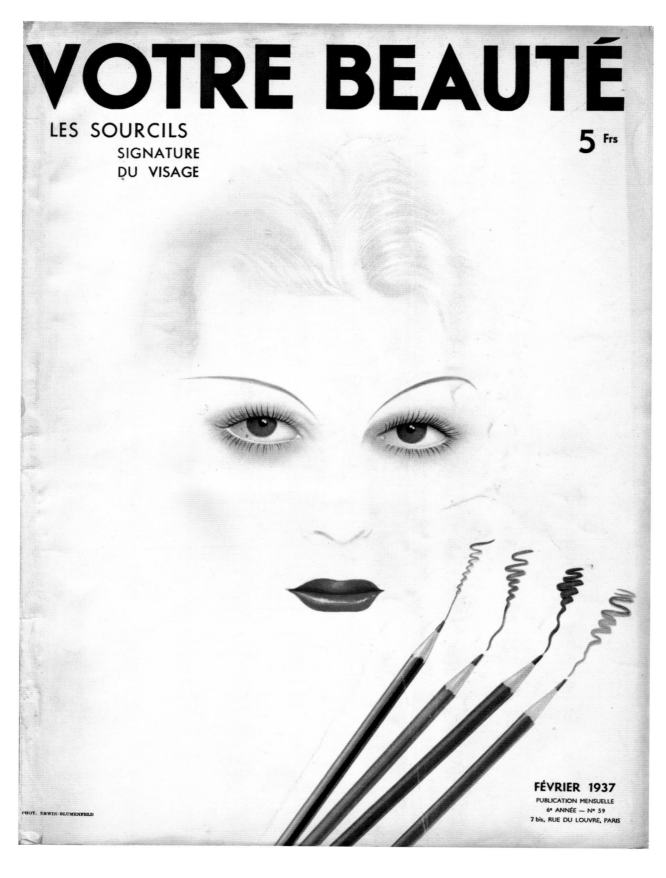

Votre Beauté
February 1937

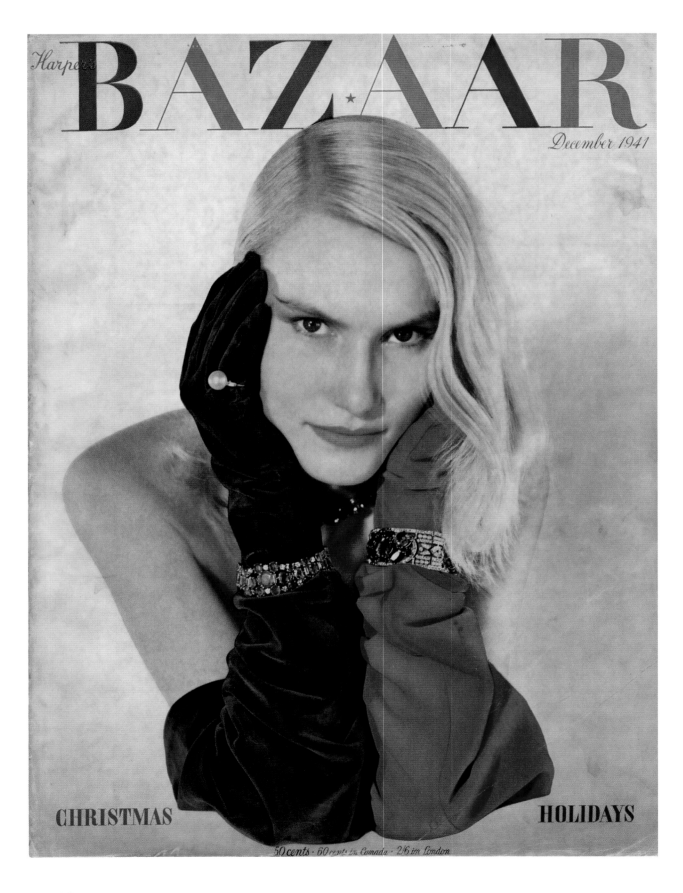

Harper's Bazaar
December 1941

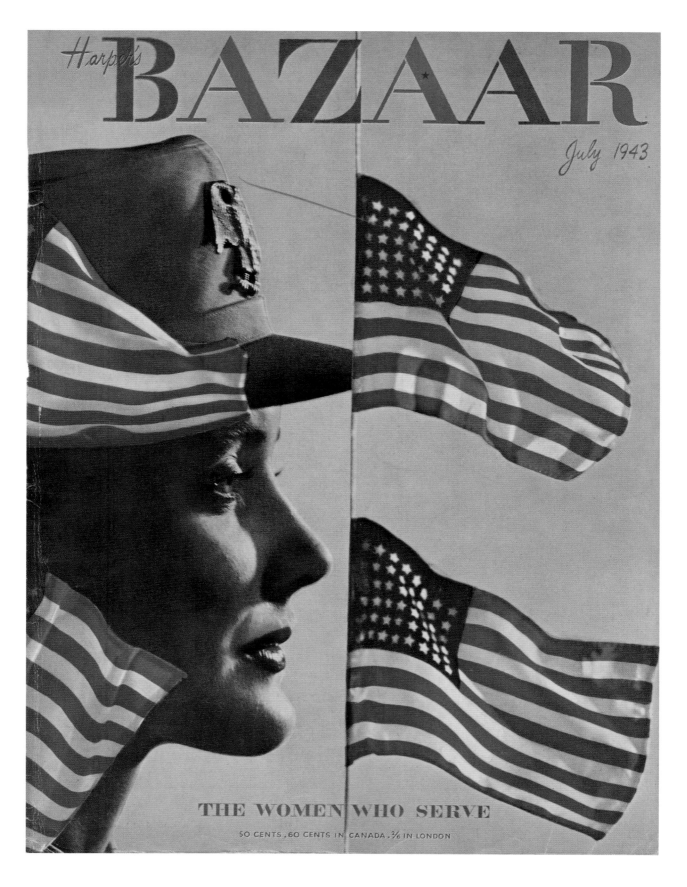

Harper's Bazaar
July 1943

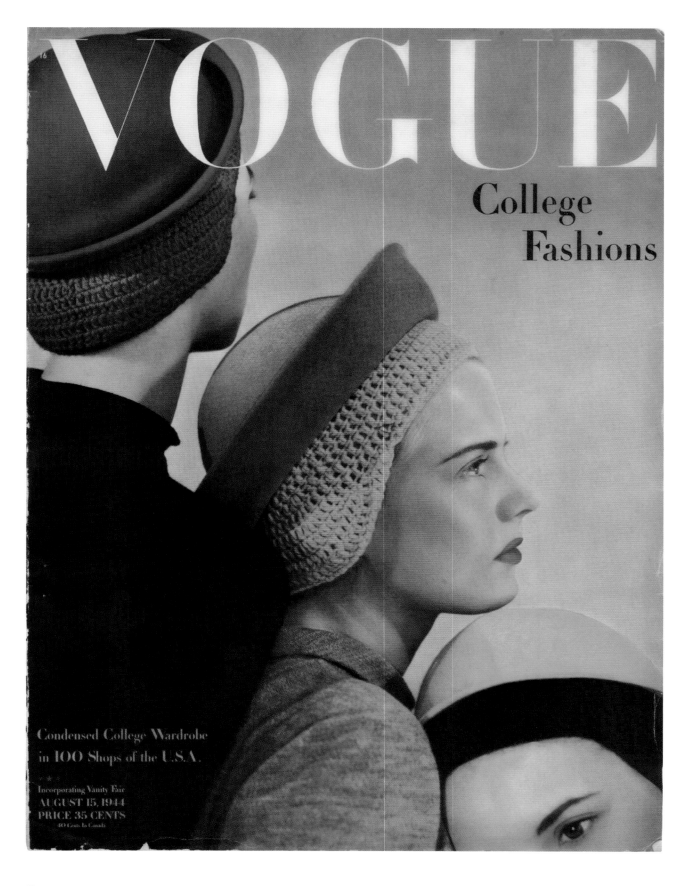

Vogue
15 August 1944

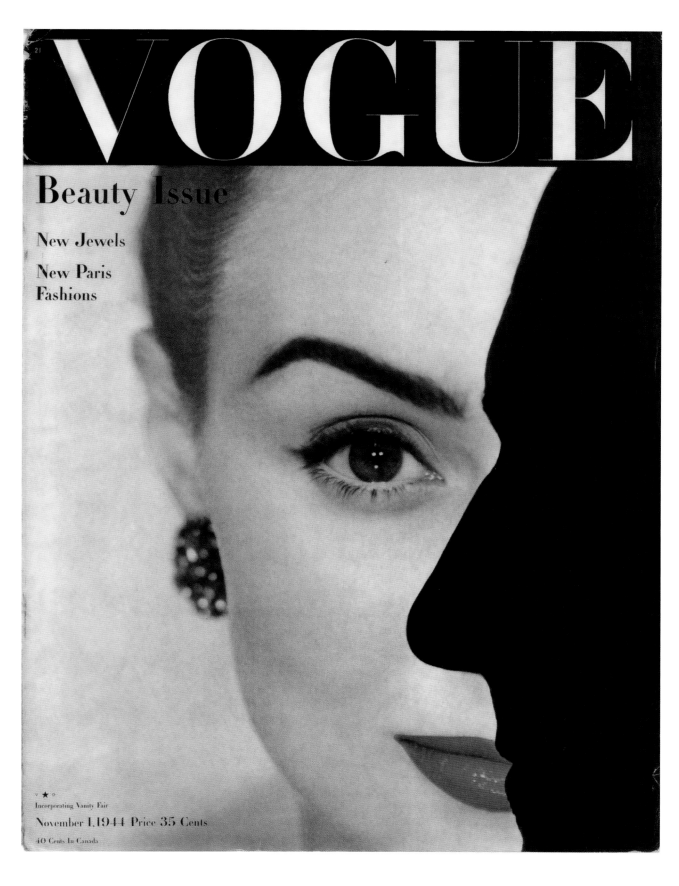

VOGUE

Beauty Issue

New Jewels

New Paris
Fashions

v ★ o
Incorporating Vanity Fair
November 1,1944 Price 35 Cents
40 Cents In Canada

Vogue US
November 1st, 1944

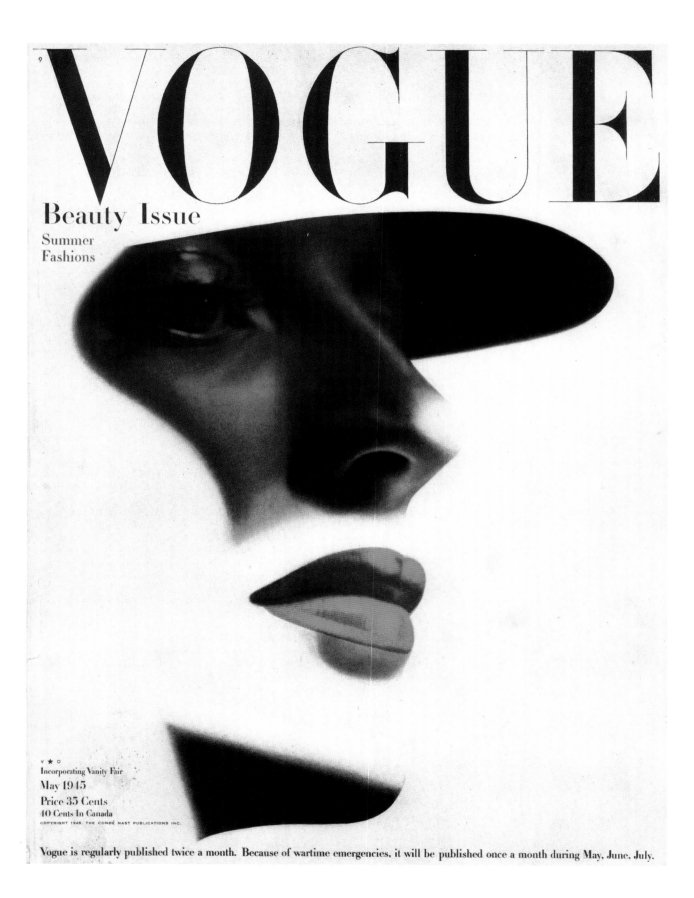

VOGUE

Beauty Issue

Summer
Fashions

v ★ ○
Incorporating Vanity Fair
May 1945
Price 35 Cents
40 Cents In Canada
COPYRIGHT 1945, THE CONDÉ NAST PUBLICATIONS INC.

Vogue is regularly published twice a month. Because of wartime emergencies, it will be published once a month during May, June, July.

Vogue US
May 1945

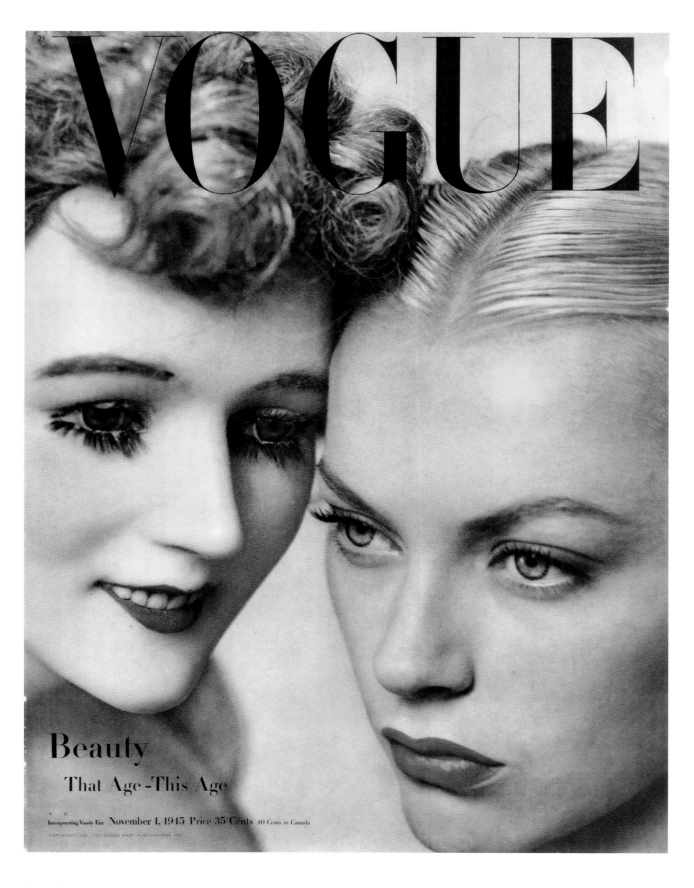

Vogue US
November 1st, 1945

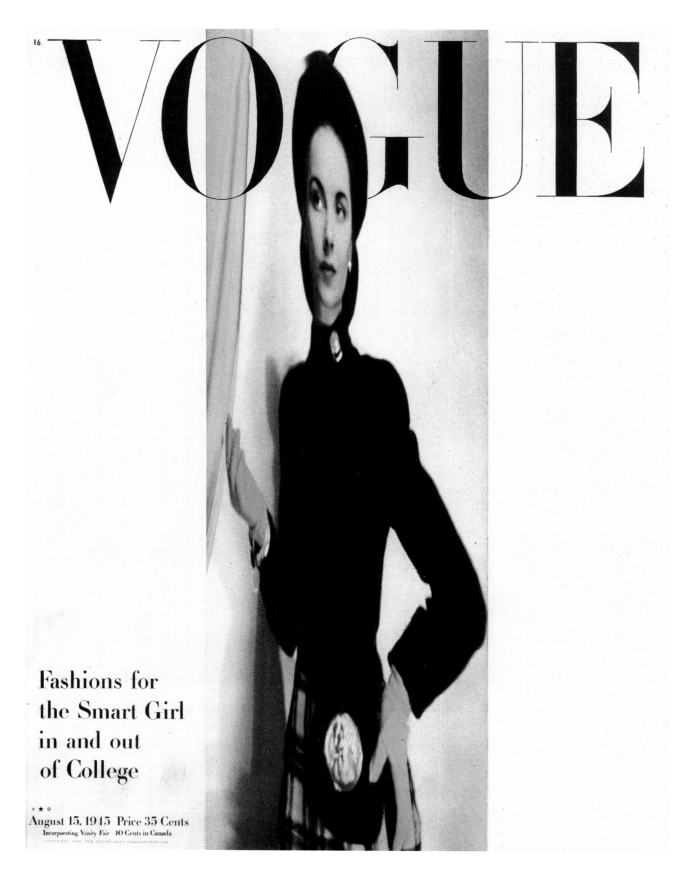

Vogue US
August 15th, 1945

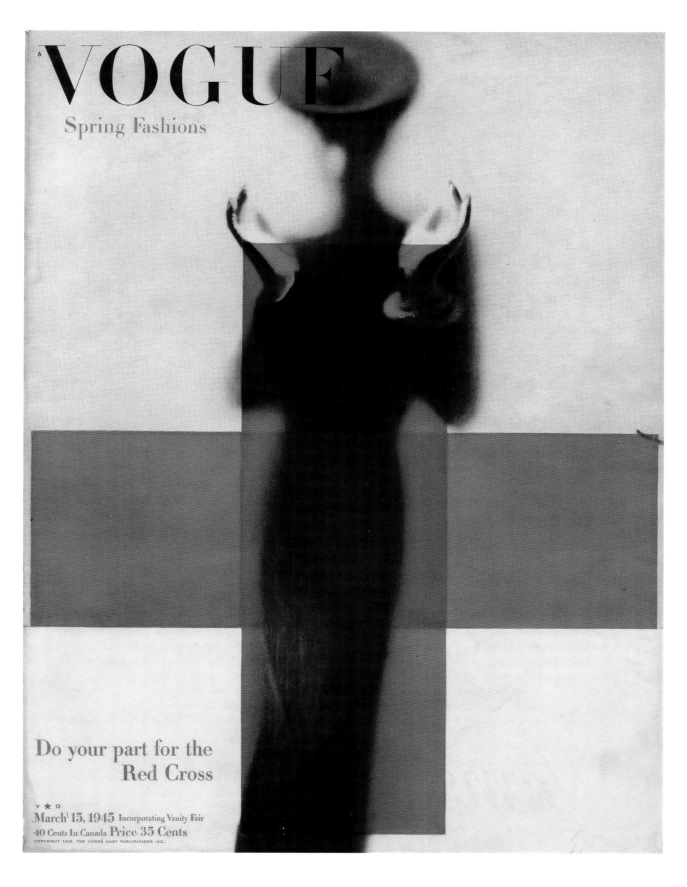

Vogue US
March 15th, 1945

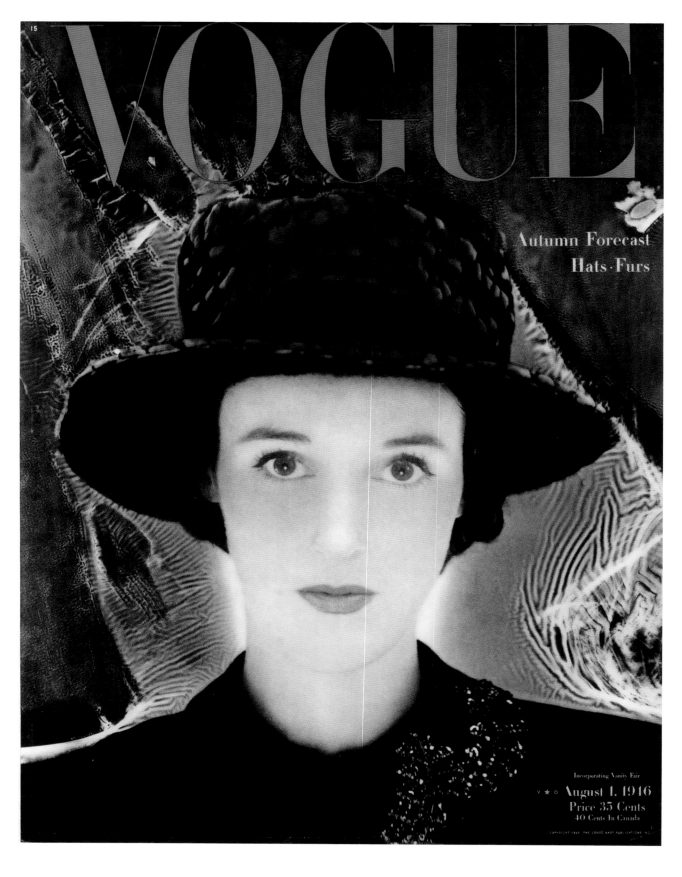

Vogue US
August 1st, 1946

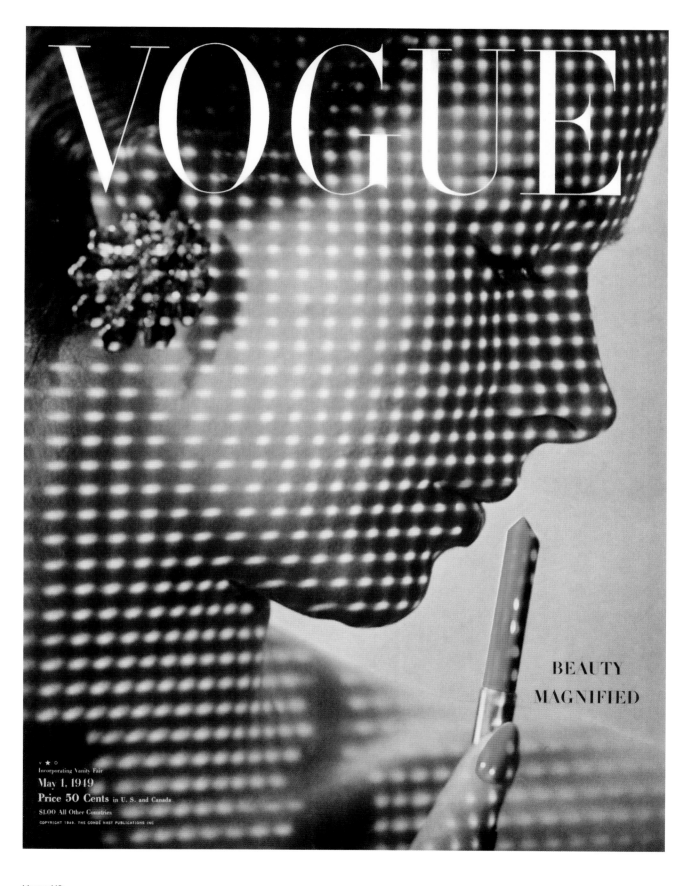

Vogue US
May 1st, 1949

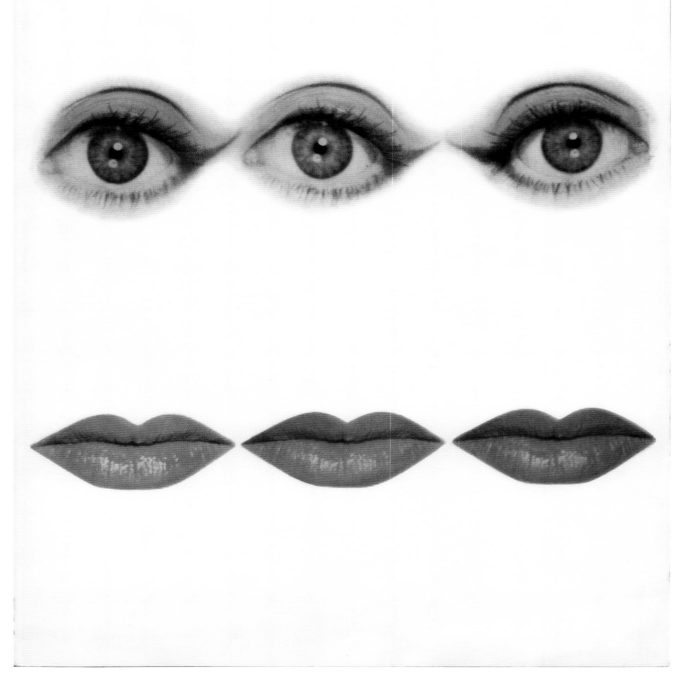

204

Vogue-Beauté
1952

VOGUE

I ANC

1951
NEW FASHION TIMETABLE
Fabric news to wear all year
Suit news to wear all year

SPECIAL FEATURES:
Travel Headliners
"Laughter" by Christopher Fry
Memo on Germany

Incorporating Vanity Fair, January, 1951. 50 Cents U.S. & Canada, $1 elsewhere.

Vogue US
1951

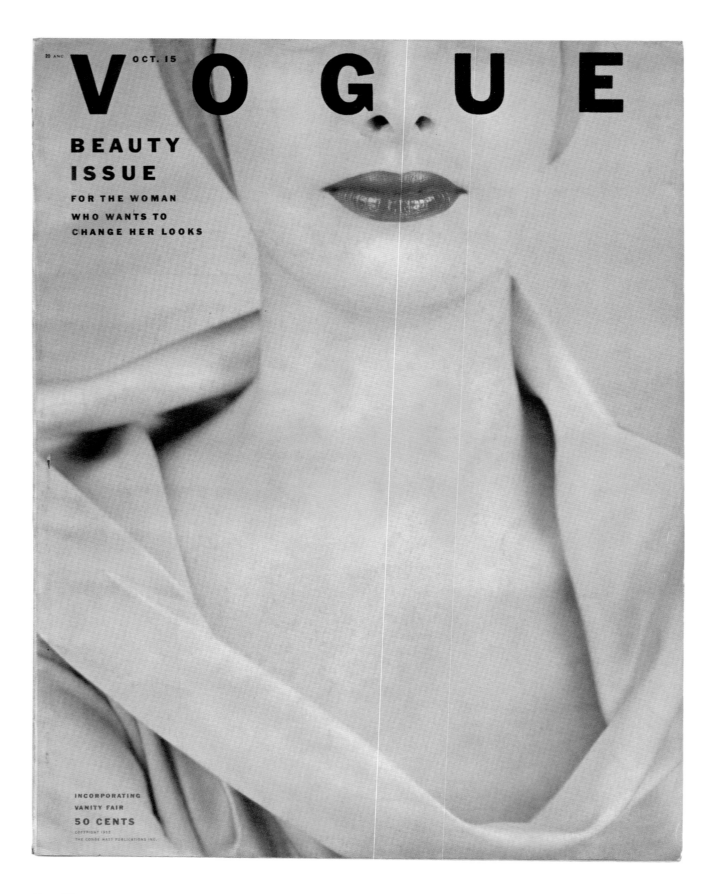

Vogue US
October 15th, 1952

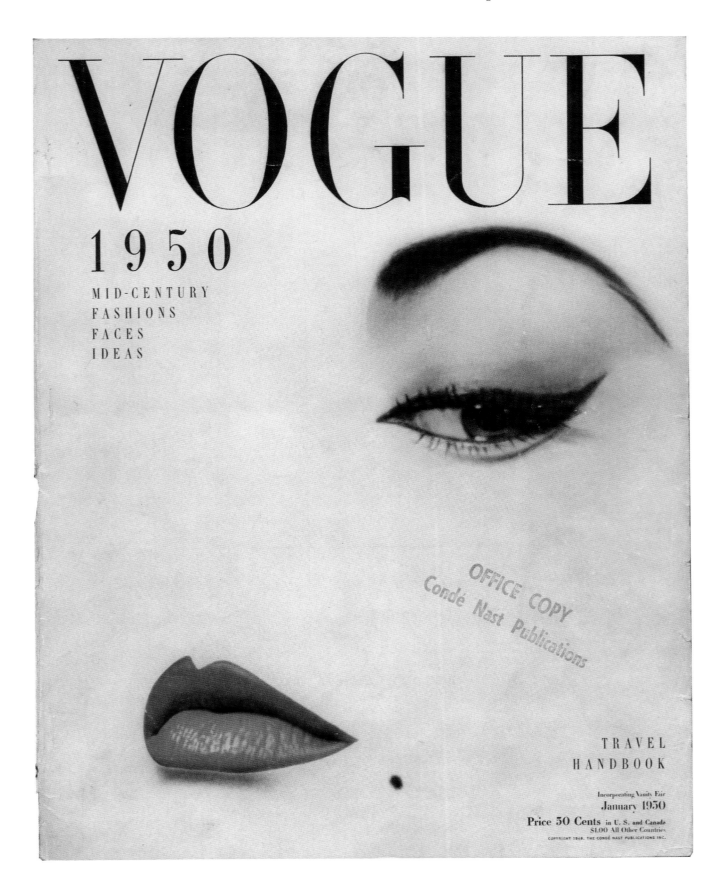

Vogue US
January 1950

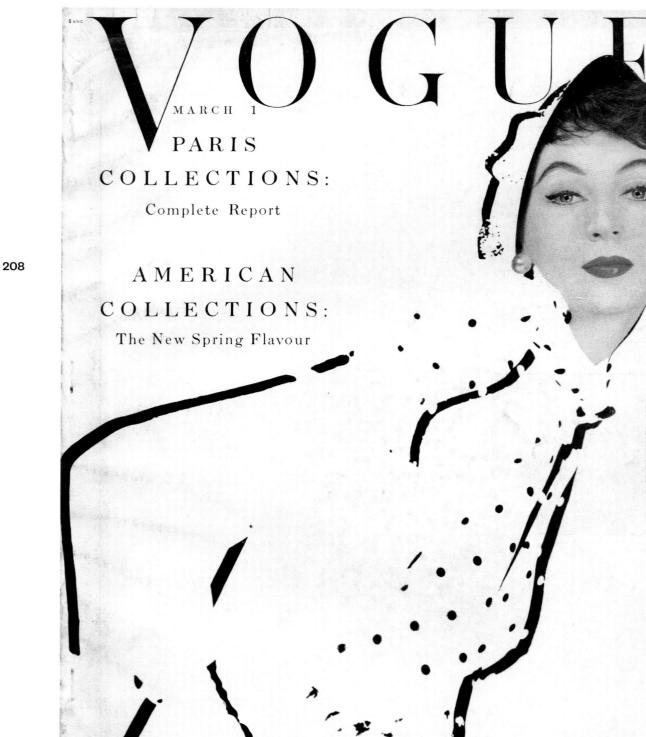

Vogue US
March 1st, 1950

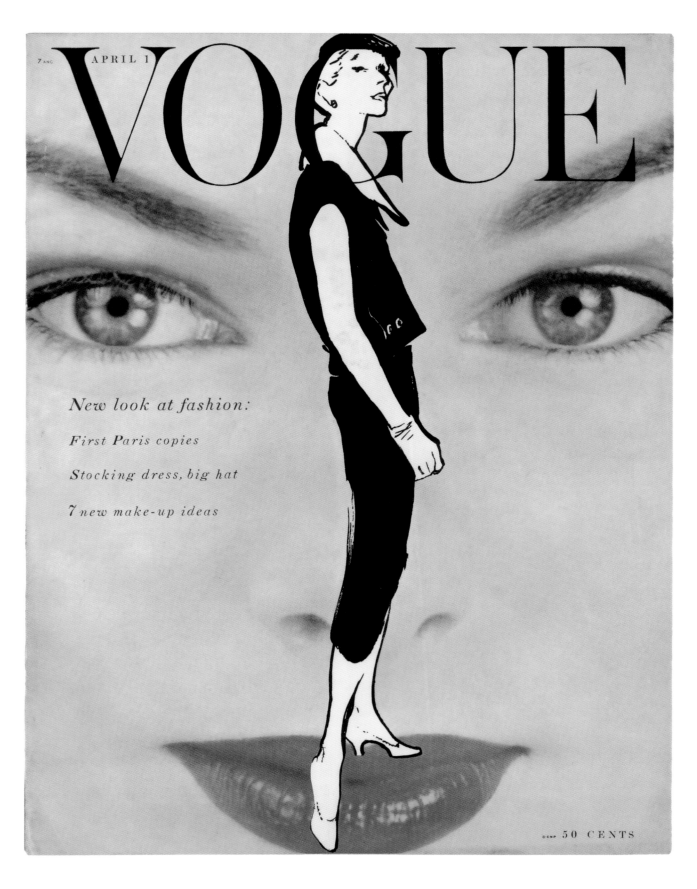

Vogue US
April 1st, 1954

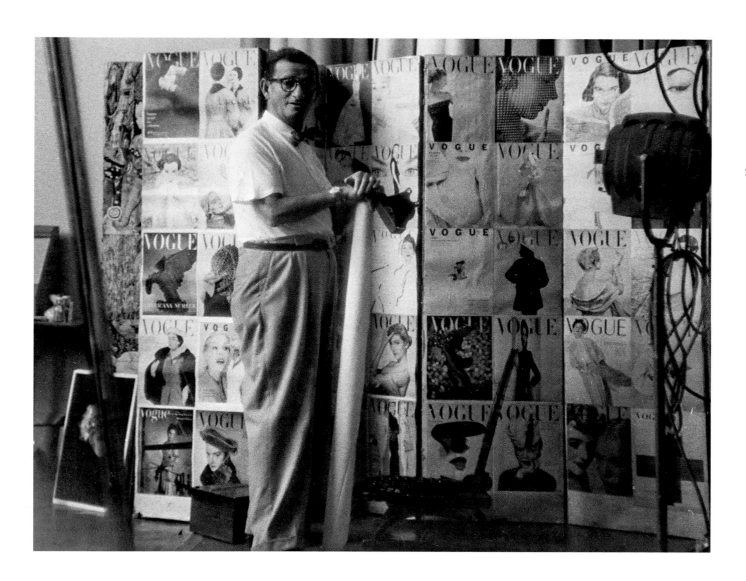

Erwin Blumenfeld in Front of his Vogue Covers
New York, 1952

Architecture

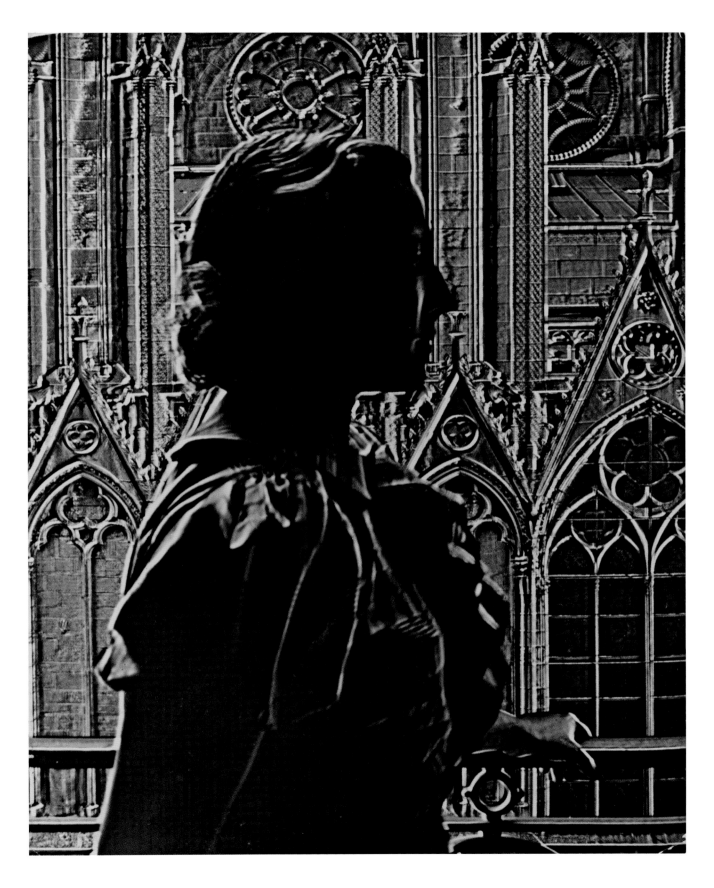

Mrs Sean Bérard, Living Rue du Cloître-Notre-Dame
Paris, 1936

214

La Sainte-Chapelle
Paris, 1936

Notre-Dame
Paris, 1936

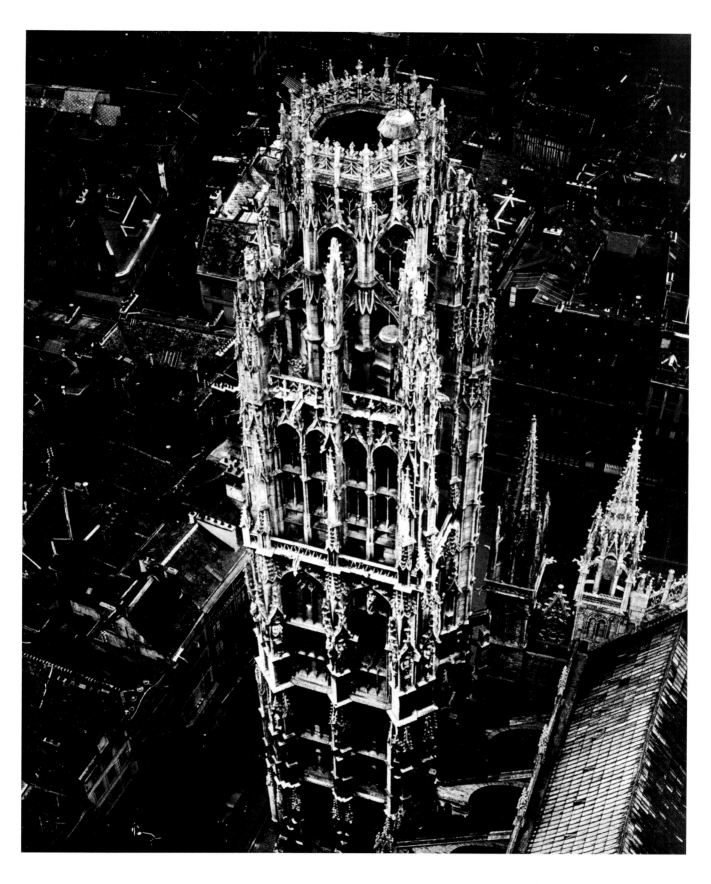

Rouen Cathedral
1937

Shadow of Eiffel Tower
Paris, 1938

Paris
c.1936

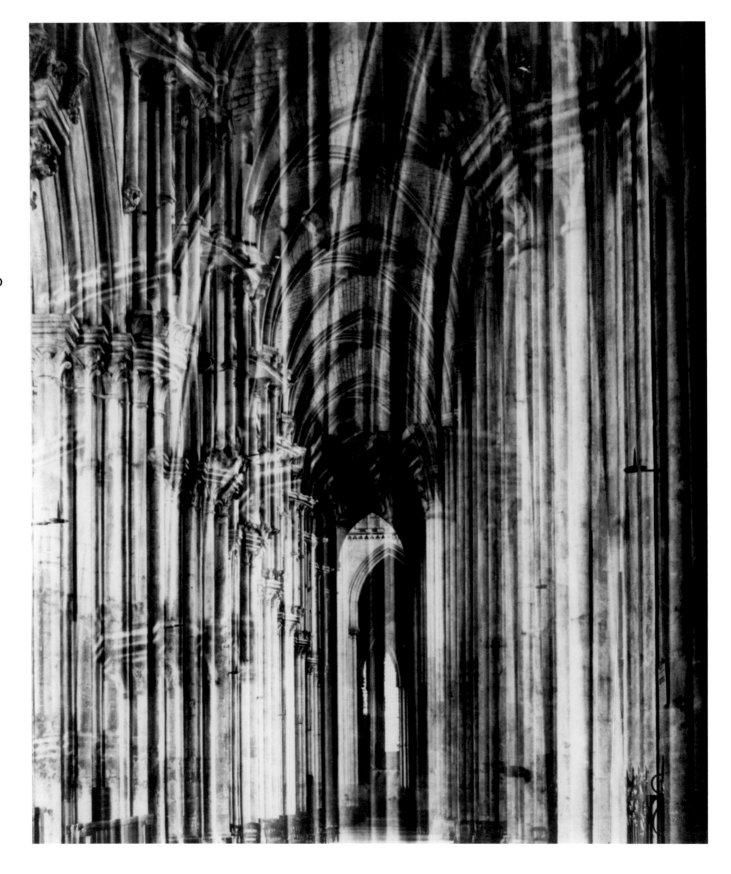

Rouen Cathedral
1937

Rouen Cathedral
1937

Rouen Cathedral
1937

Rouen Cathedral
c.1937

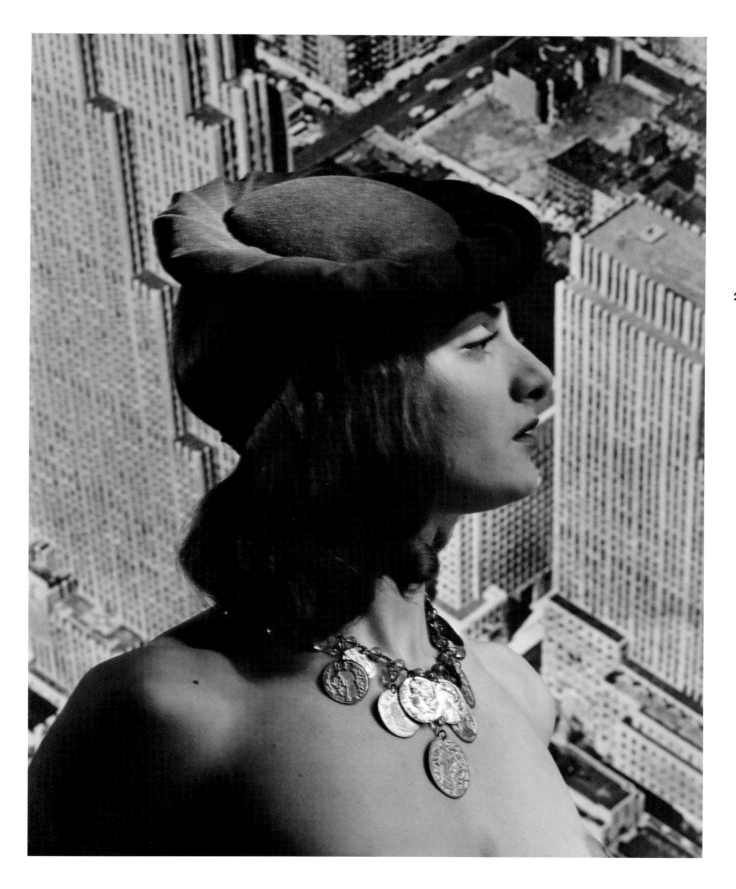

Natalia Pasco
New York, 1942

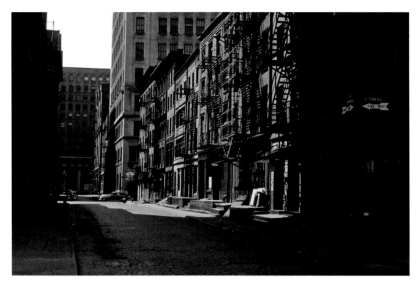

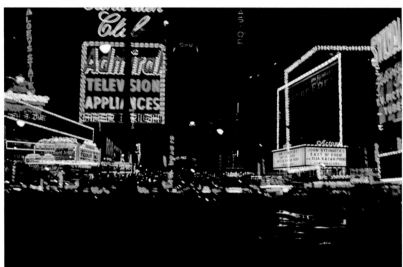

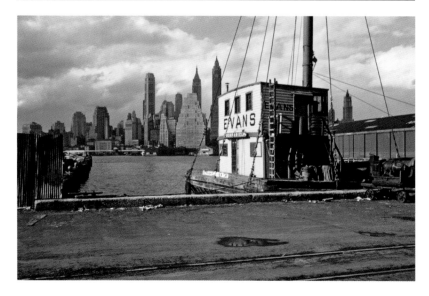

Shedding Light on What Once Was

François Cheval

Can a photograph, or rather in this case a slide, made solely in the photographer's interest, be considered something to be subjected to the appreciation of the wider public and the precepts of photography criticism? On his death, Erwin Blumenfeld's estate included some five thousand slides, raising the issue of the reception of "private" images versus those granted "artistic" status. Is the private nature of slides as a medium – not to mention their sheer number in this instance – enough to shift the gravitational centre of Blumenfeld's photographic oeuvre? Can it still be evaluated using the same criteria? Does a study of this as yet unexplored set of images bring new light to bear on the artistic experience of a creator famed for his experiments with form and his studio work? Studying an artist's photography does not just mean looking at the public face of their work; it also means exploring his output as a whole, including his experiments, the liberties he took and the dead ends this led him into. There would be little point in studying a body of photographic work's mode of existence as such – focusing on nothing else except perhaps on life – if the photographer in question were not a professional creator with a powerful artistic intent.

The thousands of slides taken by Erwin Blumenfeld between 1950 and the mid-1960s shed light on his photographic horizons. Slides, then seen as a "minor" art practice, gave him the opportunity to get out of the studio. What could be more important than testing colours in natural light, setting professional duties aside for a moment to try out practices and subjects whose contours were unclear and yet self-evident? The photographer's candid eye captured everything that artistic "taste" placed out of bounds, from clouds, skies and seascapes to carnivals and markets. There is nothing in the slides to undermine the general reading of Blumenfeld's work

Erwin Blumenfeld
Slides of New York
Late 1950s-early 1960s

1. Erwin Blumenfeld, trad.
M. Mitchell and B. Murdoch.
*Eye to I: The Autobiography of a
Photographer*, London, Thames
and Hudson, 1999.

established in his early Dadaist days, carried on in France and brought to completion in the US. However, his portraits of three cities, New York, Berlin and Paris, gradually reveal an intimate portrait more in keeping with Blumenfeld's final work: his autobiography.[1]

Working backwards: New York

Blumenfeld was confused and perturbed by New York – its slender history, taut high-rise skyline, feeling of chaos, and lack of long views. He knew fully well how much he owed the US, especially New York, but that did not mean he felt comfortable there. The country was sorely lacking in culture and enjoyed wallowing in its own vulgarity. There was but one exception to his critically cultivated eye: the city's architecture, from the Brooklyn Bridge and the old red brick houses on the East River to designs by Mies van der Rohe, Frank Lloyd Wright and Eero Saarinen. When it came down to it, New York was of interest only as a vast structure of concrete, steel and glass pinned between sea and sky. The city was modernity writ large.

Yet a number of views seem to be repeated more or less insistently across Blumenfeld's abundant output of images of New York. In the slides, reused and reiterated views and identical repetitions of shots abound. His photography could hardly take an aesthetic approach to the modern city without adopting the conventions of the American school! The real landscape imposed a predetermined manner of seeing and taking shots, a photographic conception of urbanity, a descriptive approach defined by the repetition of the motif. Blumenfeld's style tends to depict the layout of streets and neighbourhoods with geometric precision. A faithful approach to the subject and a rigorous approach to photographic proce-

dures assures the viewer of grasping the very essence of the modern world. The explanation lies in the mechanical, automatic repetition of the photographic gesture, in accepting that which is there in front of the lens, as if it were self-evident. Erwin Blumenfeld's abundant slides of New York reveal his unconscious debt to American culture and the industrial, commercial civilisation that he scorned. The constant reiteration of the same subjects should be read as taking pleasure in recycling clichés and playing with norms or, rather, as reinterpreting the weakness of the shared iconographic heritage of a land without myths.

Paris: Becoming a photographer

The pictures of Paris fall into several categories. They reveal the artist's understandable pleasure at seeing his own advertising shots on city walls, a handful of picturesque scenes, historical Montmartre and the Sacré Coeur, and shots looking down to the street from a hotel window. Again, the photographs record simple, insignificant instants of everyday life – small, pleasurable feelings that were pleasant to record for later reminiscence. The sole point of interest of these shots taken with no specific goal in mind and devoid of style is that they were taken in colour at a time when people were readjusting to joy after the war. Back in Paris, safe and sound, Blumenfeld now saw the city through the eyes of a tourist, but one with a distant gaze – the gaze of a Jew who has spent too long wandering and has stopped for a while, torn between happiness and disappointment.

One particular set of images stands out from these predictable views: an unexpected series of monuments and early-morning street scenes, with not a soul about, nothing happening – a Paris devoid of inhabitants. The photographic narrative that Blu-

Erwin Blumenfeld
Slides of Paris
Late 1950s-early 1960s

2. *Ibid.*, p. 287.

menfeld produced on his first trip back to the old continent in the 1950s is overflowing with varied hues and tonalities and plays with light and shade, bearing witness to a powerful urge to cleanse the city of its population, the better to claim sole ownership of it. True, there is nothing particularly original about this. Earlier photographers including Marville and Atget had methodically attempted the same. Blumenfeld has no ambition to produce a social or urban record other than experimenting with emptiness, reinventing space per se, with no chance encounters and no sociability. His strolls through the city are conventional, to say the least, and the list of monuments wholly unsurprising. But it matters little: the interest of his slides lies in their ability to build bridges with other, older situations.

Blumenfeld conjures up the past, not in fragmentary form but as one flawless whole. Paris, the 1930s, the five years he spent becoming a photographer: "What I really wanted to be was a photographer pure and simple."[2] The slides stoke the embers of the past contained within them. The familiarity of the monuments rediscovered prompts reminiscences to resurface in a kind of mental double exposure. The photographic sensations evoked by this personal journey, however trivial it might seem, are somehow generated by their direct relationship with the shapes discerned, with architectural features, openings, gaps and perspectives acting on memory and on the body. Paris is a moveable feast! Every step is filled with sensuality. The city's buildings and streets are writ in the only history that counts – a personal history of dazzling, blossoming moments and encounters worthy of being recorded. Reality is an operation to shed light on what once was.

Blumenfeld's strolls through Paris connected moments and places in an order that was by no means the result of improvisation or chance. He knew every hidden corner of a city shaped by hills and hollows. The city of lines can be understood only as geometric shapes, bright or dark, writ in the age of a civilisation that can only ever be European, for Blumenfeld saw the world only in terms of art and the notion of beauty. Paris is fleshily sensual. It can be taken in with a single glance, laying itself bare like a woman, openly yet at the same time modestly. The reinvented city appears unclothed, naked, vigorous. The photographer focuses on capturing its self-assured, clearly defined curves. Early in the morning, in the same light, the city is his and his alone: it belongs to him, the solitary, nostalgic figure roaming the streets with nothing – no weighty, cumbersome studio cameras – to weigh him down. It is easy to imagine his emotion when the rising sun laid bare the unusual, unique shapes of the city, when a new order arose to subjugate the old one.

In the deserted city, all he meets in the streets at this early hour are shadows – including those of his former acquaintances Matisse and Rouault, Vogel and Valéry. Who else could boast as much? The streets of Paris, a set of slides collected over the course of his professional engagements, lends a backdrop to changeless figures.

For Blumenfeld, "the concentration camp ghost", strolling the streets of Paris is a joyful proclamation, a definitive belief in art. The slides represent a colourful diary of jottings and fragments of the past, just like the little pebbles people pick up and carefully store on a shelf somewhere, forming a tiny, private theatre. He sets the fascinating yet repugnant obscenity of Berlin against Paris, Italy, the south of France. His private world and the public sphere now overlap in the interplay of transparency and open perspectives. The open city becomes a symbol of

freedom, a timeless site deferring to harmony. The light airiness of the picturesque still has its place in one coherent discourse in which photographer and *flâneur* come together. Blumenfeld harmonises with Paris, melds with it, reliving and recomposing a history, a narrative – his own.

Berlin must be destroyed!

Berlin, 1960: a city isolated in East Germany, trapped in the Soviet zone. The Soviets were preparing a blockade. They confidently challenged the Americans to a display of force; the Americans, gripped by paranoia, coldly planned for war. The events of 1953, the workers' revolt in East Berlin, and the Hungarian uprising of 1956 entrenched the split between the former allies, dividing the city in two. The atmosphere was unbearable in what just a few years previously had been the capital of the Reich.

But Blumenfeld cared little. He was back in Berlin, his hometown, where he spent the flamboyant, creative years of his youth. On his only journey to Berlin – a city to which he was never to return – he visited the haunts of his youth, perhaps in the hope of rekindling memories, as any ordinary visitor might do. The brief, fleeting visit meant he was able to maintain the illusion of being a tourist. A few slides – under a hundred – were enough to record the few remaining or new monuments, from the Brandenburg Gate to the Soviet memorial in the Tiergarten. The capital of the Reich had undergone profound changes. The gaping holes and gutted buildings had vanished as the shattered city pulsed to the rhythm of building works, financed by the Americans. There was nothing to set him, the much admired professional photographer, apart from the average visitor. He framed his shots, mostly of limited interest, with no particular artistic goal in mind, taking up a conventional angle, face-

on, not aiming for a particular effect. The (unconscious) intentions behind all the shots agreed on the supposed significance or banality of the monuments. The ordinary structure of each photograph, the common methodical link between amateurs and professionals, categorised the shots from the trip into easily substitutable, interchangeable sets: the monument to the glory of the Red Army was the equivalent of the *Siegessäule* commemorating Prussian victories.

Blumenfeld's photographs here display little effort, embodying his professional habitus; his shots are surprising because they have no aim or destination other than, perhaps, a slide projector. The results were never published. They reflect little conviction and no pathos, striving merely to relate to simple notions of intelligibility and legibility, from the preliminaries to understanding the world, but only for his own viewing. By recording the obvious (monuments, in this case), photographs can sometimes be a means of refusing to pass comment, considering the subject as a given. As a medium, slides cancel out specificities in favour of a quality of observation in colour, giving pride of place to the conventional and to common sense. They are empirical, fictional objects, often refusing to engage in any process of social and cultural selection.

So are the Berlin photographs something of a non-event? This point of view is contradicted by a series of shots of houses that can be supposed to be connected with Blumenfeld's family history. The journey was unambiguous: nothing reached beyond the horizon of the ruins to allow for a shared future to be imagined. For Blumenfeld, who was to devote his final years to writing his memoirs and sorting through his archives, any attempt to rid himself of his earliest memories from before the catastrophe was doomed to failure. It was not that he wanted anything from the return to Berlin – he expected no compensation and

3. *Ibid.*, p. 126.
4. *Ibid.*, p. 54, Mr Hermann Sendtke "had a charming repertoire of songs that he would bawl out loud [...] His songs were as full of shit as the soul of the German *Volk*".
5. *Ibid.*, p. 56, " 'That's the way we should exterminate those Jew rats, the vermin of humanity. And you, Erwin, you'll grow up to be a proper German' [...] I found this German virility fascinatingly revolting: my first insight into the sport of genocide".
6. Kurt Tucholsky said that Berliners "do what the city demands of them – except, unfortunately, for living". "God Bless this city", published in the *Berliner Tageblatt*, 21 July 1919.
7. *Eye to I: The Autobiography of a Photographer, op. cit.*, p. 53.

made no claim for restitution. Berlin was long since forgotten, its memory repressed. The Netherlands, France and the United States swallowed up the very idea of nostalgia. All he wanted was to return to Wilhelmstrasse 140. Behind the shots of buildings that he alone could recognise lay the final source of anguish and the object of his successfully completed mourning – the family home: "The building where we lived was the ideal setting for wild games: robbery, murder, assassination." Only pre-1914 Berlin conjured up – and deserved – his memoirs, his wit and his memories, through its risqué nightclubs and its prostitutes, its poets and its radicalism, its stench and its debauchery: "On every street corner death lurked in depraved surprise."[3]

Blumenfeld did not go to Berlin with the illusion of finding himself; he hoped simply to rediscover the traces, perhaps even scents and debts of his past. Nor did he start chasing ghosts. The characters of his autobiography began to take shape: his sister Annie and his younger brother Heinz, the foul-mouthed porter Hermann Sendtke,[4] and Mr Müschel, the landlord, hatmaker, pastor, knight of the Johannite church, occasional transvestite, and anti-Semite.[5] Other figures emerge from the mists of time, all just as solid and even more beautiful than before, endowed with the essence of the scents and shapes of his youth, all fundamental figures because they were part of his foundational experience: Hilde, Carola, Lotte, and Mitze, the chubby little blonde prostitute who worked on Schillstrasse...

Berlin had the unpleasant taste of desire and the raw violence of a sexuality that nothing could ever assuage. These were the unique Berlin surroundings – a joyful blend of libido, poems, tracts and collages – that led to the birth of Erwin Blumenfeld, the Dada artist and photographer, destined to ground his artistic practice in a freedom that was almost perfect – albeit elsewhere.[6] Travel narratives accompanied by a camera are biographies, or rather autobiographies, whose history is bound up with the imperious necessity of telling stories. Photography is no exception.

Yet one particular architectural object captured Blumenfeld's attention – the Kaiser-Wilhelm-Gedächtniskirche, an abandoned ruin, which he photographed from every angle, lost in the midst of towering edifices. The narrative character of this single building's thorough photographic record and the repetition of the motif form a sequence weighty with significance. The church no longer represents an isolated incident, but rather the neo-Roman and neo-Rhenish ruin of the Prussian dynasty and the defeat of militarism and jingoism. The fragmentary narrative is merely the continuation of stories experienced since early childhood: "The nightmares of my childhood in which the Germans were torturing me to death were not my persecution mania, as my parents soothing tried to persuade me, but German reality."[7] Blumenfeld responded to a "pure" Germany rid of its Jews with scorn, irony and barely contained hatred. He literally captured the grotesque pile of stones and turned his photographic record of the edifice in the round into jubilation, into deadening contemplation. There was obvious satisfaction to be had in the event; the compulsion to repeat the motif is almost hallucinatory in nature, lending the shots a compulsive, dramatic edge.

Fields of ruins were now firmly behind him – for good. Did he wish for them? Certainly. His pitiless, remorseless gaze never wavered in staring down at what had become of the capital of the Reich.

He would have been glad to see Berlin suffer the same fate as Carthage: "*Berlin delenda est*".

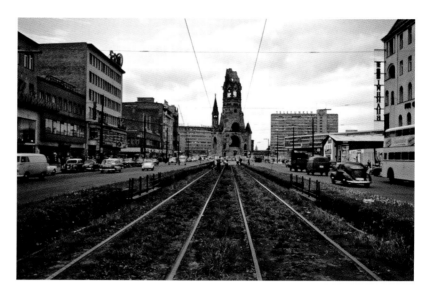

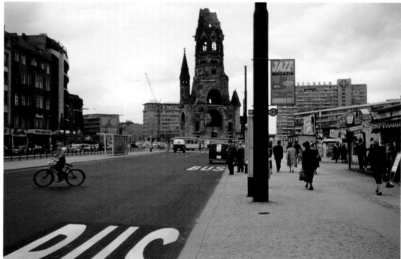

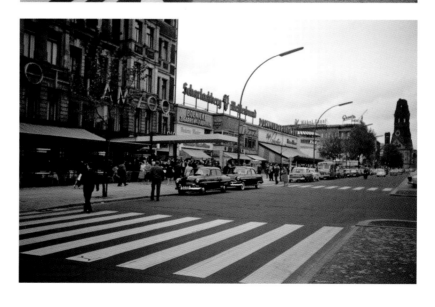

Erwin Blumenfeld
Slides of Berlin
1960

A Biography

Nadia Blumenfeld Charbit

1

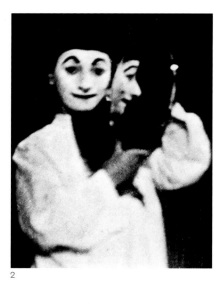

2

Facing page
Lisa Fonssagrives in a Dress by Lucien Lelong,
Vogue Portfolio, May 1939 (variant)

1
Family on the Beach in Ahlbeck, 1900
(Mama, Papa, Erwin and Annie)

2
Self-Portrait as Pierrot, 1911

Berlin (1897-1918)

26 January 1897

"*Thus on 26 January 1897, a Thursday morning I shall never forget, half-squashed, speechless, at the end of my tether, stark naked and sincerely yours, I was sent out into the fresh air. They thought I ought to breathe so they slapped me on the back. What I inhaled was the carbolic enriched stench of Lysol gutter-blended with the steam of fresh horse droppings –the celebrated Berlin air.*"
Blumenfeld will always consider himself as a Berliner, nothing else.
His parents are Albert Blumenfeld; "*an impressive sea lion with a philosopher's brow, omnipotent, omniscient*", and Emma Cohn; with pince-nez and flat chest (the brooch is there to indicate the front). They already have a daughter, Annie, born in 1894 (she will die in 1925 of tuberculosis).
Albert Blumenfeld is principal partner in the firm of Jordan & Blumenfeld, umbrellas and walking sticks.
The family lives in Berlin on Wilhelmstrasse 140.

22 December 1899

Birth of his brother Heinz (Emma has three children "by principle"; principles rule her life).

1903

Attends the Askanisches Gymnasium in Berlin where he meets Paul Citroen, a boy from a Dutch family living in Berlin, who will become his best friend.

1907

Erwin receives his first camera from his uncle Carl after bravely surviving an operation for a pretended appendicitis (he had not done his Latin prep...):
"*My real life started with the discovery of chemical magic, the play of light and shade, the two-edged problem of negative and positive. I had a good photographer's eye right from the start. In order to test out the little device straight away, to see if it was really capable of capturing everything that was placed in front of the lens, I composed the most elaborate still life imaginable: Michelangelo's Moses with a half-peeled potato-into which I had stuck a toothbrush-in his lap. Moses was standing on our open deluxe edition of Doré's Bible. Above it was brother Heinz resting his head on an upturned chamber pot, wearing Mama's pince-nez and Papa's moustache trainer, and clutching mama's rolled up corset in his fist. It was only a short step from that experiment to advertising pictures for which, forty years later, American companies paid me $2500 per photo.
I developed that picture straight away in my parent's bathroom by red candlelight. My hands were shaking as I rocked the glass plate up and down in a soup bowl filled to overflowing with pyrogallol. The new white lavatory seat ever after bore a brown stain, and I was punished accordingly, but the negative was perfection itself. I made the print by sunlight on Celloidine paper with a Goldtone fixer. I was a photographer.*"

1911

Bar mitzvah. Submits to his parents wish in order to start his library of complete editions of all classic authors, including all forbidden books.
First self-portrait in a mirror: "*I remain convinced there is life in another world going on behind the transparent glass. We are doubles. Without a mirror I would never have become a human being. Only fools call it a Narcissus complex. No mirror-no art, no echo-no music.*"

1913

His father has a breakdown due to tertiary syphilis. His mother is in and out of sanatoriums. There is no more money to allow him to study, he starts to work as an apprentice at a women's wear manufacturer: Moses and Schlochauer to help support the family. His father dies, and Erwin writes: "*I let the teardrops drip onto the poems I had just written and solemnly swore never to masturbate again and to look after my mother. I have broken both oaths.*"

1915

Goes with his friends Paul Citroen and Walter Mehring to Café des Westens in Berlin, meets the poetess Else Lasker-Schüler "the black swan of Israel", and Saul Friedländer alias Mynona who writes for *Der Sturm*.
Befriends the artist Georg Grosz: "*One night, it must have been around 1915, I went in mellow mood to the urinal on Potsdamerplatz. A young dandy came in by the opposite entrance, stood beside me, fixed his monocle in his eye and in one fell swoop pissed my profile on the wall so masterfully that I could not but cry out in admiration. We became friends. He was the most brilliant man I ever met in all my life, a great raconteur and an immensely powerful draughtsman.*"
Erwin starts a correspondence with Paul Citroen's cousin Lena Citroen, "Leentje" who lives in Amsterdam.

3

4

236

1916

Lena comes for two weeks to Berlin, they had already decided to marry before having met: "*we decided, we ignorant romantics, to go through life hand in hand and soul to soul, unto the very end of the world, a point which now, half a century later, we have nearly reached as incorrigibly smart-ass grandparents.*"

1917-1918

Conscripted in the German army as ambulance driver, he is sent to France after a hellish training period in Zwickau. He collects mostly corpses in his ambulance, he is in Ardon-sous-Laon, on the Chemin des Dames. He also serves as an army brothel bookkeeper.

While on leave in June 1918, he plans to desert with Lena to Holland but is reported to the army by his uncle Bruno.

His brother Heinz called up in 1918, dies on the French front:

"*Dear Brother,*

Back in Flanders. Just spending a day or two here at the base. A fortnight ago on Thursday, arrested with Lena and put on remand thanks to Uncle Bruno. Lena deported, I was set free on the last day after innocence proven. Mama triumphant. Swears she knows nothing about the whole thing. Mama says, 'Better dead in the trenches than a traitor', because she is scared of aunt Minna.

Hope you're still alive!

Your brother Erwin.

Three weeks later when they distributed letters, I got this one back with a note written across the address: Killed in battle, return to sender."

Amsterdam (1918-1935)

1918-1920

Leaves for Holland. He tries to deal in art with Paul Citroen, but with little success. He enters the garment business, joining the Gerzon Brothers Fashion House.

Participates in the Dada movement with Grosz, Mynona, Mehring and Citroen; paints and writes and does collages under the pseudonym of Jan Bloomfield. Together with Paul Citroen, they are self-proclaimed directors of the "Holland Dadacentrale".

26 janvier 1921

Marries Lena Citroen.

1921-1935

Runs a leather goods shop in Amsterdam: the Fox Leather Company (Kalverstraat). He starts taking photographs, mainly of the shop clientele, but also of family and friends from Berlin and Amsterdam, which he develops in a darkroom that existed in the back of his shop.

Birth of his children Lisette (1922), Heinz (1925) and Frank Yorick (1932).

The family lives in Zandvoort. Blumenfeld will never obtain Dutch citizenship as he has been arrested for dropping a shoulder strap of his bathing suit on the beach.

1932

Does the stills for Jacques Feyder's film *Pension Mimosa*.

1933

Photomontage *Hitler's Mug Shot*.

First exhibitions of his photographs in Kunstzaal van Lier (Amsterdam) in 1932 and 1934.

1935

His first published photograph appears in *Arts et Métiers Graphiques*, Paris: the portrait of Tara Twain, from Hollywood.

No longer receiving supplies from Germany, his shop, the Fox Leather Company, which was already faring badly, goes bankrupt.

"*And so I became when there was really nothing left for me to do, a photographer. Everyone told me not to do it. Failed painters became window-dressers, failed window-dressers became photographers.*"

5

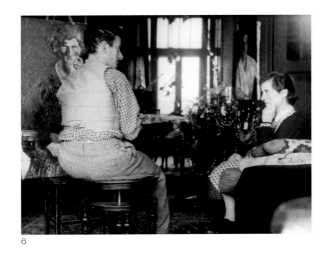

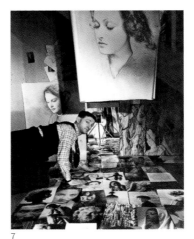

6

7

9

Paris (1936-1939)

"I fell in love with Paris when I was a child, sight unseen, as is ever my way, and when I finally got there at the age of forty, I realized that taste is merely foretaste. Taste comes from tasting."

1936

Encouraged by Geneviève Rouault, the daughter of the painter George Rouault, whom he had photographed in Amsterdam, Erwin moves to Paris as a photographer. First exhibition in Paris at Pierre Vorms' Billiet Galerie (rue La Boétie) 2-13 March: "Erwin Blumenfeld, Amsterdam, Photos."
Encounters his first art director, Robert Guesclin : "*The first time I heard that word, I thought it was a joke. It wasn't. It seemed incomprehensible to me that my ideas, my work, and my photos should be manipulated, castrated, denatured and prepared for press by someone else: an art director.*"

1937

Publication of his photographs in the first issues of *Verve* (published by Tériade) and first cover for *Votre Beauté*. Has a studio 9 rue Delambre.

1938

First photographs for the French edition of *Vogue*, thanks to an introduction from Cecil Beaton who admires his work. Works for Michel de Brunhoff the editor in chief of *Vogue*, who tells him: "*If only you'd been born a baron and become a homosexual, you'd be the greatest photographer in the world.*" Blumenfeld had already discovered: "*the world no longer exists.*"

8

1939

Portfolios in *Vogue*, including his photographs of the Eiffel Tower in May 1939 commemorating the 50th anniversary of the Eiffel Tower.
Trip to New York where he signs a contract with *Harper's Bazaar*, editor Carmel Snow.

1939-1941

"*[...] when the old world collapsed, I was there, playing my own personal part in it all; it was ugly, stupid and life-threatening. It was only a matter of luck that I and my family managed to escape with nothing more than the fright of our lives.*"
Returns to France, the war breaks out in September, Blumenfeld and his family live in Burgundy, in Voutenay-sur-Cure and in

Vézelay. In May 1940, he is interned in camps as an undesirable alien at Montbard-Marmagne, Loriol (Drôme), Le Vernet d'Ariège and Catus (Lot).

Here is his description of Le Vernet, a camp also shared with Spanish republicans and political prisoners, and from which convoys were deported to Auschwitz: "*behind tangled thickets of barbed wire, with electrified fences and trenches stood wretched windowless shacks overcrowded with rotting corpses on shit-coloured mud with sharp stones.*"

His daughter Lisette is interned at 18, in the camp of Gurs in the Pyrenees.

Catus is dismantled. The family lives in Agen and manages to regroup with Lisette, who could be released from Gurs on condition that a parent was there to fetch her as she was not yet 21.
Blumenfeld obtains visas for the family in Marseille from the vice-consul Oliver Hiss.
They flee to the USA in May 1941 on The Mont Viso steamship.
They are stopped and detained in Morocco, in the port of Casablanca, then in the camp of Sidi-el-Ayachi in July, but finally, thanks to the Hebrew Immigration Aid Society, they can continue the journey on a Portuguese liner, the SS Nyassa to New York, arriving in August 1941.

11

12

238

New York (1941-1969)

"*The metropolis of New York, the only living wonder of the world, is, like the pyramids, not a work of art but a gigantic manifestation of power. It still has one foot in Europe, glancing back over both shoulders on its desperate look out for new attractions. America only begins where New York ends.*"

1941-1955

"*I resolved to smuggle culture into my new country by way of thanks for accepting me.*"

Blumenfeld starts immediately to work for *Harper's Bazaar*, he shares the studio of photographer Martin Munkácsi.
His apartment is on 1 West 67th street, Hotel des Artistes.

He acquires his own studio at 222 Central Park South in 1943, success comes soon; he becomes one of the best known and best paid fashion photographers. Works for *Harper's Bazaar* and Alexey Brodovitch (until 1943), *Look*, *Life*, *Vogue* and Alexander Liberman, *Cosmopolitan*, *Kaleidoscope*, *Photography*, *Picture Post*, *Pageant*… producing over 100 covers for fashion and photography magazines in the following years.

His son Heinz (Henry) is conscripted in the American army from 1943 to 1946.

1946
Blumenfeld is naturalized American citizen

1948
Exhibits in "In and Out of Focus" curated by Edward Steichen at the Museum of Modern Art, New York, and in "Seventeen American Photographers" at the Los Angeles Museum.

1954
Buys a house in the dunes on Westhampton beach in 1954. It will later disappear in a storm.

1955-1969

Blumenfeld stops working for *Vogue* in 1955, he evolves towards advertising, and works for Helena Rubinstein, Elisabeth Arden, L'Oréal, The Dayton Company's Oval Room among many others.
His agent is Kathleen Levy Barnett, later to become his daughter-in-law.

In the following years, Blumenfeld travels, returning to France, Greece, Spain, also to Berlin in 1960. Also travels extensively throughout the United States, and to Mexico, Cuba, Haiti. He photographs without cease with a Leica and tries to interest art directors in his travel production with lengthy slide shows. He has no commercial success with these, nor with his films, test films for The Dayton company and L'Oréal. The films contain many of his ideas from fashion shoots.

Blumenfeld starts to write his autobiography in German: *Einbildungsroman*. He will be assisted in this task by Marina Schinz, who comes to work for him in 1964.

Birth of his six grandchildren: Lisette and Paul Georges have two daughters, Paulette and Yvette; Henry and Kathleen Levy have a son Yorick and a daughter Nadia; Yorick and Helaine Becker have two sons, Remy and Jared.

Composes a photography book to be called: *My One Hundred Best Photos*, 100 black and white images in 50 pairs. Finishes his autobiography.

In an article in *Popular Photography* (September 1958) Blumenfeld states: "Currently, I am absorbed in magazine and advertising illustration, and I remain as true an amateur as I was at ten. The wonder that the camera can really reproduce anything shown to it still astounds me; and I am strongly determined to show the lens a more exciting, dramatic and beautiful way of presenting life."

Dies in Rome on **July 4 1969** of a heart attack.

All the quotes in italics in this text are taken from Blumenfeld's autobiography *Einbildungsroman*; English edition *Eye to I*, translated by Mike Mitchell and Brian Murdoch, London, Thames and Hudson, 1999.

13

13
222 Central Park South with assistant Jake Daniels

14
In front of advertising photo for L'Oréal

15
Westhampton Beach, New York

14

15

Selected bibliography

Books by Erwin Blumenfeld

Autobiography published posthumously
Jadis et Daguerre, Foreword by David Rousset, Paris, Robert Laffont, 1975; reed. Paris, Éditions de La Martinière, 1996; Paris, Éditions Textuel, 2013.
Durch tausendjährige Zeit, Foreword by Alfred Andersch, Frauenfeld, Huber, 1976; reed. Zurich, Buchclub Ex Libris, 1978; Munich, Deutscher Taschenbuch-Verlag, 1980; Berlin, Argon, 1988
Spiegelbeeld, Amsterdam, Uitgeverij De Harmonie, 1980
Einbildungsroman, Postscript by Rudolf Trefzer, Frankfurt am Main, Eichborn, 1998
Eye to I: The Autobiography of a Photographer, Translated by Mike Mitchell and Brian Murdoch, London, Thames & Hudson, 1999
The Autobiography of a Photographer, Hang Zhou, Zhejiang Sheying Chubanshe, 2010

My One Hundred Best Photos
All editions with a text by Hendel Teicher and an introduction by Maurice Besset
Erwin Blumenfeld : Mes 100 meilleures photos, Geneva, Musée Rath, 1979
Erwin Blumenfeld: Meine 100 besten Fotos, Berne, Benteli, 1979
Erwin Blumenfeld: My One Hundred Best Photos, London, Zwemmer, 1981
Erwin Blumenfeld: My One Hundred Best Photos, New York, Rizzoli, 1981

Texts by Erwin Blumenfeld
"Atze. Lesegedicht", *Schall und Rauch* 6 (May 1920), p. 100 M [published as "Erwin Bloomfield"]
"Le mystère de la réalité redécouvert par la photographie", *L'Amour de l'art*, Paris, No. 5 (June 1938), pp. 204-214
"How I Won the Iron Cross", *Lilliput Magazine* vol. 5, No. 6 (December 1939), pp. 581-591
"My Favourite Model", *Lilliput Magazine* vol. 17, No. 2 (August 1945), pp. 153-162
"One Girl–Twice", *Picture Post* vol.34, No. 3 (18 January 1947), n.p.

"Another Girl–Twice", *Picture Post* vol. 34, No. 8 (22 February 1947), n.p.
"Still-Life and Mirrors", *Picture Post* vol. 35, No. 11 (14 June 1947), pp. 16-17
"Smuggled art", *Commercial Camera Magazine* (December 1948), pp. 2-8
"Seventeen American Photographers", exhibition catalogue, Los Angeles, 1948
"Men and Beautiful Women", *Cosmopolitan* (June 1958), pp. 39-44
"A Photographer Talks Candidly", *Minneapolis Sunday Tribune*, 7 September 1958
"I Was an Amateur: Blumenfeld as Told to Mildred Stagg", *Popular Photography*, September 1958, pp. 88 ff.

Magazines

Early image publications
Paris magazine, Paris, No. 63 (November 1936), p. 632; nr 82 (June 1938), p. 260; No. 84 (August 1938), p. 368
Photographie, art et métiers graphiques, 1936 (3 images), 1937 (2 images), 1938 (2 images), 1939 (2 images) and 1940 (1 image)
Verve, Paris (December 1937), pp. 17-19; (March-June 1938), pp. 30, 36, 85-89
Photography Year Book, The International Annual of Camera Art, T. Korda (ed.), London, 1936-37 (4 images)
Modern Photography. The Studio Annual of Camera Art, London/New York, 1937, plate 65
Votre Beauté, Paris, cover photograph (February 1937)
L'Amour de l'art, Paris, No. 5 (June 1938), pp. 204-214
XXᵉ siècle, Paris, French and European publication (July, August, September 1938), p. 13, 14 and 15
Vogue, Paris, portfolio (October 1938)
Harper's Bazaar, New York, cover photograph (December 1941)
Collier's, New York (September 1943)
Vogue, New York, cover photograph (September 1943)

Early publications on Erwin Blumenfeld
"Speaking of pictures ... Blumenfeld's are the Tops", *Life*, New York (3 July 1939), pp. 4-6 and 70
H. Felix Kraus and Bruce Downes, "Blumenfeld at Work", *Popular Photography*, New York (October 1944), page 38 and 40-47
Walter H. Allner, "Erwin Blumenfeld", *Graphis*, Zurich, 15, 1946, pp. 316-327
"Erwin Blumenfeld. Great American Photographer", *Pageant*, New York (October/November 1947), pp. 106-120
"Rage for Colour", *Look*, New York (15 October 1958)

Books and thesis

Adkins, Helen, *Erwin Blumenfeld – "In Wahrheit war ich nur Berliner". Dada-Montagen 1916-1933*, Ostfildern, Hatje Cantz, 2008. English edition: Erwin Blumenfeld – *"I was nothing but a Berliner". Dada Montages 1916-1933*, Ostfildern, Hatje Cantz, 2008
Blumenfeld, Yorick, *The Naked and the Veiled: The Photographic Nudes of Erwin Blumenfeld*, London, Thames and Hudson, 1999. German edition: *Erwin Blumenfeld: Erotische Fotografien*, Leipzig, Seemann-Henschel, 2000. French edition: *Blumenfeld, Nus*, Éditions de La Martinière, 1999
Carvalho, Fleur Roos Rosa De, *"Ich will neue Menschen schaffen. Ich will alle Frauen lieben." Erwin Blumenfelds Amsterdamse portrellen 1930-1936*, Unpublished master's thesis, Vrije Universiteit, Amsterdam, 2007
Ewing, William A., *Erwin Blumenfeld 1897-1969: A Fetish for Beauty*, London, Thames and Hudson, 1996. American edition: *Erwin Blumenfeld 1897-1969: A Passion for Beauty*, New York, Harry N Abrams, 1997. German edition: *A Fetish for Beauty: Blumenfeld (1897-1969): Sein Gesamtwerk*, Zurich, Stemmle Verlag, 1996. French edition: *Erwin Blumenfeld 1897-1969 : Le Culte de la beauté*, Paris, Éditions de La Martinière, 1996
Métayer, Michel, *Erwin Blumenfeld*, London and New York, Phaidon, 2004

Werner, Anja, *Das verkaufte Ich : Selbstbildnisse deutscher Modefotografen im 20. Und 21. Jh. Unter besonderer Berücksichtigung von Erwin Blumenfeld, Helmut Newton und Wolfgang Tillmans*, Dissertation, Georg-August-Universität, Göttingen. Online publication, 2009.

Zenns, Kirsten, *Erwin Blumenfeld: Ästhetische Konzeptionen von Weiblichkeit im Medium der Modefotografie: Paris 1936-39 / New York 1938-47*, Ph.D. diss., Universität der Künste Berlin, 2003. Online publication 2004.

Radio broadcast

Frecot, Janos, "Zeit, Schönheit, Tod: Erinnerungen an den Fotografen Erwin Blumenfeld", Sender Freies Berlin (SFB), 10 November 1997

Documentary film

Blumenfeld, Remy, "The Man who shot Beautiful Women", Thinking Violets, 2013

Internet

Experiments in Advertising: The Films of Erwin Blumenfeld, edited by Penny Martin and Paul Hetherington.
www.showstudio.com/projects/blumenfeld [July 2008] (including Blumenfeld's film archive and an interview with Yorick Blumenfeld).

Exhibitions

Exhibitions marked with an asterisk have given rise to a catalogue.

"Erwin Blumenfeld's foto", Kunstzaal Van Lier, Amsterdam, May-June 1932

"Cinquante têtes de femmes", Kunstzaal Van Lier, Amsterdam, autumn 1933, Esther Surrey Art Galleries, The Hague, spring 1934

"Erwin Blumenfeld Amsterdam", Galerie Billiet, Paris, 2-13 March 1936

"L'Art cruel" (group show), Galerie Billiet, Paris, 1937 (folder)

"In and Out of Focus – A Survey of Today's Photography", Museum of Modern Art, New York, 6 April-11 July 1948 (group and touring show)*

"Seventeen American Photographers", Los Angeles County Museum, Los Angeles, January/February 1948

"Erwin Blumenfeld", Pentax Gallery, London, 1 November-2 December 1977

"Erwin Blumenfeld", Witkin Gallery, New York, 8 March-8 April 1978

"Erwin Blumenfeld", Sander Gallery, Washington, 9 September-1 October 1980

"Erwin Blumenfeld: Collages Dada 1916-1931", Galerie Sonia Zannettacci, Geneva, 1981*

"Erwin Blumenfeld: Dada Collages 1916-1931", Israel Museum, Jerusalem, 1981

"Erwin Blumenfeld", PPS Galerie F.C.Gundlach, Hamburg, spring 1981

"Erwin Blumenfeld–Photographs", Prakapas Gallery, New York, 6 October-7 November 1981

"Blumenfeld : photographies de mode 1940-1950", Centre Georges Pompidou, Paris, 1981

"Erwin Blumenfeld 1897-1969", La Remise du Parc, Paris, 1982

"Erwin Blumenfeld. Experiments in Perception", Staley Wise Gallery, New York, 16 February-2 April 1983

"Blumenfeld. Vintage Black & White and Color Photographs 1934-1969", Staley Wise Gallery, New York, 12 April-18 May 1985

"Erwin Blumenfeld", Museum Folkwang Essen; Kunstverein Ludwigsburg, Villa Franck; Frankfurter Kunstverein, Steinernes Haus am Römerberg, Essen, 1987-1988*

"Erwin Blumenfeld: DADA Collage and Photography", Rachel Adler Gallery, New York, 1988*

"Erwin Blumenfeld Dye Transfer Prints", Jane Corkin Gallery, Toronto, 24 September-22 October 1988

"Erwin Blumenfeld. Vintage Photographs", Pace/MacGill Gallery, New York, 27 October-26 November 1988

"Erwin Blumenfeld, Photographs 1937-1954", Fahey/Klein Gallery, Los Angeles, 21 October-end November 1988

"Erwin Blumenfeld: Dada: Collages e fotografie 1916-1930, Fotografie 1933-1968", Galleria Milano, Milan, 1989

"Erwin Blumenfeld : entre avant-garde et photographie de mode, parcours exemplaire d'un photographe cosmopolite", Musée de l'Élysée, Lausanne, 16 February-2 April 1989

"Erwin Blumenfeld. Vintage Photographs", Pace/MacGill Gallery, New York, 27 October-26 November 1988

"Erwin Blumenfeld. Photographie", Berlinische Galerie, Museum für moderne Kunst, Photographie und Architektur, Berlin, 1989

"Erwin Blumenfeld. Photography and Collage", Robert Koch Gallery, San Francisco, 1992

"Paul Citroen and Erwin Blumenfeld 1919-1939", The Photographers' Gallery, London, 5-29 June 1993*

"Blumenfeld. Photographies : 1936-1958", Galerie Sonia Zannettacci, Geneva, 8 February-31 March 1995

"Blumenfeld. A Fetish for Beauty", Barbican Art Gallery, London, 12 September-15 December 1996

"Erwin Blumenfeld : Le culte de la beauté", Musée de l'Élysée, Lausanne, 10 April-11 May 1997

"Erwin Blumenfeld: 'Coming Home': Collagen und Zeichnungen 1916 bis 1930", Galerie Brusberg, Berlin, 1997*

"Erwin Blumenfeld : Le culte de la beauté", Maison européenne de la photographie, Paris, 19 February-17 May 1998

"Erwin Blumenfeld: Amsterdam, Paris, New York", Deborah Bell Photographs, New York, 2005

"Erwin Blumenfeld: Paintings, Drawings, Collages & Photographs", Modernism Gallery, San Francisco, 2006*

"Erwin Blumenfeld: His Dutch Years 1918-1936", Fotomuseum Den Haag, The Hague, 2006*

"Blumenfeld: Photographies: France 1936-1941", Galerie Sonia Zanettacci, Geneva, 2008 *

"Erwin Blumenfeld", Galerie Esther Woerdehoff, Paris, 2008

"Erwin Blumenfeld", Galerie Le Minotaure, Paris, 2009

"Erwin Blumenfeld, Vintage", Galerie Andres Thalmann, Zurich, 14 June-17 July 2010

"Erwin Blumenfeld Modern Beauty", 26ᵉ Festival international de Mode et de Photographie, Villa Noailles, Hyères, May 2011

"Erwin Blumenfeld Vintage Fashion", Edwynn Houk Gallery, New York, November 2011-January 2012

"Blumenfeld Studio, couleur, New York, 1941-1960", Musée Nicéphore Niépce, Chalon-sur-Saône, June-September 2012, Museum Folkwang, Essen, March-May 2013, Somerset House, London, May-September 2013*

"Erwin Blumenfeld : A Hidden Ritual of Beauty", Tokyo Metropolitan Museum of Photography, Tokyo, March-May 2013*

List of exhibits

All the photographs and documents listed here are on display in the exhibition. They are reproduced in the catalogue with the exception of those in the sections "Not reproduced".
Unless stated otherwise, all photographs are by Erwin Blumenfeld, and are gelatin silver vintage prints.
Author's titles are in italics, the other are descriptive titles.
Dimensions are in centimetres; height before width.

Drawings

Allegro, Sterb. Schwan
[Allegro, Dying Swan]
February 1919
Pastel and ink on paper; verso: ink drawing of a house and trees, title handwritten, signed
30 × 24
Collection Henry Blumenfeld
p. 17

Man with Red Lips
Early 1920s
Pastel on paper
25 × 15
Collection Henry Blumenfeld
p. 18

Man with Bell
Early 1920s
Pastel on paper
15 × 19.7
Collection Henry Blumenfeld
p. 19

Du Ich Frühlingsabend
[You Me Spring Evening]
May 1919
Ink and coloured pencil on paper, handwriting
31 × 22.1
New York, collection Yvette Blumenfeld Georges

Deeton / Art + Commerce, Berlin, Gallery Kicken Berlin
p. 20

Interieur und Liebe (Der Menschenliebe Blatt 100)
[Interior and Love (To Human Love Sheet 100)]
1919
Ink, coloured pencils and crayon on paper
29 × 22
Collection Henry Blumenfeld
p. 21

Figuration
Early 1920s
Crayon on paper (signed Grosz, possibly imitated by Erwin Blumenfeld. It is not his handwriting and only similar to George Grosz's signature)
33 × 22
Collection Henry Blumenfeld
p. 22

Woman with Blue Jacket
Early 1920s
Pencil and watercolour on paper
35.5 × 25
Collection Henry Blumenfeld
p. 23

3 Mark
c.1919
Ink on paper
22 × 155
Collection Henry Blumenfeld
p. 24

Seated Man
Holland, c.1919
Ink on paper
31.2 × 22.1
New York, collection Yvette Blumenfeld Georges
Deeton / Art + Commerce, Berlin, Gallery Kicken Berlin
p. 25

Sie heisst Olga Schmidt und er Abdullah
[Her Name is Olga Schmidt and his is Abdullah]
25 January 1919
Blue ink and watercolour on paper, handwritten poem, signed
33 × 26
Collection Henry Blumenfeld
p. 26

The Jockey
1919-25
Ink and watercolour on paper
21.3 × 16.5
Collection Helaine and Yorick Blumenfeld
p. 27

Man
January 1923
Watercolour and pencil on paper
28 × 21
Collection Henry Blumenfeld
p. 28

Portrait of Sylvia von Harden, journalist and poet
c.1926
Watercolour and ink on paper
42 × 30
Collection Helaine and Yorick Blumenfeld
p. 29

Group with Charlie Chaplin
1920
Watercolour and pencil on paper
35 × 25
Collection Henry Blumenfeld
p. 31

Old Man with Cigar
Early 1920s
Watercolour and pencil on paper (drawing verso)
35 × 25
Collection Henry Blumenfeld
p. 32

245

Charlie
1920
Collage, ink, watercolour and pencil on paper
25 × 17
Collection Helaine and Yorick Blumenfeld
p. 52

Chaplin Fox
Early 1920s
Collage, ink and pencil on postcard
13.3 × 7.9
Private collection
p. 53

Diskus
[Discus]
1919-25
Pencil, crayon and collage on paper, signed
15 × 25.5
Collection Henry Blumenfeld
p. 54

Absolue
1921-26
Collage with photographs and text
18 × 24.5
Written on the left side: Bloomfield Holland Dada
Archiv Marzona
p. 55

Ehe ist Blutschande!!
[Wedlock is Incest!!]
1919-22
Collage and black ink on paper, handwriting
27.8 × 21
Hamburg, F.C. Gundlach Foundation
p. 56

Autobiographie [Autobiography]
Amsterdam, 1923
Collage and handwriting on stationary "Fox Leather
Comp. Amsterdam"
28 × 22
Collection Helaine and Yorick Blumenfeld
p. 57

Kneeling Man (with Tower)
1920
Indian ink, watercolour, pencil and collage on paper
24 × 17
Collection Henry Blumenfeld
p. 59

Querschnitt deutsch
[Average German]
1920s
Photocollage, black and red ink, pencil and
typescript on stationary "FOX Leather Comp.
Amsterdam"
27.7 × 21.8
Zurich, Kunsthaus Zürich, Grafische Sammlung
p. 60

Verse fliessen mir
[Verses Flow]
1921-24
Indian ink, watercolour and collage on paper,
handwritten text, signed
27 × 21
Collection Henry Blumenfeld
p. 61

Omnium Photo
c.1923
Collage, watercolour and pencil on headed letter
paper: Erwin Blumenfeld, Zandvoort, 35a
Parallelweg
27.7 × 21.5
Private collection
p. 62

Nun
[Now]
Amsterdam, February 1923
Collage, watercolour, ink and pencil on paper signed
29 × 23
Collection Helaine and Yorick Blumenfeld
p. 63

Raucherinnen
[Smoking Women]
1924
Watercolour, ink and collage on paper
30.3 × 23
Private collection
p. 64

Cat Woman
Amsterdam, c.1923-1926
Collage and crayon on paper
28 × 19
Collection Helaine and Yorick Blumenfeld
p. 65

Self-Portraits

Masked Self-Portrait
New York, c.1958
Mounted photograph
36 × 28
Collection Helaine and Yorick Blumenfeld
p. 8

Self-Portrait wiyh Lena, Lisette in Mirror
and Henry
Holland, 1930
30 × 22
Collection Henry Blumenfeld
p. 66

Self-Portrait
Holland, c.1930
Later print
23 × 19
Collection Helaine and Yorick Blumenfeld
p. 73

Erwin Blumenfeld and Paul Citroen
1916
7.7 × 10.5
Amsterdam, Stedelijk Museum
p. 74

Portraits

Heinz Blumenfeld
c.1930
29.5 × 22.6
Leiden University Library, Special Collections
p. 91

Paul Citroen with Lena's Hair
1929
11 × 8
Amsterdam, Stedelijk Museum
p. 92

Triple Exposure
Amsterdam, c.1930
Mounted photograph
40 × 30
Collection Helaine and Yorick Blumenfeld
p. 93

May Kalf, Kapteijn [Captain]
Amsterdam, 1934
Printed on cardboard in the mid-1950s
36 × 28
Collection Helaine and Yorick Blumenfeld
p. 95

Jewish Nursing Home
Amsterdam, c.1932
30 × 24
Collection Helaine and Yorick Blumenfeld
p. 96

Jewish Nursing Home
Amsterdam, c.1932
Mounted Photograph
30 × 24
Collection Helaine and Yorick Blumenfeld
p. 97

Oty Reijne-Lebeau
Amsterdam, c.1932
30 × 24
Collection Helaine and Yorick Blumenfeld
p. 98

Mrs José Maria Sert (Princess Roussadana Mdivani)
Amsterdam, 1935
Mounted on cardboard
29 × 17
Collection Helaine and Yorick Blumenfeld
p. 99

Carel Van Lier with Skeleton
Amsterdam, c.1933
Multiple negatives
30 × 21.4
Amsterdam, Stedelijk Museum
p. 100

John Rädecker, Sculptor
Amsterdam, c.1932
40 × 30
Leiden University Library, Special Collections
p. 101

Solarized Portrait (Wilhelmina Leeuwenstein)
c.1933
30 × 24.4
Leiden University Library, Special Collections
p. 102

Portrait of a Woman
Holland, c. 1933-36
29.8 × 24.1
Amsterdam, Rijksmuseum. Purchased with the support of Paul Huf Fonds/Rijksmuseum Fonds
p. 103

Solarized Portrait
Amsterdam, 1933
Mounted photography
30 × 24
Collection Helaine and Yorick Blumenfeld
p. 105

Georges Rouault, Painter
Paris, c.1936
29.9 × 22.8
New York, collection Yvette Blumenfeld Georges
Deeton / Art + Commerce, Berlin, Gallery Kicken Berlin
p. 106

Carmen, Rodin's Model for The Kiss
Paris, 1936
45.8 × 36.7
Hamburg, F.C. Gundlach Foundation
p. 107

Spivy
1930s
Printed in the 1940s
34 × 26
Switzerland, private collection
p. 108

Henri Matisse, Painter
Paris, c.1936
30 × 24
Switzerland, private collection
p. 109

Valeska Gert, Cabaret Performer
New York, c.1943
30 × 23.7
New York, collection Yvette Blumenfeld Georges
Deeton / Art + Commerce, Berlin, Gallery Kicken
Berlin
p. 110

Marianne Breslauer, Photographer
Amsterdam, 1937
30 × 24
Private collection
p. 111

Detail of a Tapestry
Paris, c.1936
30 × 24
Switzerland, private collection
p. 112

Muth
Paris, c.1938
Mounted on cardboard
30 × 24.2
New York, collection Yvette Blumenfeld Georges
Deeton / Art + Commerce, Berlin, Gallery Kicken Berlin
p. 113

249

Der Augenblick [The Instant]
Paris, 1937
30 × 24
Switzerland, private collection
p. 140

Not reproduced

Paul Citroen Seen Through a Glass Vase
1928
10.9 × 8.1
Amsterdam, Rijksmuseum. Gift of J.P. Filedt Kok,
Amsterdam

Portrait
Amsterdam, c.1930
30.4 × 24.4
Leiden University Library, Special Collections

Jewish Nursing Home
Amsterdam, c.1932
Mounted photograph
25 × 31
Collection Helaine and Yorick Blumenfeld

Karin Van Leyden, Painter
Amsterdam, c.1933
40 × 30
Leiden University Library, Special Collections

Karin Van Leyden, Painter
c.1933
29.8 × 24.1
Amsterdam, Stedelijk Museum

Karin Van Leyden, Painter
1930s
Solarization
30.3 × 24
Berlin, Berlinische Galerie Museum für Moderne
Kunst

Eva Pennink (?), Fashion Illustrater
c.1934
29.5 × 24.2
Switzerland, private collection

Johanna Hendrika Van de Pol
Holland, 1935
22.4 × 19.3
Amsterdam, Stedelijk Museum

Dotz
Amsterdam, 1935
Printed and mounted on cardboard in the 1950s
36 × 28
Collection Helaine and Yorick Blumenfeld

Leonor Fini, Painter
Paris, c.1937
30 × 24
Switzerland, private collection

Lucien Vogel, Publisher
New York, 1940s
35 × 28
Switzerland, private collection

Theodora Roosevelt, Dancer and Writer
1940s-50s
33 × 25
Switzerland, private collection

Kick-Off (Maroua Motherwell) or *Mademoiselle
Seurat*
New York, 1942
34 × 26.5
Switzerland, private collection

Profiles White and Gray
New York, c.1943-44
Superimposed
32 × 27
Collection Helaine and Yorick Blumenfeld

Nudes

Nude
Late 1920s
20.5 × 28.5
Leiden University Library, Special Collections
p. 143

Nude
Amsterdam, c.1935
30.5 × 24
Leiden University Library, Special Collections
p. 144

Nude
Amsterdam, c.1935
Covered with tissue paper
39.5 × 30
Leiden University Library, Special Collections
p. 145

Nude (Lisette)
Paris, 1937
29.8 × 24.1
New York, collection Yvette Blumenfeld Georges
Deeton/Art + Commerce, Berlin, Gallery Kicken Berlin
p. 146

Nude (Lisette)
Paris, 1937
Negative print, solarization
30 × 24.2
New York, collection Yvette Blumenfeld Georges
Deeton/Art + Commerce, Berlin, Gallery Kicken Berlin
p. 147

Nude (Lisette)
Paris, 1937
Printed c.1944
33.5 × 26.3
New York, collection Yvette Blumenfeld Georges
Deeton/Art + Commerce, Berlin, Gallery Kicken Berlin
p. 149

Margarete von Sivers
Paris, 1937
34 × 26
Collection Henry Blumenfeld
p. 150

Nude Under Wet Silk
Paris, 1937
21 × 30
Switzerland, private collection
p. 151

Nude Under Wet Silk
c. 1937
28 × 36
Collection Henry Blumenfeld
p. 152

Nude Under Wet Silk
c. 1937
28 × 36
Collection Henry Blumenfeld
p. 153

Nude
1936
30.3 × 21.1
Amsterdam, Stedelijk Museum
p. 155

Marguerite von Sivers on the Roof of Blumenfeld's
Studio at 9 Rue Delambre
Paris, 1937
30 × 24.1
New York, collection Yvette Blumenfeld Georges
Deeton/Art + Commerce, Berlin, Gallery Kicken Berlin
p. 156

Hair
Paris, 1936
Printed later
36 × 28
Collection Henry Blumenfeld
p. 157

Nude ("Musi mit Busi")
Paris, 1938
28.4 × 23.6
Berlin, Berlinische Galerie Museum für Moderne
Kunst
p. 158

Distorted Nude
New York, 1940s
34 × 26
Collection Henry Blumenfeld
p. 159

Low-Key Nude
Paris, 1937
34.6 × 26
Amsterdam, Rijksmuseum
p. 160

Torso
1940
34 × 26.2
Amsterdam, Rijksmuseum
p. 161

Broken Mirror Nude
New York, c.1947
35.4 × 28
Switzerland, private collection
p. 162

Nude
c.1949
35 × 28
Switzerland, private collection
p. 163

Nude
Paris, late 1930s
Prined later
30.2 × 47.2
Switzerland, private collection
p. 164

Resting Nude
New York, 1949
17.1 × 34.2
New York, collection Yvette Blumenfeld Georges
Deeton/Art + Commerce, Berlin, Gallery Kicken Berlin
p. 165

Not reproduced

Hair
Paris, 1937
29.9 × 24.3
New York, collection Yvette Blumenfeld Georges
Deeton/Art + Commerce, Berlin, Gallery Kicken Berlin

Female Body
1937
29.5 × 22.4
Berlin, Berlinische Galerie Museum für Moderne Kunst

French Statuette, 15th Century (Detail)
Paris, 1936
35.5 × 26.2
Switzerland, private collection

Detail of a Sculpture by Maillol
Paris, 1936
30 × 24.2
Switzerland, private collection

François I
Paris, 1938
30 × 24.4
Berlin, Berlinische Galerie Museum für Moderne Kunst

Mirror Nude Shadow
1955
Printed in the 1950s
33.7 × 26.5
New York, collection Yvette Blumenfeld Georges
Deeton/Art + Commerce, Berlin, Gallery Kicken Berlin

Nude (Betty Biehn)
New York, 1960

36 × 28
Collection Henry Blumenfeld

Betty Biehn
New York, 1960
40 × 50
Collection Henry Blumenfeld

In hoc signo vinces
[In this sign you will conquer]
1967
33.5 × 27.8
Switzerland, private collection

The Dictator

Le Dictateur
[The Dictator]
c.1937
Gelatin silver print, enhanced with airbrush
33.7 × 26.7
Paris, Centre Georges-Pompidou, Musée national
d'art moderne/Centre de création industrielle,
purchase 1995
p. 166

Hitler, *Grauenfresse*
[Hitler, *Face of Terror*]
1933
Multiple negatives
30.5 × 24
Berlin, Berlinische Galerie Museum für Moderne
Kunst
p. 175

Hitler (with Swastika), *Grauenfresse*
[Hitler (with Swastika), *Face of Terror*]
Holland, 1933
Collage and ink on photomontage
Multiple negatives
53 × 45
Collection Helaine and Yorick Blumenfeld, Courtesy
of Modernism Inc., San Francisco
p. 176

Hitler with Bleeding Eyes
Holland, c.1933
Mounted photograph with paint
30 × 23
Collection Helaine and Yorick Blumenfeld
p. 177

The Minotaur or the Dictator
Paris, c.1937
30 × 24
New York, collection Yvette Blumenfeld Georges
Deeton/Art + Commerce, Berlin, Gallery Kicken Berlin
p. 178

Self-Portrait with Calf's Head
Paris, 1937
Printed c.1951
36 × 28
Collection Helaine and Yorick Blumenfeld
p. 179

Masks

Covered Face
Amsterdam, c.1932
29 × 22.5
Leiden University Library, Special Collections
p. 181

Superimposed Portrait (Woman with skull)
1932-33
30 × 24.3
Berlin, Berlinische Galerie Museum für Moderne
Kunst
p. 182

Superimposed Portrait
Amsterdam, c.1933
Multiple negatives
29.5 × 23.8
Leiden University Library, Special Collections
p. 183

Solarized Mask
Paris, 1938
30 x 24
Collection Henry Blumenfeld
p. 184

Mannequin
Amsterdam, 1932
Mounted Photograph
30 × 24
Collection Helaine and Yorick Blumenfeld
p. 185

Fashion Shot for Vogue
Paris, 1937-39
32 × 24
Switzerland, private collection
p. 187

Jewels
Paris, 1936-39
23.8 × 18
Switzerland, private collection
p. 188

The Princess of Pearls (advertisement for Cartier
jewels)
Paris, 1936-39
Negative Print
31 × 24.3
Switzerland, private collection
p. 189

New York, 1944
26 × 33
Collection Henry Blumenfeld
p. 191

Fashion

Lisa Fonssagrives on the Eiffel Tower
Paris, 1939
38.7 x 29.2
San Francisco, Modernism Inc.
p. 238

Not reproduced

Havana Nude
1949
Inkjet printing on Canson baryta paper
Posthumous print (2012)
44 × 37
Collection Henry Blumenfeld

Red Lips
Date unknown
Inkjet printing on Canson baryta paper
Posthumous print (2012)
44 × 37
Collection Henry Blumenfeld

Model Anne Gunning
Date unknown
Inkjet printing on Canson baryta paper
Posthumous print (2012)
44 × 37
Collection Henry Blumenfeld

Advertisement for Elizabeth Arden (Model: Evelyn Tripp)
Date unknown
Inkjet printing on Canson baryta paper
Posthumous print (2012)
44 × 37
Collection Henry Blumenfeld

Four hair colours
Date unknown
Inkjet printing on Canson baryta paper
Posthumous print (2012)
44 × 37
Collection Henry Blumenfeld

Variation on the Cover Photograph of *Harper's Bazaar*, "The Women who Serve"
July 1st, 1943
Inkjet printing on Canson baryta paper
Posthumous print (2012)
44 × 37
Collection Henry Blumenfeld

Variation on the Cover Photograph of *Vogue US*
August 15th, 1944
Inkjet printing on Canson baryta paper
Posthumous print (2012)
44 × 37
Collection Henry Blumenfeld

Model swimming
c.1944
Inkjet printing on Canson baryta paper
Posthumous print (2012)
44 × 37
Collection Henry Blumenfeld

Photograph for Advertisement Shampoos Drene
c.1945
Inkjet printing on Canson baryta paper
Posthumous print (2012)
37 × 44
Collection Henry Blumenfeld

Jewels on Profile (Black Starr and Gorham, Harry Winston, Van Cleef and Arpels, Cartier). Variation on the photograph published in *Vogue US*
November 1st, 1945
Inkjet printing on Canson baryta paper
Posthumous print (2012)
44 × 37
Collection Henry Blumenfeld

Salute to Freedom, Variation on the Advertising Photography for Bianchini Ferier, *Harper's Bazaar*
1945
Inkjet printing on Canson baryta paper
Posthumous print (2012)
44 × 37
Collection Henry Blumenfeld

Variation on the Photograph Published in the Article "Vogue's Eye View of Evenings Out", in *Vogue US*
September 15th, 1946
Inkjet printing on Canson baryta paper
Posthumous print (2012)
44 × 37
Collection Henry Blumenfeld

Barbara (Cover of *Vogue*)
New York, 1946
46 × 36
Collection Helaine and Yorick Blumenfeld

Green dress
1946
Inkjet printing on Canson baryta paper
Posthumous print (2012)
44 × 37
Collection Henry Blumenfeld

Dress of Cadwallader (Model: Leslie Petersen)
1947
Inkjet printing on Canson baryta paper
Posthumous print (2012)
44 × 37
Collection Henry Blumenfeld

Photograph Published Reframed in the Article "Still-life and Mirrors" of *Picture Post*, with Caption: "The eye of male mortality"
June 14th, 1947
Inkjet printing on Canson baryta paper
Posthumous print (2012)
44 × 37
Collection Henry Blumenfeld

Variation of the Photograph Published in *Life Magazine* and Titled "The Picasso Girl" (Model: Lisette)
c.1941-42
Inkjet printing on Canson baryta paper
Posthumous print (2012)
44 × 37
Collection Henry Blumenfeld

Variation on the Cover Photograph of *Vogue US*, *"Do Your Part for the Red Cross"*
March 15th, 1945
Inkjet printing on Canson baryta paper
Posthumous print (2012)
44 × 37
Collection Henry Blumenfeld

For the Cover of *Popular Photography*, Special
"Salon Issue"
December 1948
Inkjet printing on Canson baryta paper
Posthumous print (2012)
44 × 37
Collection Henry Blumenfeld

Presentation of Season Hats. Variation of a
Photograph Published in *Vogue US*, 1st October
1949, p. 144
Inkjet printing on Canson baryta paper
Posthumous print (2012)
78 x 64
Collection Henry Blumenfeld

Variation of a Photograph Published in *Vogue US*,
November 1st, 1949, p. 101. Dress Sargent of
Christian Dior (Model: Evelyn Tripp)
Inkjet printing on Canson baryta paper
Posthumous print (2012)
78 × 64
Collection Henry Blumenfeld

Variation of the Cover of *Vogue US* (Model:
Catherine Cassidy)
1949
Inkjet printing on Canson baryta paper
Posthumous print (2012)
44 × 37
Collection Henry Blumenfeld

Variation of the Cover of *Vogue US* (Model: Ruth
Knowles)
May 1st, 1949
Inkjet printing on Canson baryta paper
Posthumous print (2012)
44 × 37
Collection Henry Blumenfeld

Mode-Montage
c.1950
30.5 × 21.6
Collection Helaine and Yorick Blumenfeld, Courtesy
of Modernism Inc., San Francisco

Behind Colour Strips
c.1950
Inkjet printing on Canson baryta paper
Posthumous print (2012)
44 × 37
Collection Henry Blumenfeld

Variation of the Photograph Published in *Vogue US*
April 1st, 1950
Inkjet printing on Canson baryta paper
Posthumous print (2012)
78 × 64
Collection Henry Blumenfeld

Variation of a Photograph Used for Advertising
Perfumes Dana
c.1950
Inkjet printing on Canson baryta paper
Posthumous print (2012)
44 × 37
Collection Henry Blumenfeld

Variation of the Photography Published in *Vogue US*
(Model: Dovima)
August 1st, 1950
Inkjet printing on Canson baryta paper
Posthumous print (2012)
78 × 64
Collection Henry Blumenfeld

Variation of the Cover of *Vogue US*, Outfit by
Christian Dior (Model: Lilian Marcusson)
January 1st, 1951
Inkjet printing on Canson baryta paper
Posthumous print (2012)
78 × 64
Collection Henry Blumenfeld

Variation of the Photograph Published in the Article
"Presenting– for the First Time Anywhere – the New,
the Inimitable Topaze Mink", *Vogue US*
July 1st, 1952
Inkjet printing on Canson baryta paper
Posthumous print (2012)

37 × 44
Collection Henry Blumenfeld

Cat
c.1952
Inkjet printing on Canson baryta paper
Posthumous print (2012)
44 × 37
Collection Henry Blumenfeld

New York Goddess. Photograph Used for the Cover
of *Photography* (Model: Exilona Sarve)
1952
Inkjet printing on Canson baryta paper
Posthumous print (2012)
44 × 37
Collection Henry Blumenfeld

Three Profiles. Variation of the Photograph
Published in the Article "Colour and Lighting", of
*Photograph Annua*l 1952
1952
Inkjet printing on Canson baryta paper
Posthumous print (2012)
44 × 37
Collection Henry Blumenfeld

Variation of the Photograph Published in the Article
"Retouching the Figure", *Vogue US*. Organdy Dior,
Corset Lily of France, Stockings Modeltex, Satin
Sandals Valley (Model: Ruth Knowles)
February 15th, 1953
Inkjet printing on Canson baryta paper
Posthumous print (2012)
44 × 37
Collection Henry Blumenfeld

Variation of the Cover of *Vogue US*, "A Shake-Up in
Young Fashion"
August 1st, 1953
Inkjet printing on Canson baryta paper
Posthumous print (2012)
44 × 37
Collection Henry Blumenfeld

Variation of the Cover of *Vogue US*. Dress Traina-Norell (Model: Nancy Berg)
May 1st, 1953
Inkjet printing on Canson baryta paper
Posthumous print (2012)
44 × 37
Collection Henry Blumenfeld

Variation of the Cover of *Vogue US*, "A Shake-Up in Young Fashion"
August 1st, 1953
Inkjet printing on Canson baryta paper
Posthumous print (2012)
78 × 64
Collection Henry Blumenfeld

Variation of the Photograph Published in *Vogue US*. Dress Christian Dior and Jewels Verdura (Model: Evelyn Tripp)
March 15th, 1953
Inkjet printing on Canson baryta paper
Posthumous print (2012)
44 × 37
Collection Henry Blumenfeld

Untitled (Model: Jean Patchett)
c.1954
Inkjet printing on Canson baryta paper
Posthumous print (2012)
78 × 64
Collection Henry Blumenfeld

Advertisement for Chesterfield Cigarettes (Model: Nancy Berg)
c.1956
Inkjet printing on Canson baryta paper
Posthumous print (2012)
44 × 37
Collection Henry Blumenfeld

Advertisement for Chesterfield Cigarettes (Model: Nancy Berg)
c.1956
Inkjet printing on Canson baryta paper

Posthumous print (2012)
44 × 37
Collection Henry Blumenfeld

Dayton Oval Room
New York
1962
Superimposed
Mounted photograph
51 × 41
Collection Helaine and Yorick Blumenfeld

Magazines

Vogue US, "Beauty Issue-New Jewels-New Paris Fashion"
November 1st, 1944
Magazine cover
32.2 × 24.5
Switzerland, private collection
p. 197

Vogue US, "Beauty Issue. Summer Fashions"
1945
Magazine cover
32,2 × 24,5
Switzerland, private collection
p. 198

Vogue US, "Beauty That Age-This Age"
November 1st, 1945
Magazine cover
32.2 × 24.5
Switzerland, private collection
p. 199

Vogue US, "Fashions for the Smart Girl in and out of College"
August 15th, 1945
Magazine cover
32.2 × 24.5
Switzerland, private collection
p. 200

Vogue US, "Autumn forecast-Hats-Furs"
August 1st, 1946
Magazine cover
32 × 24.5
Switzerland, private collection
p. 202

Vogue US, "Beauty Magnified"
May 5th, 1949
Magazine cover
32.2 × 24.5
Switzerland, private collection
p. 203

Not reproduced

Verve, vol. 1, No. 1
1937
Magazine
Paris, Musée national d'art moderne – Centre Georges-Pompidou

XXᵉ Siècle
1st year, July-August-September 1938
Magazine
Paris, Musée national d'art moderne – Centre Georges-Pompidou, fonds Destribats, Trésor national acquis grâce au mécénat du groupe Lagardère, 2005

L'Amour de l'art
No. 5
1938
Magazine
Suisse, private collection

Vogue
1939
Magazine
32 × 24
Collection Henry Blumenfeld

Harper's Bazaar
1943
Magazine cover
32 x 24
Collection Henry Blumenfeld

Vogue
August 15th, 1944
Magazine cover
31 x 23
Collection Henry Blumenfeld

Graphis
No. 15
1946
Magazine
Suisse, private collection

Vogue
October 15th, 1949
Magazine cover
32 x 25
Collection Henry Blumenfeld

Vogue
October 15th, 1952
Magazine cover
32 x 24.5
Collection Henry Blumenfeld

Vogue US, "Men's Issue: Clothes (m. and f.), Travel & Ideas"
May 28th, 1953
magazine cover
32.2 × 24.5
Switzerland, private collection

Vogue
March 1st, 1953
Magazine cover
32 x 24.5
Collection Henry Blumenfeld

Vogue
March 15th, 1953
Magazine cover
32 x 24.5
Collection Henry Blumenfeld

Vogue
May 1st, 1953
Magazine cover
32 x 24.5
Collection Henry Blumenfeld

Vogue
1st August 1953
Magazine cover
32 x 26
Collection Henry Blumenfeld

Vogue
December 1st, 1953
Magazine cover
32 x 24.5
Collection Henry Blumenfeld

Vogue
April, 1st 1954
Magazine cover and a few pages
32 x 24.5
Collection Henry Blumenfeld

Vogue
January 1st, 1954
Magazine cover
32 x 24.5
Collection Henry Blumenfeld

Look
October 15th, 1958
Magazine
31 × 25
Collection Henry Blumenfeld

Look
1959
Magazine cover
33 x 27
Collection Henry Blumenfeld

Look
February 16th, 1960
Magazine cover
33 x 27
Collection Henry Blumenfeld

Architecture

Mrs Sean Bérard, Living Rue du Cloître-Notre-Dame
Paris, 1936
30 × 23
Berlin, Berlinische Galerie Museum für Moderne Kunst
p. 213

La Sainte-Chapelle
Paris, 1936
30 × 24.4
Berlin, Berlinische Galerie Museum für Moderne Kunst
p. 214

Notre-Dame
Paris, 1936
30.2 × 24
Berlin, Berlinische Galerie Museum für Moderne Kunst
p. 215

Rouen Cathedral
1937
36 × 28
Collection Henry Blumenfeld
p. 217

Shadow of Eiffel Tower
Paris, 1938
34 × 26
Collection Henry Blumenfeld
p. 218

Paris
c.1936
29.8 × 40.7
Leiden University Library, Special Collections
p. 219

Rouen Cathedral
1937
Multiple negatives
30 × 24
Private collection
p. 220

Rouen Cathedral
1937
Multiple negatives
Printed in 1949-50
50.5 × 40.5
Private collection
p. 221

Rouen Cathedral
1937
32 × 25
Collection Henry Blumenfeld
p. 222

Rouen Cathedral (Detail)
c.1937
29.4 × 24.3
Leiden University Library, Special Collections
p. 223

Natalia Pasco
New York, 1942
34 × 27
Collection Henry Blumenfeld
p. 225

Not reproduced

New York Double Exposure
1950
48 × 40
Collection Helaine and Yorick Blumenfeld, Courtesy of Modernism Inc., San Francisco

Documents

Contact sheets

Not reproduced

Contact Copies of Paris Glass Negatives
Date unknown
Contact sheet
20.3 × 25.4
Switzerland, private collection

Karin Van Leyden, Painter
Amsterdam, c.1933
Contact sheet
Later print
25 × 21,5
Collection Henry Blumenfeld

Mannequins
Holland, 1932
Contact sheet
Later print
25 × 20.5
Collection Helaine and Yorick Blumenfeld

Indonesian Dancer
Amsterdam, c.1933
Contact sheet
Later print
25 × 20.5
Collection Helaine and Yorick Blumenfeld

Indonesian Dancer
Amsterdam, c.1933
Contact sheet

Later print
25 × 20.5
Collection Helaine and Yorick Blumenfeld

Annemarie Schwarzenbach
Amsterdam, c.1934
Contact sheet
Later print
25 × 20.5
Collection Henry Blumenfeld

Dutch Nude Model
Amsterdam, c.1934
Contact sheet
Later print
25 × 20.5
Collection Helaine and Yorick Blumenfeld

American Couple
Amsterdam, 1932
Contact sheet
Later print
25 × 20.5
Collection Helaine and Yorick Blumenfeld

Untitled
Paris, c.1936
Contact sheet
Later print
20.3 × 25.4
Switzerland, private collection

Reproductions

Studio Wall
Amsterdam, c.1934-35
Reproduction
Collection Helaine and Yorick Blumenfeld
p. 138

Erwin Blumenfeld in Front of his *Vogue* Covers
New York, 1952
Reproduction
Collection Helaine and Yorick Blumenfeld
p. 211

Paul Citroen
Erwin as Clown
Berlin, 1912
Reproduction
Collection Helaine and Yorick Blumenfeld
p. 235

Erwin Blumenfeld in German Army Uniform with Iron
Cross
Berlin, 1917
Reproduction
Collection Helaine and Yorick Blumenfeld
p. 236

Erwin Blumenfeld in Swimsuit
c.1929-50
Reproduction
Collection Helaine and Yorick Blumenfeld
p. 236

Not reproduced

Henry
Amsterdam, 1926
Reproduction
Collection Helaine and Yorick Blumenfeld

Living Room in Zandvoort
c.1931
Reproduction
Collection Henry Blumenfeld

Erwin and Lena in Bed
Zandvoort, Holland
c.1933
Reproduction
Collection Helaine and Yorick Blumenfeld

Fox Shop Leather Company
Amsterdam, c.1930
Reproduction
Collection Helaine and Yorick Blumenfeld

Postcard from Erwin Blumenfeld to his Wife
Camp de triage de Marmagne, Côte d'Or
1940
Reproduction
Collection Helaine and Yorick Blumenfeld

Certificate of release
April 27th, 1941
Reproduction
Collection Helaine and Yorick Blumenfeld

Authorisation to Visit to Lisette Blumenfeld
Auxerre
10 June 1940
Reproduction
Collection Helaine and Yorick Blumenfeld

Telegram
Camp of Vernet d'Ariège
1941
Reproduction
Collection Helaine and Yorick Blumenfeld

Erwin Blumenfeld in his New York Photographic
Studio
1950s
Reproduction
Collection Henry Blumenfeld

Postcards, invitations

Blumenfeld's Business card
Amsterdam, 1932
Collection Helaine and Yorick Blumenfeld
p. 140

Not reproduced

Postcard of Paris, Notre-Dame
Paris, 1923
Postcard collage
Collection Helaine and Yorick Blumenfeld

Erotic Card (to George Grosz)
1935
Postcard collage
Collection Helaine and Yorick Blumenfeld

Invitation to the exhibition "Erwin Blumenfeld
Amsterdam" at Galerie Billiet, Paris
1936
Collection Helaine and Yorick Blumenfeld

Letters, manuscripts

meer lena pv
[sea lena pv]
After 1923
Typescript on headed-letter paper "Fox Leather
Comp Kalverstr 116"
Berlin, Akademie der Künste
p. 68

Not reproduced

Charlie Chaplin, Friedrich Nietzsche und ich!
[Charlie Chaplin Friedrich Nietzsche and Me!]
Early 1920s
Typescript
Berlin, Akademie der Künste

Erwin Blumenfeld Letter to Lena
from Berlin to Holland, c.1923
Handwriting on stationery
Collection Helaine and Yorick Blumenfeld

Erwin Blumenfeld Letter to Paul Citroen
from Berlin to Holland, c.1924
Handwritten letter
Collection Helaine and Yorick Blumenfeld

Zum Geleite
[Preface]
1927
Typescript
Berlin, Akademie der Künste

Totenkult
[Death Cult]
1929
Typescript
Berlin, Akademie der Künste

Films, diaporama

Henry and Yorick Blumenfeld
Family films
1960-66
Colour film shot in 16 or 8 mm by the son of Erwin
Blumenfeld and commented by Henry Blumenfeld
4'49"

Cities Portraits (Berlin, New York and Paris)
Late 1950s and early 1960s
Diaporama from 35 mm Ektachrome or
Kodachrome colour negatives

Film Cuts for the Department Store Dayton,
Minneapolis (USA)
c.1960-69
Black and white film made up of 5 sequences, 3'20'
'Voice off for 28' then images

Books, catalogues

Jadis et Daguerre
Foreword of David Rousset
Paris, Robert Laffont
1975
Book
22 × 15 × 5
Collection Henry Blumenfeld

Durch tausendjährige Zeit
Foreword of Alfred Andersch

Frauenfeld, Huber
1976
Book
20,4 × 13.8 × 5.2
Collection Henry Blumenfeld

Durch tausendjährige Zeit
Foreword of Alfred Andersch
Munich, Deutscher Taschenbuch-Verlag
1980
Book
20 × 13
Collection Henry Blumenfeld

Einbildungsroman
Postface of Rudolf Trefzer
Frankfurt am Main, Eichborn
1998
Book
22 × 13
Collection Henry Blumenfeld

Einbildungsroman
Postface of Rudolf Trefzer
Frankfurt am Main, Eichborn
1998
Book (luxury edition)
22 × 13
Collection Henry Blumenfeld

William A. Ewing
Erwin Blumenfeld, Le Culte de la Beauté
Paris, Éditions de La Martinière
1996
Book
31 × 24.8 × 3
Collection Henry Blumenfeld

William A. Ewing
Erwin Blumenfeld, Le Culte de la Beauté
Paris, Éditions de La Martinière
1996
Book
31 × 27
Collection Henry Blumenfeld

Yorick Blumenfeld
Blumenfeld, Nus
1999
Book
29.8 × 23.6 × 2.2
Collection Henry Blumenfeld

Yorick Blumenfeld
*The Naked and the Veiled : The Photographic
Nudes of Erwin Blumenfeld*
London, Thames and Hudson
1999
Book
30 × 25.5
Collection Henry Blumenfeld

Michel Métayer
Erwin Blumenfeld
London and New York, Phaidon
2004
Book
24.1 × 21.1 × 1.5
Collection Henry Blumenfeld

Helen Adkins
*Erwin Blumenfeld "I was nothing but a Berliner"
Dada Montages 1916-1933*
Ostfildern, Hatje Cantz
2008
Book
28 × 22
Collection Henry Blumenfeld

Seventeen American Photographers
Los Angeles, Los Angeles County Museum
January-February 1948
Catalogue
21 × 14
Collection Henry Blumenfeld

Erwin Blumenfeld : Collages Dada 1916-1931
Geneva, Galerie Sonia Zannettacci
1981
Catalogue

25 × 21
Essen, Private collection

Erwin Blumenfeld
Museum Folkwang Essen, Kunstverein Ludwigsburg,
Essen, Villa Franck, Frankfurter Kunstverein,
Steinernes Haus am Römerberg
1987-1988
Catalogue
23.6 × 21.5
Collection Henry Blumenfeld

Erwin Blumenfeld: DADA Collage and Photography
New York, Rachel Adler Gallery
1988
Catalogue
23.5 × 16.5
Collection Henry Blumenfeld

*Erwin Blumenfeld: Dada: Collages e fotografie 1916-
1930, Fotografie 1933-1968*
Milan, Galleria Milano
1989
Catalogue
24 × 17
Essen, Private collection

Blumenfeld : Photographies : 1936-1958
Geneva, Galerie Sonia Zannettacci
March 1995
Catalogue
25 × 21
Collection Henry Blumenfeld

*Erwin Blumenfeld: Coming Home: Collagen und
Zeichnungen*
1916 bis 1930
Berlin, Galerie Brusberg
1997
Catalogue
24 × 16
Essen, Private collection

Erwin Blumenfeld: Amsterdam, Paris, New York
New York, Deborah Bell Photographs
2005
Catalogue
28 × 21.5
Collection Henry Blumenfeld

*Erin Blumenfeld: Paintings, Drawings, Collages &
Photographs*
San Francisco, Modernism Gallery
2006
Catalogue
31 × 24
Essen, Private collection

Erwin Blumenfeld: His Dutch Years 1918-1936
The Hague, Fotomuseum Den Haag
2006
Catalogue
28 × 21.5 × 1.5
Collection Henry Blumenfeld

Blumenfeld: Photographies: France 1936-1941
Geneva, Galerie Sonia Zannettacci
2008
Catalogue
25 × 20
Collection Henry Blumenfeld

Erwin Blumenfeld
Paris, Galerie Le Minotaure
2009
Catalogue
25.5 × 19.5
Collection Henry Blumenfeld

*Erwin Blumenfeld: entre avant-garde et
photographie de mode, parcours exemplaire d'un
photographe cosmopolite*
Lausanne, Musée de l'Élysée
1989
Catalogue
Collection Henry Blumenfeld

Paul Citroen and Erwin Blumenfeld 1919-1939
London, The Photographers' Gallery
1993
Catalogue
28 × 20.5
Collection Henry Blumenfeld

262 This book is published by Jeu de Paume and Hazan on the occasion of the exhibition "Erwin Blumenfeld (1897-1969). Photographs, drawings and photomontages" presented at Jeu de Paume, Paris (October 15, 2013-January 26, 2014) and at Multimedia Art Museum, Moscow (February 17-May 11, 2014).

Curator of the exhibition and editor of the catalogue

Ute Eskildsen

Jeu de Paume

Marta Gili, Director

Maryline Dunaud, General Secretary
Claude Bocage, Head of Administration and Finances
Véronique Dabin, Head of Exhibitions
Pierre-Yves Horel, Head of Technical Services
Marta Ponsa, Head of Public Programmes
Pascal Priest, Bookshop Manager
Anne Racine, Head of Communications and Fundraising
Sabine Thiriot, Head of Educational Programmes

Catalogue
Muriel Rausch, Head of Publications

Exhibition
Edwige Baron, Alice Rivollier, Exhibitions Coordinators
Maddy Cougouluègnes, Registrar
Eric Michaux, Technical Coordinator
Christin Müller, Documentation

Scenography

Nino Comba

Acknowledgements

The Jeu de Paume and the curator of the exhibition would like to thank the Estate of Erwin Blumenfeld for its generous loans and support:

Henry Blumenfeld
Yorick and Helaine Blumenfeld
Yvette Blumenfeld Georges Deeton

And all the private and public lenders who made this exhibition possible:

Akademie der Künste, Berlin, Dr. Wolfgang Trautwein, Director, Michael Krejsa, Head of Visual Art Archive, Catherine Amé, Registrar

Berlinische Galerie – Landesmuseum für moderne Kunst, Berlin, Dr. Thomas Köhler, Director, Maria Bortfeldt, Restorer, Tanja Keppler, Photographic Collection, Christian Tagger, Fine Arts Collection

Bibliothèque littéraire Jacques Doucet, Isabelle Diu, Director, Marie-Dominique Nobécourt Mutarelli, Chief Curator

Centre Pompidou, Musée national d'art moderne, Paris, Alfred Pacquement, Director of the Musée national d'art moderne, Olga Makhroff, Loans Coordinator, Didier Schulmann, Curator at Bibliothèque Kandinsky, Nathalie Cissé, Loans Coordinator at Bibliothèque Kandinsky, Laurence Gueye-Parmentier, Head of Department of Periodicals at Bibliothèque Kandinsky

F.C. Gundlach Foundation, Hamburg, Prof. Franz Christian Gundlach, President, Sebastian Lux, Managing Director

Galerie Kicken Berlin, Berlin, Rudolf and Annette Kicken, Directors, Ina Schmidt-Runke, Gallery Director

Kunsthaus Zürich, Dr. Christoph Becker, Director, Karin Marti, Registrar Collection

Archiv Marzona

Modernism Inc., San Francisco, Martin Muller, President, Danielle Beaulieu, Director

Rijksmuseum Amsterdam, Taco Dibbits, Director of Collection, Mattie Boom, Curator for Photography, Joke Brom Rijnhout, Executive Assistant, Janneke Martens, Registrar's office

Marina Schinz

Stedelijk Museum, Ann Goldstein, Director, Hripsimé Visser, Conservator of Photography, Jette Hoog Antink, Registrar, Annette Cozijn, Registrar

Universiteitbibliotheek Leiden, Kurt De Belder, Director, Maartje van den Heuvel, Curator of Photography, Matthijs Holwerda, Head of Special Collections Services

And those who wish to remain anonymous.

We would also like to express heartfeld gratitude to : Helen Adkins, Nadia Blumenfeld Charbit, Wolfgang Brückle, François Cheval, Janos Frecot, Esther Ruelfs

The Jeu de Paume is subsidized by the Ministry of Culture and Communication

It is supported by NEUFLIZE VIE, principal partner

Picture credits

References are to page numbers.

Akademie der Künste, Berlin: 68
Berlinische Galerie: 36, 47, 158, 175, 182, 213, 214, 215
Henry Blumenfeld: 17, 18, 19, 20, 21, 22, 23, 24, 26, 28, 31, 32, 33, 34, 35, 54, 59, 61, 66, 116, 117, 118, 119, 120, 126, 128, 131, 132, 133, 135, 150, 152, 153, 157, 159, 184, 191, 201, 217, 218, 222, 225, 235, 236, 237, 238, 239
Collection Yvette Blumenfeld Georges Deeton / Art+Commerce (New York), Gallery Kicken Berlin (Berlin): 25, 78, 106, 110, 113, 146, 147, 149, 156, 165, 178
© Centre Pompidou, MNAM-CCI, Dist. RMN-Grand Palais / Bertrand Prévost: 166
Chancellerie des Universités de Paris – Bibliothèque littéraire Jacques Doucet: 48, 49
Courtesy Galerie Michèle Chomette, Paris: 140 (right)
F.C. Gundlach Foundation (Atelier Rohlfs): 46, 56, 107, 124
Henryk Hetflaisz: 8, 27, 29, 41, 45, 52, 57, 63, 65, 73, 80, 81, 85, 86, 87, 89, 93, 95, 96, 97, 98, 99, 105, 114, 121, 138 (left), 140 (left), 170 (left), 177, 179, 185, 211, 235, 236
Kunsthaus Zürich: 51, 60
Leiden University Library – Special Collections: 91, 101, 102, 123, 136, 143, 144, 145, 181, 183, 219, 223
Courtesy of Modernism Inc, San Francisco: 176, 238
Christoph Münstermann, Düsseldorf: 220, 221
Musée Nicéphore-Niépce, Chalon-sur-Saône: 193, 194, 195, 196, 204, 205, 206, 207, 208, 209, 226, 229, 233
Rijksmuseum, Amsterdam: 103, 160, 161
Marcus Schneider, Berlin: 55
Collection Stedelijk Museum, Amsterdam: 74, 75, 79, 92, 100, 155
Dieter Schwer: 111

All rights reserved.

Erwin Blumenfeld: © The Estate of Erwin Blumenfeld

Andreas Feininger: © Andreas Feininger / Premium archive / Getty Images
Franz Fiedler: © Franz Fiedler, rights reserved
John Heartfield: © The Heartfield Community of Heirs / ADAGP, Paris, 2013
René Magritte: © ADAGP, Paris, 2013
Umbo: © Gallery Kicken Berlin / Phyllis Umbehr / ADAGP, Paris, 2013
Willy Zielke : © Willy Zielke, rights reserved

Harper's Bazaar: © Harper's Bazaar
Vogue US: Condé Nast Archive © Condé Nast
Vogue Paris: © Condé Nast France

The covers of Erwin Blumenfeld's autobiography are reproduced with permission from: Deutscher Taschenbuch Verlag GmbH & Co, Munich; Die Andere Bibliothek, Berlin ; Robert Laffont, Paris; Thames & Hudson Ltd, London; Uitgeverij De Harmonie, Amsterdam (for Spiegelbeeld cover: © Erwin Blumenfeld and Leendert Stofbergen, 1980).

Catalogue

Editing
Natasha Edwards

Graphic Design
Nicolas Hubert

Translations from German and French
Susan Pickford (texts of François Cheval, Wolfgang
Brückle, Esther Ruelfs)

Translation from German
Emer Lettow (text of Ute Eskildsen, poem "meer
lena pv")

Translation from Spanish
BarcelonaKontext (preface)

Cover
Jean-Marc Barrier (Poem)

Production
Claire Hostalier and Marie Dubourg

Photoengraving
Reproscan, Orio Al Serio (Italy)

© Éditions Hazan, 2013
© Jeu de Paume, 2013
www.editions-hazan.com
www.jeudepaume.org

ISBN 978 0 300 19938 3

Printed in Castelli Bolis, Cenate Soto (Italy)

Library of Congress Control Number: 2013946692

A catalogue record for this book is available from
The British Library